Turner

The Life and Masterworks

with best wishes

Turner

The Life and Masterworks

Eric Shanes

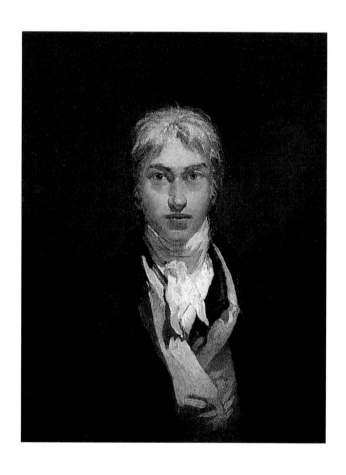

Front cover illustration:

The Lauerzersee, with the Mythens (detail), *c.*1848, watercolour on white
paper, 33.7 x 54.5 cm, Victoria and Albert Museum, London.

Title page:

*Self-Portrait, c.*1798, oil on canvas, 74.5 x 58.5 cm,
Turner Bequest, Tate Britain, London.

Back cover illustration:

MARXBOURG and BRUGBERG on the RHINE, 1820,
watercolour on white paper, 29.1 x 45.8 cm, British Museum, London.

Text: Eric Shanes
Layout: Baseline Co Ltd, Thu Nguyen
19-25 Nguyen Hue Blvd., District 1, Ho Chi Minh City, Vietnam

ISBN 1-85995-905-9

© 2004 Confidential Concept, worldwide, USA
© 2004 Parkstone Press Ltd, New York, USA

Printed in France

CREDITS

Tate Britain: 1, 4, 5, 10, 11, 14, 15, 17, 23, 28, 30, 34, 41, 43, 47, 48,
50, 53, 57, 61, 64, 65, 70, 72, 75, 80, 81, 89, 99, 104, 107, 114
British Museum, London: 2, 3, 6, 16, 19, 24, 62, 68, 74, 85, 87, 101
Royal Academy of Arts, London: 33
Victoria and Albert Museum, London: 7, 113
Fitzwilliam Museum, Cambridge, UK: 20
Lady Lever Art Gallery, Port Sunlight, UK: 21, 73, 112
University of Reading, Reading, UK: 22
National Portrait Gallery, UK: 25
Cecil Higgins Art Gallery, Bedford: 40, 59, 60
Indianapolis Museum of Art: 26, 63

In vivid memory of Tim Whitmore,

who led the way

This is a revised, expanded and updated third edition of *Turner/The Masterworks* by Eric Shanes which was first published in London in 1990.

Note to the Reader: Throughout this book Turner's original titles have been used for his paintings and watercolours, even where the spellings of names and words in those titles may differ from modern ones, or even from each other. Short references to literature within the text allude to full citations in the Bibliography. The abbreviation 'RA' stands for either Royal Academy or Royal Academician (depending on context), while 'ARA' denotes Associate Royal Academician and 'PRA' denotes President of the Royal Academy. 'TB' signifies works in the Turner Bequest, the vast holding of the painter's output in the collection of Tate Britain, London.

Contents

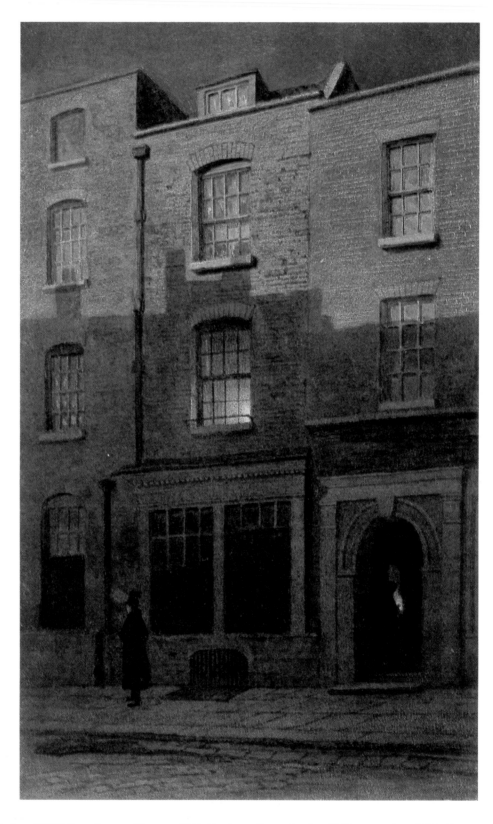

J.W. Archer, *J.M.W. Turner's second home at 26 Maiden Lane, Covent Garden*, 1852, watercolour, British Museum, London.
The Turner family moved here from the artist's birthplace across the road about 1782 or 1783.

THE LIFE

From darkness to light: perhaps no painter in the history of western art evolved over a greater visual span than Turner. If we compare one of his earliest exhibited masterworks, such as the fairly low-keyed *St Anselm's Chapel, with part of Thomas-à-Becket's crown, Canterbury Cathedral* of 1794, with a vividly bright picture dating from the 1840s, such as *The Clyde* (both of which are reproduced below), it seems hard to credit that the two images stemmed from the same hand, so vastly do they differ in appearance. Yet this apparent disjunction can easily obscure the profound continuity that underpins Turner's art, just as the dazzling colour, high tonality and loose forms of the late images can lead to the belief that the painter shared the aims of the French Impressionists or even that he wanted to be some kind of abstractionist, both of which notions are untrue. Instead, that continuity demonstrates how single-mindedly Turner pursued his early goals, and how magnificently he finally attained them. To trace those aims and their achievement by means of a selective number of works, as well as briefly to recount the artist's life, is the underlying purpose of this book.

Joseph Mallord William Turner was born at 21 Maiden Lane, Covent Garden, London, sometime in late April or early May 1775. (The artist himself liked to claim that he was born on 23 April which is both our national day, St George's Day, and William Shakespeare's birthday, although no verification of that claim has ever been found.) His father, William, was a wig-maker who had taken to cutting hair after wigs began to go out of fashion in the 1770s. We know little about Turner's mother, Mary (née Marshall), other than that she was mentally unbalanced, and that her instability was exacerbated by the fatal illness of Turner's younger sister, who died in 1786. Because of the stresses put upon the family by these afflictions, in 1785 Turner was sent to stay with an uncle in Brentford, a small market town to the west of London. It was here he first went to school. Brentford was the county town of Middlesex, and had a long history of political radicalism, which may have surfaced much later in Turner's work. But more importantly, the surroundings of the town – the rural stretches of the Thames down-river to Chelsea, and the countryside upriver to Windsor and beyond – must have struck the boy as Arcadian (especially after the squalid surroundings of Covent Garden), and done much to form his later visions of an ideal world.

By 1786 Turner was attending school in Margate, a small holiday resort on the Thames estuary far to the east of London. Some drawings from this stay have survived and they are remarkably precocious, especially in their grasp of the rudiments of perspective. His formal schooling apparently completed, by the late 1780s Turner was back in London and working under various architects or architectural topographers. They included Thomas Malton, Jr, whose influence on his work is discernible around this time.

After Turner had spent a term as a probationer at the Royal Academy Schools, on 11 December 1789 the first President of the Royal Academy, Sir Joshua Reynolds (1723-92), personally interviewed and admitted him to the institution. The Royal Academy Schools was then the only regular art training establishment in Britain. Painting was not taught there – it would only appear on the curriculum in 1816 – and students merely learned to draw, initially from plaster casts of antique statuary and then, when deemed good enough, from the nude. It took the youth about two and a half years to make the move. Amongst the Visitors or teachers in the life class were History painters such as James Barry RA and Henry Fuseli RA whose lofty artistic aspirations would soon rub off on the young Turner. Naturally, as Turner lived in the days before student grants, he had

to earn his keep from the beginning. In 1790 he exhibited in a Royal Academy Exhibition for the first time, and with a few exceptions he went on participating in those annual displays of contemporary art until 1850. In that era the Royal Academy only mounted one exhibition every year, and consequently the show enjoyed far more impact than it does today, swamped as it now is by innumerable rivals (some of the best of which are mounted by the Royal Academy itself). Turner quickly provoked highly favourable responses to his vivacious and inventive offerings.

In 1791 he briefly supplemented his income by working as a scene painter at the Pantheon Opera House in Oxford Street. This contact with the theatre bore long-term dividends by demonstrating that the covering of large areas of canvas held no terrors, that light could be used dramatically and that the stage positionings of actors and props could usefully be carried over to the staffing of images. Thus in his mature works Turner would often place his figures and/or objects in downstage left, centre and right locations when he especially wanted us to notice them.

At the 1792 Royal Academy Exhibition Turner also received a lesson that would eventually move his art into dimensions of light and colour previously unknown to painting. He was especially struck by a watercolour, *Battle Abbey*, by Michael Angelo Rooker ARA (1746-1801), and copied it twice in watercolour (the Rooker is today in the Royal Academy collection, London, while both of Turner's copies reside in the Turner Bequest). Rooker was unusually adept in minutely differentiating the tones of masonry (tone being the range of a given colour from light to dark). The exceptionally rich spectrum of tones Rooker had deployed in his *Battle Abbey* demonstrated something vital to Turner. He emulated Rooker's multiplicity of tones not only in his two copies but also in many elaborate drawings made later in 1792. Very soon the young artist attained the ability to differentiate tones with even more subtlety than the master he emulated.

The technical procedure used for such tonal variation was known as the 'scale practice', and it was rooted in the inherent nature of watercolour. Because watercolour is essentially a transparent medium, it requires its practitioners to work from light to dark (for it is very difficult to place a light mark over a darker one but not the reverse). Instead of mixing up a palette containing all of the many tones he required for a given image, Turner instead copied Rooker and mixed up merely one tone at a time before placing it at different locations across a sheet of paper. Then, while that work dried, he would take some of the remaining tonal mixture off his palette and brush it onto various locations in further watercolours, which were laid out around his studio in a production line. By the time he returned to the first drawing it would have dried. Turner would then slightly darken the given colour on his palette and add the next 'note' down the tonal 'scale' from light to dark to this work and its successors.

Naturally, such a process saved enormous time, for it did not require the simultaneous creation of a vast range of tones, which would also have required a huge palette and a multitude of brushes, one for each tone. And as well as permitting the production of large numbers of watercolours, this procedure helped with the reinforcement of spatial depth, for because the finishing touches would always be the darkest tones mixed on a palette, their placement in the foreground of an image would help suggest the maximum degree of recession beyond them. Before too long Turner would enjoy an unrivalled ability to differentiate the most phenomenally minute degrees of light and dark, and eventually he would become the most subtle tonalist in world art.

J.M.W. Turner, *Folly Bridge and Bacon's Tower, Oxford*, 1787, pen and ink with watercolour, 30.8 x 43.2 cm, Turner Bequest, Tate Britain, London.
The work is a transcription of an image made for the *Oxford Almanack* by Michael Angelo Rooker.

Within a good many watercolours created after the summer of 1792 the ability to create subtle tonal distinctions within an extremely narrow range of tones from light to dark already permitted Turner to project a dazzling radiance of light (for very bright light forces tones into an extremely constricted tonal band). And eventually tonal differentiation would free the artist to move into new realms of colour. Thus many of the very late works reproduced in this book are all flooded with fields of pure colour, within which only slightly lighter or darker variants of the same colour were used to denote the people, objects, landscapes and seascapes existing within those areas. Despite the tonal delicacy with which such forms are depicted, they all seem fully concrete. Increasingly, Turner's powers as a colourist would become stronger and ever more sophisticated, especially after his first visit to Italy in 1819. By the latter half of his life he would develop into one of the finest and most inventive colourists in European painting. That development began early in life, and initially as a result of seeing Rooker's *Battle Abbey* in 1792. Turner always took what he required from other artists, and the Rooker watercolour gave him exactly what he wanted just when he needed it most.

In 1793 the Royal Society of Arts awarded the seventeen-year-old its 'Greater Silver Pallet' award for landscape drawing. By now the youth was selling works easily, and he supplemented his income throughout the 1790s by giving private lessons. And on winter evenings between 1794 and 1797 he met with various artists – including another leading young watercolourist, Thomas Girtin (1775-1802) – at the home of Dr Thomas Monro. This physician was a consultant to King George III and a doctor specialising in mental illness who would later treat Turner's mother. (She would subsequently die in his care in 1804.) Monro had established an unofficial artistic 'academy' in his house in Adelphi Terrace overlooking the Thames, and he paid Turner three shillings and sixpence per evening plus a supper of oysters to tint copies made in outline by Girtin from works by a number of artists, including Antonio Canaletto (1697-1768), Edward Dayes (1763-1804), Thomas Hearne (1744-1817) and John Robert Cozens (1752-1797), who at the time was a mental patient under the supervision of Dr Monro. Naturally, Turner absorbed the influence of all these painters, and the breadth of Cozens's landscapes particularly impressed him, as it did Tom Girtin.

Further important artistic influences upon Turner during the 1790s were Thomas Gainsborough RA (1727-1788), Philippe Jacques de Loutherbourg RA (1740-1812), Henry Fuseli RA (1741-1825) and Richard Wilson RA (1713?-1782). Gainsborough's Dutch-inspired landscapes led Turner to a liking for those selfsame types of scenes, while de Loutherbourg especially influenced the way that Turner painted his figures, varying their style according to the type of images in which they appeared. Fuseli's approach to the human form may occasionally be detected in Turner's works as well. An appreciation of the pictures of Richard Wilson, who had grafted an Italianate style onto British scenery, soon led Turner to a passionate liking for the works of Claude Gellée (known as Claude le Lorrain, 1600-1682) who had heavily influenced Wilson and who proved to be the most enduring pictorial influence upon Turner for the rest of his life. Yet from his mid-teens onwards, one overriding aesthetic influence came to shape Turner's thinking about his art, and not surprisingly it derived from within the Royal Academy itself, albeit mostly through reading rather than from being imparted directly. This was the influence of Sir Joshua Reynolds.

Turner had attended the last of Reynolds's lectures or Discourses in December 1790, and from reading the rest of them he seems to have assimilated or responded to all of Reynolds's lessons concerning the idealizing aspirations for art that were so eloquently set forth in those fifteen talks. In order to understand Turner's overall creative development, it is vital to perceive it in the context of Reynolds's teachings.

J.W. Archer, *Attic in Turner's house in Maiden Lane, Covent Garden*, said to have been Turner's first studio, 1852, watercolour, British Museum, London.

In his Discourses Reynolds not only set forth a comprehensive educational programme for aspiring artists; he also upheld the central idealizing doctrine of academic art that had evolved since the Italian Renaissance. This can validly be termed the Theory of Poetic Painting. It maintained that painting and sculpture are disciplines akin to poetry, and that their practitioners should therefore attempt to attain an equivalence to the profound humanism, mellifluity of utterance, aptness of language, measure and imagery, grandeur of scale, and moral discourse of the most exalted poetry and poetic dramas.

From the mid-1790s onwards we encounter Turner setting out to realise all of these ambitions. Thus his landscapes and seascapes rarely lack some human dimension after this time, and frequently their subject-matter is drawn from history, literature and poetry. The images are also increasingly structured to attain the maximum degrees of visual consonance, coherence and mellifluity. The visual equivalent to the aptness of language, measure and imagery encountered in poetry (and to the additional appropriateness of gesture and deportment found in poetic dramas, such as the plays of Shakespeare) was known as 'Decorum' in the aesthetic literature known to Reynolds and Turner. Many of the latter's favourite landscape painters, particularly Claude, Nicholas Poussin (1594-1665) and Salvator Rosa (1615-1673), had often observed such Decorum through matching their times of day, light and weather-effects to the central meanings of their pictures. By 1800 Turner had also begun to create such appropriateness, and an example of this procedure can be witnessed in the watercolour of *Caernarvon Castle* displayed at the Royal Academy in that year; it is discussed below, as are particularly ingenious observances of Decorum, *Pope's Villa at Twickenham* of 1808 and a far better-known later example, *The Fighting 'Temeraire'* of 1839.

Decorum is an associative method, and because Turner possessed an unusually connective mind, he always found it easy to match times of day, light and weather-effects most appropriately to the meanings of his pictures. He also imbued many of his works with associative devices commonly encountered in poetry. These are allusions, or subtle hints at specific meanings; puns or plays upon the similarity of appearances; similes or direct comparisons between forms; and metaphors, whereby something we see doubles for something unseen. Occasionally Turner could even string together his visual metaphors to cre-

J.M.W. Turner, *The Pantheon, the morning after the fire*, RA 1792, watercolour, 39.5 x 51.5 cm, Turner Bequest, Tate Britain, London.
The Pantheon Opera House in Oxford Street, London, was burnt down by arsonists on 14 February 1792.
Turner may have worked there as a scene-painter during the previous year.

ate complex allegories. (Many of these devices are explored below.) Here Turner was again following Reynolds, who in his seventh Discourse had suggested that, like poets and playwrights, painters and sculptors should use 'figurative and metaphorical expressions' to broaden the imaginative dimensions of their art.

In the final, 1790 Discourse attended by Turner, Reynolds had especially celebrated the grandeur of Michelangelo's art. As early as 1794 Turner began doubling or trebling the size of objects and settings he represented (such as trees, buildings, ships, hills and mountains) in order to aggrandize them greatly. He would continue to do so for the rest of his life, in ways that ultimately make his landscapes and seascapes seem every bit as grand as the figures of Michelangelo.

And by 1796, with a watercolour of Llandaff cathedral (reproduced here), Turner also began making moral points in his works. Often he would comment upon both the brevity of human life and of our civilisations, our frequent indifference to that transience, the destructiveness of mankind, and on much else besides. To that end, and equally to expand the temporal range of his images, from 1800 onwards he starting making complementary pairs of works; usually these were on identically-sized supports and created in the same medium, although not invariably so (for example, see the *Dolbadern Castle* and *Caernarvon Castle* discussed below, which are respectively an oil and a watercolour). In these and other ways he responded keenly to Reynolds's demand that artists should be moralists, putting human affairs in a judgemental perspective. And linked to the moralism was Reynolds's admonition that artists should not concern themselves with arbitrary or petty human experience but instead investigate the universal truths of our existence, as they are commonly explored in the highest types of poetry and poetic drama. To further this end, Reynolds entreated artists to go beyond the emulation of mere appearances and convey what Turner himself would characterise in an 1809 book annotation as 'the qualities and causes of things', or the universal truths of behaviour and form.

We shall return to Turner's approach to the universals of human existence presently. But from the mid-1790s onwards he began to express 'the qualities and causes of things' in his representations of buildings, as can readily be seen in the 1794 watercolour of St Anselm's Chapel, Canterbury reproduced below. In works like this we can already detect a growing comprehension of the underlying structural dynamics of man-made edifices. Within a short time, in watercolours such as the *Trancept of Ewenny Priory, Glamorganshire* of 1797 (also reproduced below), this insight would become complete. And because Turner believed that the underlying principles of manmade architecture derived from those of natural architecture, it was but a short step to understanding geological structures too. Certainly, Turner made apparent the 'qualities and causes' of the latter types of forms by early in the following century (for example, see the rock stratification apparent in *The Fall of the Reichenbach, in the valley of Oberhasli, Switzerland* of 1804 reproduced below).

From the mid-1790s onwards we can simultaneously detect Turner's thorough apprehension of the fundamentals of hydrodynamics. The *Fishermen at Sea* of 1796 (reproduced below) demonstrates how fully the painter already understood wave-formation, reflectivity and the underlying motion of the sea. From this time onwards his depiction of the sea would become ever more masterly, soon achieving a mimetic and expressive power that is unrivalled in the history of marine painting. Undoubtedly there have been, and still are, many marine painters who have gone far beyond Turner in the degrees of photographic realism they have brought to the depiction of the sea. Yet none of them has come within miles – nautical miles, naturally – of expressing the fundamental behaviour of water. By 1801, when Turner exhibited 'The Bridgewater Seapiece' (reproduced below), his grasp of such dynamics was complete.

By that time also the painter had simultaneously begun to master the essential dynamics of cloud motion, thereby making apparent the fundamental truths of meteorology, a comprehension he fully attained by the mid-1800s. Only his trees remained somewhat mannered during the decade following 1800. However, between 1809 and 1813 Turner gradually attained a profound understanding of the 'qualities and causes' of arboreal forms, and thereafter replaced a rather old-fashioned mannerism in his depictions of trunks, boughs and foliage with a greater sinuousness of line and an increased sense of the structural complexity of such forms. By 1815 that transformation was complete, and over the following decades, in works such as *Crook of Lune, looking towards Hornby Castle* and the two views of Mortlake Terrace dating from 1826 and 1827 (all three of which are reproduced below), Turner's trees would become perhaps the loveliest, most florescent and expressive natural organisms to be encountered anywhere in art.

All these various insights are manifestations of Turner's idealism, for they subtly make evident the ideality of forms, those essentials of behaviour that determine why a building is shaped the way it is in order to stand up, why a rockface or mountain appears as it does structurally, what forces water to move as it must, what determines the way clouds are shaped and move, and what impels plants and trees to grow as they do. No artist has ever matched Turner in the insight he brought to these processes. This was recognised even before his death in 1851 by some astute critics, especially John Ruskin who in his writings extensively explored the artist's grasp of the 'truths' of architecture, geology, the sea, the sky and the other principal components of a landscape or marine picture.

In order to create idealised images, throughout his life Turner followed a procedure recommended by Reynolds. This was ideal synthesis, which was a way of overcoming the arbitrariness of appearances. Reynolds accorded landscape painting a rather lowly place in his artistic scheme of things because he held landscapists to be mainly beholden to chance: if they visited a place, say, when it happened to be raining, then that was how they would be forced to represent it if they were at all 'truthful'. In order to avoid this arbitrariness, Reynolds recommended another kind of truth in landscape painting. This was the practice of landscapists like Claude le Lorrain, who had synthesized into fictive and ideal scenes the most attractive features of *several* places as viewed in the most beautiful of weather and lighting conditions, thus transcending the arbitrary. Although Turner gave more weight to representing individual places than Reynolds was prepared to permit, this individuation was largely offset by a wholehearted adoption of the synthesizing practice recommended by Reynolds (so much so that often his representations of places bore little resemblance to actualities). As Turner would state around 1810:

> To select, combine and concentrate that which is beautiful in nature and admirable in art is as much the business of the landscape painter in his line as in the other departments of art.

And Turner equally overcame arbitrariness by employing his unusual powers of imagination to the full. He stated his belief in the supremacy of the imagination in a paraphrase of Reynolds that stands at the very core of his artistic thinking:

> ...it is necessary to mark the greater from the lesser truth: namely the larger and more liberal idea of nature from the comparatively narrow and confined; namely that which addresses itself to the imagination from that which is solely addressed to the Eye.

J.M.W. Turner, *Llandaff Cathedral, South Wales*, RA 1796, watercolour, 35.7 x 25.8 cm, British Museum, London.
With its children dancing on graves – and thus oblivious to the fact that one day they too will occupy such tombs
– this drawing may have been Turner's first moral landscape.

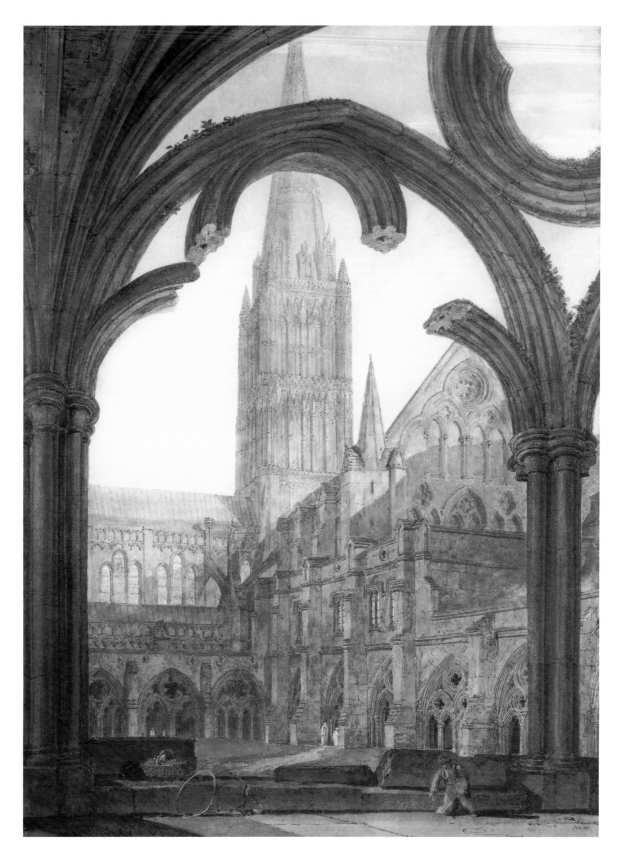

J.M.W. Turner, *South view from the cloisters, Salisbury Cathedral*, c. 1802, watercolour, 68 x 49.6 cm,
Victoria and Albert Museum, London. This is one of a set of large views of the cathedral made for Sir Richard Colt Hoare.

Yet this does not mean that Turner neglected the eye. He was an inveterate sketcher, and there are over 300 sketchbooks in the Turner Bequest, incorporating over 10,000 individual sketches. Often he would sketch a place even if he had sketched it several times before. By doing so he not only mastered the appearances of things but also honed his unusually retentive memory, which is a crucial tool for an idealizing artist, inasmuch as memory sifts the essential from the inessential.

Turner's principal method of studying appearances and still allowing himself room for imaginative manoeuvre was to sketch a view in outline, omitting any effects of weather and light, or even its human and other live inhabitants (if needed, those ancillaries could be studied separately). He would then return to the sketch at a later date, supplying many visual components of the scene mainly from memory and/or the imagination. Turner kept all his sketchbooks for later reference, and sometimes he would return to them as much as forty years after they were first used in order to obtain the factual data for an image. This practice began in the early 1790s, and it is easy to perceive how it grew directly out of the idealizing admonitions of Reynolds.

And another, higher kind of idealisation grew out of Reynolds's teachings as well. From fairly early on in his career Turner came to believe that ultimately forms enjoy a metaphysical, eternal and universal existence, independent of man. This apprehension first formed through the analysis of architecture. Like many before him, Turner maintained that not only is there a profound linkage between man-made architecture and natural architecture, but that a universal geometry underlies both. After the mid-1790s this belief was fuelled by a close reading of poetry, most particularly the verse of Mark Akenside, whose long poem 'The Pleasures of the Imagination' states a Platonic idealism with which Turner completely identified, with momentous results for his art.

In post-1807 perspective lecture manuscripts, Turner wrote of the artistic necessity of making earthly forms approximate to such 'imagined species' of archetypal, Platonic form. He followed many others in characterising these ultimate realities as 'Ideal beauties'. From such an apprehension it was easy for him eventually to believe in the metaphysical power of light, and even – because it is the source of all earthly light and physical existence – that 'The Sun is God' (as he stated shortly before his death). Due to such a viewpoint it is clear that the near-abstraction of Turner's late images is no mere painterly device, despite many recent claims to the contrary. Instead, it resulted from an attempt to represent some higher power, if not even the divinity itself. Turner's idealism was lifelong. Everywhere in his oeuvre, but especially in his later works, we can witness the projection of an ideal world of colour, form and feeling. Not for nothing did a writer in 1910 imagine that if Plato could have seen a Turner landscape, he would 'at once have given to painting a place in his Republic'.

Only in one important respect did Turner depart from the teachings of Reynolds: his representations of the human figure. Another reason Reynolds held landscape painting in fairly low esteem was because it had never said much about the human condition, which for him was necessarily the principal concern of high art. From the outset Turner became intent on disproving him: to imbue landscape and marine painting with the humanism encountered in genres more directly concerned with mankind was his lifelong ambition. But he quickly realised that in order to be absolutely truthful to his own insight into the human condition he would have to reject a central aspect of Reynolds's thinking. For the great teacher, as well as for a host of other academic theorists of like mind, one of the supreme purposes of poetic painting was to exalt mankind through projecting an ideal beauty of human form: to that end Reynolds recommended the creation of beautified physiques similar to those encountered in the works of Michelangelo and other, comparable idealising artists. But

Turner rejected that central tenet of the Theory of Poetic Painting. Instead he consciously evolved a decidedly unidealised physique for his representations of humanity.

Even by 1794, as in the Canterbury Cathedral view reproduced below, we can see Turner drawing upon Lowlands painting for the formation of his figures. He especially modelled his people upon those by David Teniers the younger (1610-1690). Precisely because of his intentionally boorish people, Teniers had a large following in Britain, especially among members of the upper class, who found them droll (which is why many British country houses still have pictures by Teniers hanging on their walls). In impressive marine paintings such as the 'Bridgewater Seapiece' of 1801, the *Calais Pier* of 1803 and *The Shipwreck* of 1805 (all reproduced below), Turner consciously imitated the appearance of Teniers's figures in order to state the central moral contrast of his entire art as far as humanity is concerned: the world around us may be immense, beautiful, ugly, peaceful, ferocious or whatever, but humankind is small, vain and of exceedingly limited strength within that surround. For Turner we are not the 'lords of creation'. Far from it. Instead, we are merely insignificant specks of matter in an often hostile and always indifferent universe. We may try to overcome the forces of external nature, but such attempts are both a cosmic and a comic self-delusion. To point up this 'fallacy of hope' Turner constantly made us look as imperfect, gauche, crude, child-like or even doll-like as possible, just as Teniers and other painters influenced by that Flemish artist (including de Loutherbourg) had represented us. In this respect he was consciously turning his back on a dominant aspect of the academic idealism propounded by Reynolds, namely the formation of beautified human archetypes. But if Turner had filled his works with heroic, Michelangelesque figures, those people would have severely diminished what he had to say about our lowly place in the universal scheme of things. Instead, by creating an anti-heroic and 'low' model for humanity, Turner not only maximised the contrast between humanity and the natural world beyond us but simultaneously he stated something that is even more intensely truthful and universal about humankind than Reynolds had demanded. Turner lived in an age in which the majority of people were often made ugly by the harshness of survival, and endured tragically short, brutalized, uneducated and anonymous lives. He represented such people countless times, and his consciously imperfect figures are totally congruent with the extremely imperfect lives they led. This is the ultimate form of Turnerian Decorum: a complete matching of human appearances to our underlying realities.

In addition to ideal 'imitation' – the creation of perfected notions of form, which by definition included the expression of the 'qualities and causes' of things – Reynolds had also advocated artistic 'imitation', the absorption of the qualities of the finest masters of past art through imitation of their works stylistically. Here too Turner followed Reynolds assiduously. Throughout his life he emulated the pictorial formulations of a vast range of past (and present) masters, from Titian (1490?-1576), Raphael (1483-1520) and Salvator Rosa in the Italian school, to Claude, Nicolas Poussin and Watteau (1684-1721) in the French school, to Rembrandt (1606-1669), Cuyp (1620-1691), van de Velde the younger (1633-1707) and Backhuizen (1631-1708) in the Dutch school, to any number of his contemporaries in the English school. Such emulation was not the sign of any imaginative deficiency in Turner, and even less was it due to him being possessed of a supposed inferiority complex that led to rivalry with his betters, as has often been suggested. Turner was merely following Reynolds's teachings and example. It is a mark of his creative vision that whomsoever he emulated, the results always ended up looking thoroughly Turnerian (even if they might well fall short of their models qualitatively).

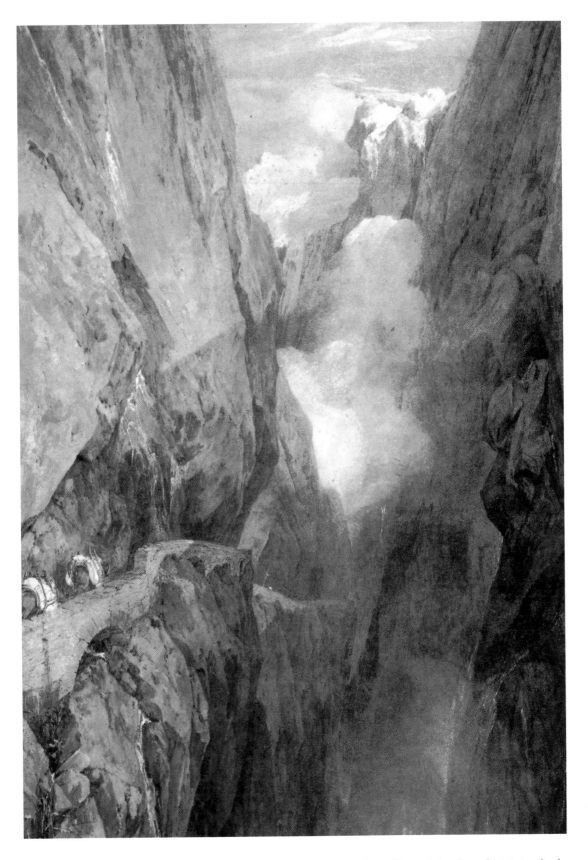

J.M.W. Turner, *The Passage of Mount St Gothard, taken from the centre of the Teufels Broch (Devil's Bridge), Switzerland,* signed and dated 1804, watercolour, 98.5 x 68.5 cm, Abbot Hall Art Gallery, Kendal, Cumbria.

J.M.W. Turner, *Frontispiece of 'Liber Studiorum'*, mezzotint engraving, 1812, Tate Britain, London.

In 1791 Turner made the first of his sketching tours; by the end of his career he would have undertaken more than fifty such tours. During the 1790s alone he ranged over the south of England, the Midlands and the north of England (including the Lake District). He also made five tours of Wales in search of the kind of scenery that Richard Wilson had painted. On each tour he filled a number of sketchbooks with dry topographical studies and the occasional watercolour, from which he would work up elaborate paintings and watercolours back in London.

A memoir of Turner on his sketching tour of Wales and the West Country in 1798 makes his creative priorities very clear:

> *I recollect Turner as a plain uninteresting youth both in manners and appearance, he was very careless and slovenly in his dress, not particular what was the colour of his coat or clothes, and was anything but a nice looking young man....He would talk of nothing but his drawings, and of the places to which he should go for sketching. He seemed an uneducated youth, desirous of nothing but improvement in his art....*

This view of Turner seems to have been a general one, for it was echoed by the topographical artist Edward Dayes in 1805: 'The man must be loved for his works; for his person is not striking nor his conversation brilliant.' Although Turner's intellect was enormous, his patchy education and wholehearted commitment to his art meant that he cut a poor figure socially, although in time he would polish his edges and gain in public confidence. Emotionally he was remarkably sensitive, for just below the surface lay a deep vulnerability which probably derived from unhappy childhood experiences brought about by the instability of his mother. Such insecurity led Turner always to maintain his emotional defences until he felt he could fully trust people not to hurt him. When he did trust them, however – and he always trusted children – then a completely different side of his personality would emerge. This can be seen in another memoir of the painter as a young man, by his friend Clara Wells:

Of all the light-hearted, merry creatures I ever knew, Turner was the most so; and the laughter and fun that abounded when he was an inmate in our cottage was inconceivable, particularly with the juvenile members of the family. I remember coming in one day after a walk, and when the servant opened the door the uproar was so great that I asked the servant what was the matter. 'Oh, only the young ladies (my young sisters) playing with the young gentleman (Turner), Ma'am.' When I went into the sitting room, he was seated on the ground, and the children were winding his ridiculously long cravat round his neck; he said, 'See here, Clara, what these children are about!'

Turner's 'home from home' in the cottage of Clara Wells's father, William Wells, at Knockholt in Kent, was the first of several such boltholes he would enjoy throughout his life. By the end of the 1790s, as the insanity of his mother intensified, it must have seemed a vital means of escape for him. And as soon as he could afford it the painter moved from the parental abode in Maiden Lane, in late 1799 obtaining rooms at 64 Harley Street in a house that eventually he would take over completely.

The 1796 *Fishermen at Sea* was Turner's first exhibited oil painting, and it demonstrates his natural proficiency in the medium. By that date, of course, he had already mastered watercolour, and henceforth he was fully capable of investing it with the same powers of expression and representation more usually to be encountered in oil paint. Similarly, in his oil paintings the artist increasingly obtained the kind of brilliance and luminosity that are more usually to be found in watercolour. But why choose one medium rather than the other? Well, watercolour was fast to work with, and hence permitted great spontaneity. Its speed of drying also allowed for the creation of large numbers of works within a given timescale, and hence lower prices to the public. Oil paint was slower-drying but more highly regarded culturally and more publicly assertive through its capacity for deployment over much larger surfaces than watercolour. One could also charge far higher prices for oils (which was partially a necessity, as they took much longer to produce).

Turner never rested on his laurels as far as techniques were concerned. In order to extend himself, he would often set himself technical challenges. For example, in the 1820s and '30s he would choose to make sets of watercolours on an unfamiliar kind of support such as a blue or a grey paper. In some of his even later works his trust in new materials (such as a paint supposedly soluble in either oil or water) would be misplaced, with disastrous results for individual works. Yet in the main his paintings and watercolours are technically sound. And when he was especially inspired, as with *The Fighting 'Temeraire'* of 1839, he would go to great lengths to paint the work as carefully as possible.

In 1798 an alteration to the rules governing the Royal Academy annual Exhibitions allowed artists to include quotations from poetry alongside the titles of their works in the exhibition catalogues. Turner immediately availed himself of this change in order to embark upon a public examination of the roles of painting and poetry, how each discipline could support the other, and where their individual powers resided. In 1798 he appended poetic quotations to the titles of five works; they included verses by John Milton and James Thomson identifying the sun with God. With some of these quotations Turner tested the ways that painting can realize and/or heighten the imagery of poetry, while with others he explored the way that poetic imagery can extend the associations of what we see, and thus move us into realms of imaginative response we cannot reach unaided.

In 1799 Turner took this latter process a stage further, employing alongside the titles of five works a poetry that is particularly rich in metaphors in order to extend the images imaginatively into areas that pictorialism cannot explore without verbal help. And in 1800, with two views of Welsh castles (both of which are discussed below), Turner reversed the foregoing procedure by quoting only descriptive poetry that is totally devoid of metaphors; instead, he incorporated the metaphors into the images themselves, thus completing the process of integrating painting and poetry whilst greatly extending the ability of visual images to convey meanings. Thereafter, Turner did not again quote poetry in connection with the titles of his works in the exhibition catalogues for another four years, although when he did so it was to state the internal responses of the people he portrayed, something that again painting cannot fully express without the aid of words. This methodical exploration of the respective powers of painting and poetry was to prove of inestimable value during the rest of Turner's career.

Turner's 1798-1800 investigation of the mechanisms by which pictorial meanings are communicated was equally helped by the close study he made around 1799 of the imagery of Claude le Lorrain. He may have been inspired to undertake such a detailed analysis by being particularly struck by two paintings by Claude. One was the *Landscape with the Father of Psyche sacrificing at the Milesian Temple of Apollo* (Anglesey Abbey. Cambs) which had just been brought to Britain from Italy, and in front of which Turner was recorded as being 'both pleased and unhappy while He viewed it,– it seemed to be beyond the power of imitation'. The other picture was a seaport scene, *The Embarkation of the Queen of Sheba* (National Gallery, London), that belonged to the wealthy London collector John Julius Angerstein. Turner responded to this painting in a rather dramatic (and wholly characteristic) fashion:

> *When Turner was very young he went to see Angerstein's pictures. Angerstein came into the room while the young painter was looking at the Sea Port by Claude, and spoke to him. Turner was awkward, agitated, and burst into tears. Mr Angerstein enquired the cause and pressed for an answer, when Turner said passionately, 'Because I shall never be able to paint anything like that picture.'*

Turner's analysis of Claude around 1799 was undertaken not only by looking carefully at major oils like these, but also by scrutinizing two books of prints entitled *Liber Veritatis* ('Book of Truth'). This is a set of 200 mezzotints made around 1776 by the London engraver Richard Earlom that reproduces drawings created by Claude upon the completion of each of his mature paintings. The French master greatly utilized visual metaphor, and there can be no doubt that Turner recognized a good number of those metaphors, for in time he emulated them very closely indeed. Turner's responsiveness to Claude had a profound effect upon his expressions of meaning, just as it determined the development of many of his compositions and a significant amount of his subject-matter and imagery.

Throughout the 1790s Turner had been obtaining higher and higher prices for his works as demand intensified; an indication of that popularity may be gauged from the fact that by July 1799 he had orders for no less than sixty watercolours on his books. And his increasing status in the marketplace was matched by his growing recognition within the Royal Academy, an esteem that was made official on 4 November 1799 when he was elected an Associate Royal Academician. This was a necessary preliminary to becoming a full Academician, and he would not have to wait long before receiving the higher honour.

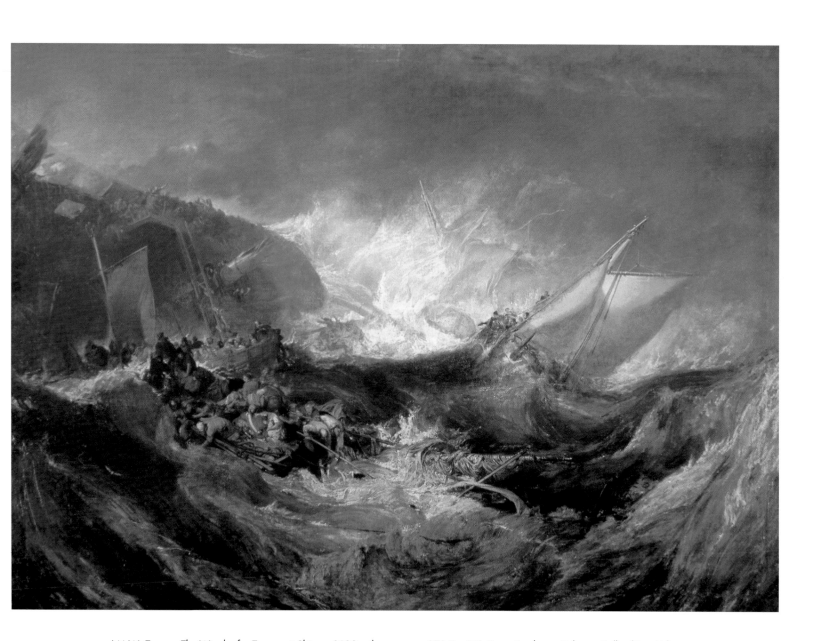

J.M.W. Turner, *The Wreck of a Transport Ship*, c. 1810, oil on canvas, 172.7 x 241.2 cm, Fundaçao Calouste Gulbenkian, Lisbon.
With this picture Turner exhausted his need to express himself by means of ferocious shipwreck scenes,
for with one exception he did not paint such a subject for another twelve years.

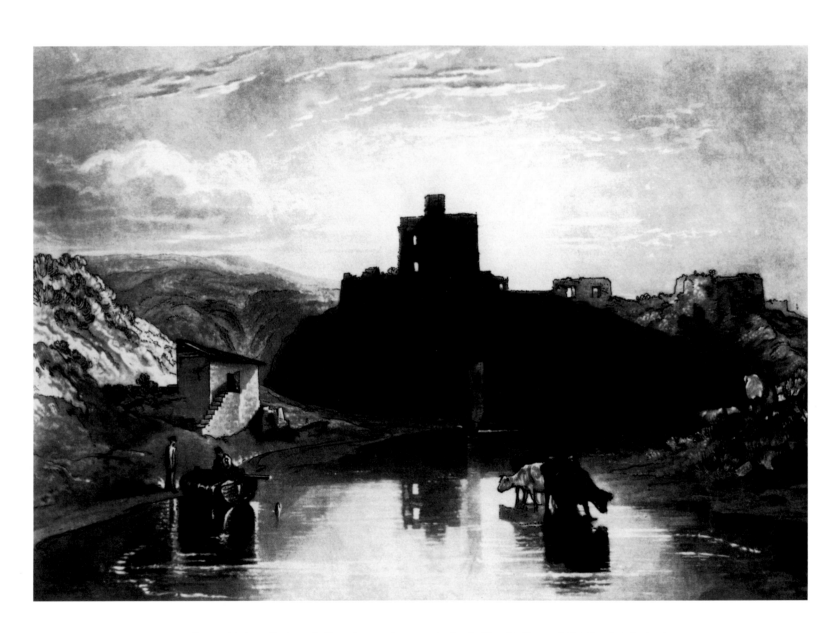

J.M.W. Turner, *Norham Castle on the Tweed*, mezzotint engraving for the Liber Studiorum, 1816, Tate Britain, London.

At the Royal Academy in 1801 Turner made a major contribution towards such an elevation when he exhibited his finest seascape to date, the *Dutch Boats in a Gale: Fishermen endeavouring to put their Fish on Board*, which is also known as 'The Bridgewater Seapiece' after the Duke of Bridgewater who had commissioned it. The work (reproduced below) caused a sensation. Reynolds's successor as President of the Royal Academy, Benjamin West (1738-1820), compared it favourably to a Rembrandt, which is quite a compliment for a young painter still making his way in the world. Ultimately the impression created by the picture led to Turner being raised to the status of a full Royal Academician at the unprecedentedly early age of just twenty-six, on 10 February 1802. Becoming an Academician granted him entry to a very exclusive club indeed, and one with the best of cultural and economic advantages, that of having a highly prestigious marketplace in which automatically to display his works publicly every year without having to submit them to a selection committee.

In the summer of 1801 Turner made an extensive tour of Scotland, the most ambitious trip he had undertaken so far. After his return he showed his Scottish drawings to his fellow landscapist, the painter and diarist Joseph Farington RA, who noted early in 1802 that 'Turner thinks Scotland a more picturesque country to study in than Wales, the lines of the mountains are finer, and the rocks of larger masses'. But later that same year Turner had the opportunity to study mountains that greatly dwarfed those of Scotland.

In March 1802 a peace was concluded between Britain and France, after some nine years of war. This allowed tens of thousands of Britons to venture abroad for the very first time. Although Turner had already seen mountains in Wales and Scotland, he knew that if you wish to be staggered by truly majestic heights in Europe then you have to visit the Swiss alps. Accordingly, that was where he made for in the summer of 1802, exploring some of the western cantons and the northern reaches of the Val d'Aosta before making his way to Schaffhausen and Basel. From there he went on to Paris to see the looted treasures Napoleon had installed in the Louvre. In the French capital Turner met Farington, and told him that in Switzerland he had suffered 'much fatigue from walking, and often experienced bad food & lodgings. The weather was very fine. He saw very fine Thunder Storms among the Mountains.' In the Louvre Turner closely scrutinized works by Poussin, Titian and others, although unfortunately the numerous Claudes in the collection do not seem to have been on display (or perhaps the Englishman simply missed them, which is understandable, given that he must have been tired and suffering from visual indigestion).

Turner began elaborating his responses to Swiss scenery on his return to England. During the winter of 1802-3 he also produced an impressive painting of the view from Calais Pier looking across the English Channel (it is reproduced below). In the work he made a wittily anti-French statement within a tradition of such sentiments going back to William Hogarth (1697-1764), another artist he particularly admired. Such a secondary purpose was perhaps natural, given that while Turner was busy on the picture all the talk in Britain was of the resumption of hostilities with France.

By this time Turner may have become a father. He always refused to marry, but has long been thought to have sired two daughters, Evelina (1801-1874) and Georgiana (?1811-1843). Their mother is thought to have been a Mrs Sarah Danby (1760/66-1861) who was some eleven to fifteen years older than the painter. She was the widow of a London composer of glees and catches, John Danby, who had died in 1798. However, recent research has thrown doubts on the assumptions that the painter had a relationship with Mrs Danby, that he was the father of the two girls, and even that she was their mother. It seems equally possible that the artist's father may have sired the two girls. An entry in a church register in Guestling, Sussex

for 19 September 1801 records the baptism of Evelina, and gives 'William and Sarah Turner' as the parents; although the painter commonly used William (rather than Joseph) as his forename, it seems equally possible that the record refers to his father. As the older William Turner would only become a widower in 1804, when Evelina was born he still needed to be fairly discreet about any extra-marital relationship he was having (which is perhaps why Evelina was baptised in an out-of-the-way church in deepest Sussex, rather than in London). Sarah Danby suffered from a more powerful need for secrecy, for she received a widow's pension from the Royal Society of Musicians which would have stopped payment had it suspected she enjoyed a relationship with a man. Certainly J.M.W.Turner left money to the widow in early drafts of his will, but eventually he revoked that bequest, which suggests that he was not the father of the two girls and that she was not their mother. And just to complicate matters even further, perhaps Sarah Danby allowed herself to be thought of as the mother of the two girls in order to protect their true mother, namely her niece, Hannah Danby. This lady always remained unmarried, and therefore had good cause not to be identified as the mother of two illegitimate daughters. She would serve as the painter's housekeeper in one of his London residences from the 1820s onwards, and Turner would leave her a fairly substantial legacy in his will, which perhaps points to her having been the mother of the girls and his having been the father. Nothing is known of Hannah Danby's personality or looks as a young woman, but later in life she seems to have been afflicted with a skin disease, which repelled visitors. In any event, it now seems impossible to determine the true paternity of the girls and the identity of their mother.

Turner was increasingly busy during the 1800s. In 1803 he began constructing a gallery for the display of his works in his house in Harley Street. Clearly he did so because a highly acrimonious political rift had developed within the Royal Academy. This threatened to lose the institution its monarchical status, and thus jeopardised its economic survival (for if the organisation had been demoted in rank, then it would have become just another exhibiting society, which the aristocracy would not have supported to the same degree). Turner was merely protecting his economic interests by creating his own gallery. The first show in the new exhibition space opened in April 1804, with as many as thirty works on display. Further annual exhibitions were held there regularly until 1810, and then more spasmodically over the following decade. (During the entire period, however, Turner went on showing works in the Royal Academy simultaneously.)

By early 1805 Turner began residing for parts of the year outside London proper, first at Sion Ferry House in Isleworth, west of London, and then, by the autumn of the following year, nearby at Hammersmith. While living in Isleworth he had a boat built for use as a floating studio upon the Thames, and painted a number of oil sketches in the open air. Although the sketches are very vivacious and prefigure Impressionism, Turner set no store on them and never exhibited them. In 1811 he began building a small villa in Twickenham, also to the west of London. At first he called the property Solus Lodge; later he renamed it Sandycombe Lodge. He designed the house himself and it still survives, although it has been somewhat altered down the years. Between 1802 and 1811 Turner did little touring, being extremely busy producing works for his own gallery and for the Academy, as well as innumerable watercolours on commission. His clientele continued to expand and came to include some of the leading collectors of the day such as Sir John Leicester (later Lord de Tabley) and Walter Fawkes. The latter was a bluff, no-nonsense and very liberal-minded Yorkshireman whose grand country seat, Farnley Hall, near Leeds, Turner began visiting around 1808. Fawkes was perhaps the closest friend Turner ever had amongst his patrons, and the painter went on regularly visiting Farnley until the mid-1820s, becoming very much a part of the Fawkes family and having a room reserved solely for his use.

William Havell, *Sandycombe Lodge, Twickenham, the Seat of J.M.W. Turner*, RA, c. 1814, watercolour, 10.8 x 20 cm, Private Collection, U.K.

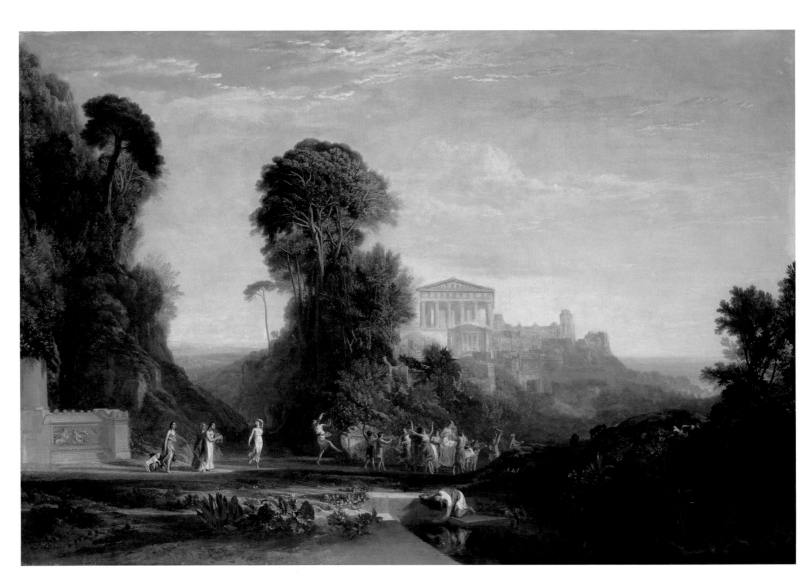

J.M.W. Turner, *The Temple of Jupiter Panellenius restored*, RA 1816, oil on canvas, 116.8 x 177.8 cm, Private Collection, New York.

In 1806 Turner embarked upon a major set of engravings, for which he drew the preliminary etchings himself. This was the *Liber Studiorum* or 'Book of Studies'. Its title not only emulates that of the Claude-Earlom *Liber Veritatis*, but it was mainly created in the identical medium of mezzotint. Originally there were to have been 100 prints in the *Liber Studiorum*. However, by 1819 only 71 of the engravings had been published and the project petered out, although drawings for all the remaining designs were created and proofs of some of the final 29 prints were pulled. Turner was clearly inspired by his own close study of the Claude-Earlom model to offer his *Liber Studiorum* as a similar teaching aid for others. In theory this was financially canny, given that at the time there was still a dearth of art schools in Britain and therefore a real need for 'teach yourself' publications beyond the major cities. To further his didactic aims, Turner broke the subjects of the *Liber Studiorum* down into categories, namely Architectural, Marine, Mountainous, Historical, Pastoral and Elevated Pastoral. He employed the last classification to differentiate the pastoralism based on classical myths, such as may be found in the works of Claude and Poussin, from the ruddy and muddy farmyard type to be seen in Lowlands painting and/or mundane reality.

At the very end of 1807 Turner took yet another step that was to have enormously beneficial results for his art: he volunteered for the position of Royal Academy Professor of Perspective. In order to do the job he embarked upon a rigorous study programme. This involved reading or re-reading more than 70 books on the science of perspective, and on art and aesthetics. The majority of treatises in the latter two categories subscribe in some degree or other to the Theory of Poetic Painting. The first annual set of six lectures was given in January 1811. Turner went on delivering the lectures spasmodically until 1828 (although he did not resign the professorship until 1838), and the manuscripts of his talks are now in the British Library. They make it clear that the painter did not limit himself to an analysis of perspective. Instead he surveyed a much wider range of subjects. His audiences were mystified, for naturally they wanted to learn about perspective. What they received instead was the Turnerian version of Reynolds's Discourses. (For example, the final lecture in the sequence of talks was a survey of the way Old Master painters had often used landscapes as backgrounds in their pictures.) Yet if the exercise was rather a waste of time for the painter's audiences, it was far from so for Turner himself. The reading for the lectures concentrated his mind wonderfully regarding his identification with the Theory of Poetic Painting, and it especially fired up his idealism, as can be seen in many works created after 1811.

The discovery or rediscovery of the potency of idealising ideas on art was not the only stimulus Turner fortuitously received at this time. Also in 1811 he developed a new appreciation of the expressive power of black-and-white line-engraved reproduction of his works. (In this process an original image such as a painting or drawing is reproduced through its design being etched and cut into a metal plate; the colouristic and tonal qualities of the original are projected monochromatically by means of varying thicknesses and concentrations of line.) Turner had made watercolours to be copied as line-engravings ever since the early 1790s but in 1811 he was astounded by the degree of tonal beauty and expressiveness attained by one of his engravers, John Pye, in a print reproducing the oil painting *Pope's Villa at Twickenham*, which is discussed below. Pye's success made Turner highly receptive to the notion of having more of his works reproduced in the same way. Obviously because word of this increased amenability quickly spread, not long afterwards the painter was commissioned by two other line-engravers and print publishers, the brothers William Bernard Cooke and George Cooke, to make a large set of watercolours depicting the scenery of the southern coast of England for subsequent line-engraving. The 'Picturesque Views on the Southern Coast' project was only completed in the mid-1820s and it led Turner to deploy enormous ingenuity in expressing the essentials of place, those underlying social, cultural, historical and economic factors that had once governed life there or continued to do so. (For an example of a

'Southern Coast' series watercolour, see *Rye, Sussex* of around 1823 below.) In time Turner would create several hundreds of watercolours for similar schemes, and in a large number of them he would similarly elaborate the truths of place with profound inventiveness.

In 1812 Turner exhibited an unusually important picture at the Royal Academy, *Snow Storm: Hannibal and his Army crossing the Alps* (reproduced below). The subject had intrigued the painter ever since the late 1790s when he had copied a representation of Hannibal looking down into Italy by J.R. Cozens, a work that is unfortunately now lost. Yet the immediate inspiration for a painting on that subject only came to Turner late in the summer of 1810 when he was staying at Farnley Hall. One day he was witnessed by Fawkes's son, Hawksworth Fawkes, standing at the doorway of the house and looking out over Wharfedale; as the latter recalled, Turner shouted:

> *'Hawkey! Hawkey! Come here! Come here! Look at this thunder-storm. Isn't it grand? – isn't it wonderful? – isn't it sublime?' All this time he was making notes of its form and colour on the back of a letter. I proposed some better drawing-block, but he said it did very well. He was absorbed – he was entranced. There was the storm rolling and sweeping and shafting out its lightning over the Yorkshire hills. Presently the storm passed, and he finished. 'There! Hawkey,' said he. 'In two years you will see this again, and call it "Hannibal Crossing the Alps".'*

This story vividly indicates not only the force of Turner's inner eye but also his precise aesthetic leanings, for his immediate placing of a sublime natural effect at the service of an epic historical subject is profoundly poetical – clearly the vastness of nature was not an end in itself for Turner, but merely a starting point. And the artist's adherence to the Theory of Poetic Painting is further proven by the method he employed to develop *Hannibal and his Army crossing the Alps*, for he synthesized the image exactly in the manner that Reynolds had recommended, in this case by marrying the Yorkshire storm to a Swiss alpine vista seen in 1802.

Turner equally made a helpful verbal debut with *Hannibal and his Army crossing the Alps*. Although the painter had been appending lines of verse to the titles of his pictures in the exhibition catalogues since 1798, and some of them were probably of his own devising, in 1812 and for the very first time he added lines that were openly by himself. These verses were drawn from a 'manuscript poem' entitled 'Fallacies of Hope' that only ever seems to have existed as short extracts in many of the Exhibition catalogues published between 1812 and 1850, the last year Turner exhibited at the Academy.

Yet the title of this supposedly epic poem, and often the verses themselves, indicate the artist's general view that all hopes of successfully defying the forces of external nature, of overcoming the inherent weaknesses and contradictions of human nature, and of religious redemption, are fallacious. In the particular case of Hannibal the verse reminds us of the central irony of the Carthaginian general's life, that for all his immensely successful effort to cross the Alps into Italy, eventually he would entirely nullify his achievement by allowing his own strength and that of his countrymen to become weakened by a life of idleness and luxury at Capua. As a result, the Carthaginians would fritter away their chances of ever defeating the Romans.

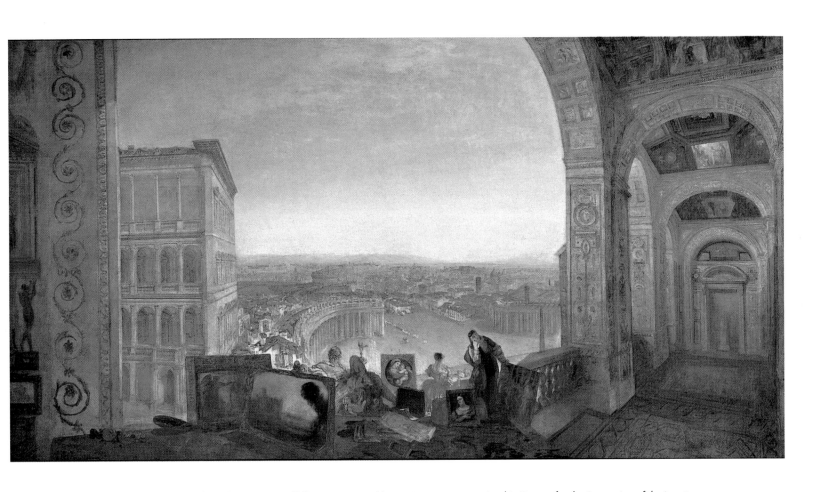

J.M.W. Turner, *Rome, from the Vatican. Raffalle, accompanied by La Fornarina, preparing his Pictures for the Decoration of the Loggia*, RA 1820, oil on canvas, 177 x 335.5 cm, Turner Bequest, Tate Britain, London.

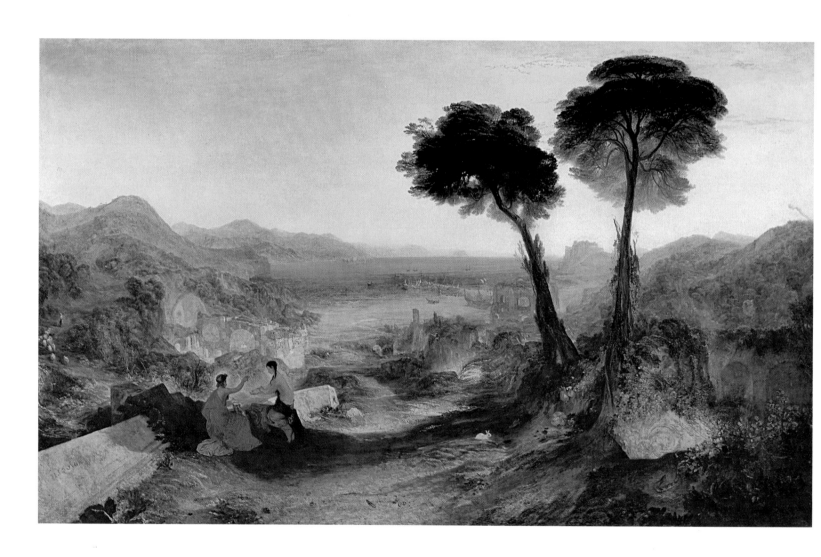

J.M.W. Turner, *The Bay of Baiae: Apollo and the Sibyl*, RA 1823, oil on canvas, 145.5 x 239 cm, Turner Bequest, Tate Britain, London.
The painting was exhibited with the inscription 'Waft me to sunny Baiae's shore'. Turner's friend, the painter George Jones, knowing the actual landscape
to be far more prosaic than depicted here, wrote the words 'SPLENDIDE MENDAX' ('Splendid lies') on the frame.
Turner was delighted and said 'all poets are liars', a statement that makes clear his equation of painting and poetry.
He left the inscription on the frame for many years.

Clearly this irony was directed at Turner's empire-building countrymen, warning of the perils that awaited them if they similarly put their own selfish interests above those of the state. At a time when Britain was still at war with Napoleon, this was a highly relevant message. The idea that the citizens of a given nation should eschew self-interest, vanity and luxury in pursuit of the common good was frequently encountered in eighteenth-century Augustan poetry, from whence Turner undoubtedly derived it. He was to repeat that old-fashioned message repeatedly after 1812 in many increasingly innovative images. These not only represent Carthage but also further great empires such as Greece, Rome and Venice, whose downfall because of individual self-interest might similarly serve as warnings to England. Such political moralism externalised Turner's belief, stated in a letter of 1811, that it is the duty of a poet – and therefore by implication a poetic painter as well – to act as a moral seer.

The 1812 *Snow Storm: Hannibal and his Army crossing the Alps* received some very favourable comments. For example, the American painter Washington Allston called it a 'wonderfully fine thing', declaring that Turner was 'the greatest painter since the days of Claude'. Yet Turner's art was not always received so rapturously. Throughout the 1800s it had been severely criticized by the influential connoisseur, collector and artist Sir George Beaumont, who professed to be alarmed both by the liberties Turner took with appearances, and by the increasingly bright tonalities he employed. Probably Beaumont was secretly jealous of Turner's great artistic success, having once himself been called the 'head of the landscape [school]', a mantle that Turner had easily assumed during the 1790s and 1800s. Because of his distaste for Turner's pictures, Beaumont did his utmost to discourage other collectors from buying them. Turner was understandably infuriated by this, although by the early 1810s he already enjoyed a loyal following that was prepared to pay high prices for his works.

In the 1813 Royal Academy Exhibition Turner displayed an unusually fine rural scene, *Frosty Morning* (Tate Britain), which for once gives us not a grand statement but a small slice of everyday life (unfortunately the painting has now lost the glazes used to convey the hoariness of the frost). Also on show was a picture first exhibited in Turner's own gallery in 1805, a dramatic riposte to Poussin's *Deluge*. In 1814 the artist exhibited two works, one of which, *Apullia in search of Appullus* (Tate Britain), contained a veiled attack on Sir George Beaumont. And in 1815 Turner displayed two of his greatest paintings to date, *Crossing the Brook* and *Dido building Carthage; or the Rise of the Carthaginian Empire*, both of which are discussed below.

Turner called *Dido building Carthage* his 'chef d'oeuvre', and when he came to draw up the first version of his will in 1829 he requested that the canvas should be used as his winding-sheet upon his death. He even asked one of his executors, Francis Chantrey, as to whether that condition of the will would be carried out. To his eternal credit Chantrey replied that the stipulation would be respected but immediately added that 'as soon as you are buried I will see you taken up and [the canvas] unrolled'. Turner saw the funny side of the situation and thereupon amended his will to bequeath the painting to the National Gallery to hang alongside the very seaport view by Claude that had moved him to tears when it was in the Angerstein collection.

It is not surprising that Turner particularly esteemed *Dido building Carthage*. He had long wanted to paint a seaport scene worthy of comparison with Claude, and with the painting he succeeded (just as in *Crossing the Brook* he painted his most successful Claudian landscape to date). Yet *Dido* also probably summarized everything he was trying so hard and so opaquely to

articulate in the perspective lectures. With its mastery of perspective, its superb exploration of light, shade and reflections, its moral contrast between life and death (as represented respectively by the teeming city and solemn tomb), and its total congruence of time of day, meaning and pictorial structure, it is certainly far more eloquent than any of Turner's tortuous verbal discourses.

Two years later Turner exhibited the companion to *Dido building Carthage*, namely *The Decline of the Carthaginian Empire* (reproduced below). In the intervening 1816 Royal Academy show he displayed two complementary pictures of a Greek temple. In one of them (Duke of Northumberland collection) he portrayed the building as it appeared in a ruined state under contemporary Turkish domination, while in the other (reproduced here) he depicted it as it had probably looked in ancient times. The ruined building is appropriately represented in evening light, for metaphorically its day has passed. In the pendant the artist showed the reconstructed building in dawn light, thus using the rebirth of day not only to suggest constant renewal within the ancient world but equally to hint at the future restoration of Greek liberty. This latter subject was immensely important to him, for he wholly shared the views of one of his favourite Augustan poets, James Thomson, that Greece was the ancient home of liberty and democracy. In 1812, Turner had been forcibly reminded of the subjugation of contemporary Greece by the publication of the second Canto of Byron's poem, 'Childe Harold's Pilgrimage', in which the loss of Greek liberty is lamented. The two 1816 paintings might therefore well have been their creator's most open statements of his identification with liberty and democracy to date.

Turner lived through the greatest period of political upheaval in European history. His affinity with demands for political and religious freedom in his own time first seems to have found expression around 1800 in works alluding to contemporary struggles for liberty in Britain and abroad. During this period he was hoping to gain election as an Academician, and many of the leading Royal Academicians, such as Barry, Fuseli and Smirke, were known to hold libertarian opinions. By painting such pictures he may have been simultaneously courting their votes. Around that time Turner's most sympathetic future patron, Walter Fawkes, even held republican convictions, although he later moderated his stance (at least publicly). There can be absolutely no doubt that the similarity of their political views strengthened the bond between Turner and Fawkes after 1808.

Moreover, the painter is known to have read banned radical political literature in the early 1820s. He would continue subtly to express his libertarian views during the rest of that decade as the Greeks struggled for their freedom and demands for parliamentary reform in Britain quickened. In a number of works made between 1829 and 1833 Turner would even allude to the latter struggle, the major British political issue of his entire lifetime. In one such design – a watercolour representing a Parliamentary election in Northampton that is reproduced below – he would even make his sympathies with the reform of Parliament quite clear, for the drawing shows the election of Lord Althorp, the Chancellor of the Exchequer in the reformist administration of Earl Grey. In several works made after the attainment of Greek independence in 1830, Turner would celebrate that rebirth of freedom (for example, see a watercolour of a fountain on the island of Chios below). The artist's identification with libertarianism is entirely understandable, given his lowly origins and immense sympathies with common humanity. Although he always had to exercise extreme caution when expressing his political views – for the majority of his monied supporters held Tory political views, and were therefore opposed to parliamentary reform – Turner would never turn his back on either the social class from which he had emerged, or its political aspirations.

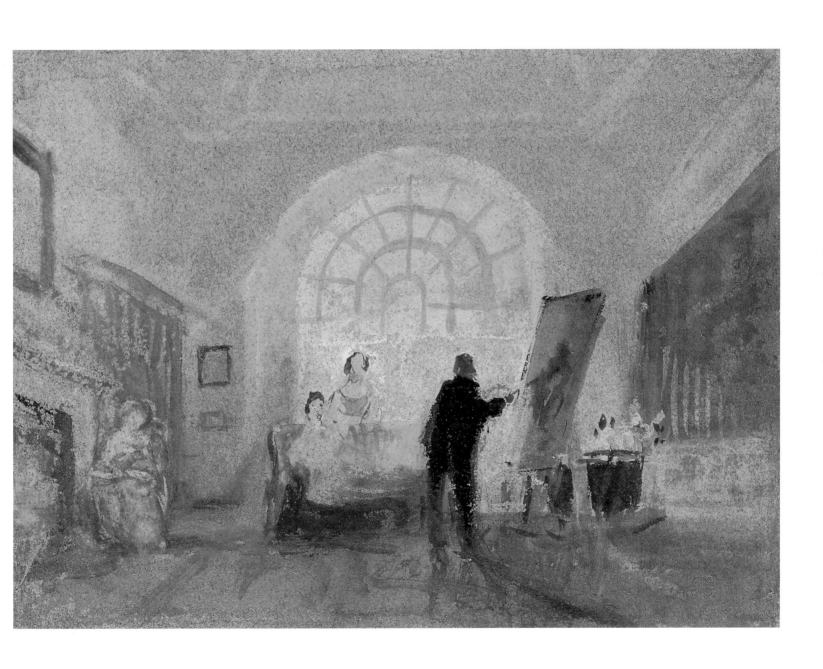

J.M.W. Turner, *The Artist and his Admirers*, c. 1827, watercolour on blue paper, 14 x 19 cm,
Turner Bequest, Tate Britain, London, TB CCXLIV 102.

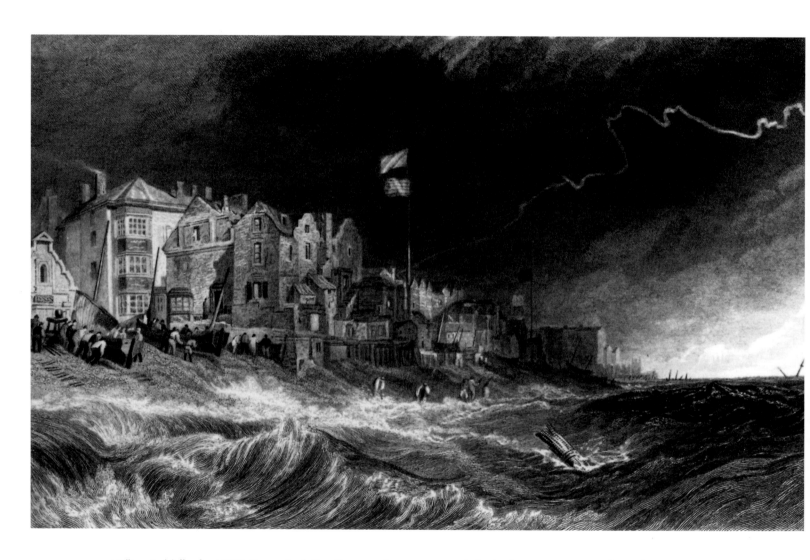

William Radclyffe after J.M.W. Turner, *Deal, Kent*, line engraving on copper made for the 'Picturesque Views on the Southern Coast' series, 1826, British Museum, London.

The painter resumed touring in the 1810s. In 1811, 1813 and 1814 he visited the West Country in order to obtain material for the 'Southern Coast' series and other engraving schemes. On the 1813 trip he had a particularly enjoyable time in Plymouth where he was much fêted locally. He treated his friends to picnics, took boat rides in stormy weather – which he enjoyed enormously, having good sea-legs – and again painted in oils in the open air.

In 1816 he undertook an extensive tour of the north of England to gather subjects for watercolours intended for engraved reproduction in the 'History of Richmondshire' scheme, a survey of a county that in medieval times had ranged from Richmond in Yorkshire to Lonsdale in Lancashire. He could not have selected a worse time for the trip, as a major volcanic eruption in the Pacific during the previous year was causing the acute disruption of world weather patterns, with endless rain in Britain (where it was called 'the year without a summer'). Originally Turner was to have made 120 watercolours for the project, and to have been paid the huge sum of 3000 guineas for those drawings. Unfortunately the venture petered out shortly after it had begun due to a lack of public enthusiasm for the antiquarian texts that accompanied Turner's images. By that time the artist had only made some twenty-one of the watercolours, an example of which can be seen below (*Crook of Lune, looking towards Hornby Castle*). In 1817 the painter revisited the Continent, stopping off at the scene of the recent battle of Waterloo before touring the Rhineland and visiting Holland where he scrutinised the Rembrandts in the Rijksmuseum in Amsterdam. Impressive paintings of Waterloo in the immediate aftermath of battle and of the river Maas at Dordrecht with shipping becalmed were exhibited at the Royal Academy the following year (both works are reproduced below); not for the first time Turner used a pair of pictures to contrast war and peace. The Dordrecht view was purchased by Walter Fawkes who installed it over the fireplace at Farnley Hall as the centrepiece of his collection. Fawkes also bought a complete set of 50 watercolours on grey-washed paper that Turner had made in the Rhineland. And in 1819 Fawkes put a considerable part of his large collection of Turner watercolours on public display in his London residence. For the catalogue he wrote an impressive dedication to Turner, stating that he was never able to look at the artist's works 'without intensely feeling the delight I have experienced, during the greater part of my life, from the exercise of your talent and the pleasure of your society.' The dedication must have gratified the painter enormously.

Turner finally visited Italy in 1819, although he had already developed a number of superb watercolours of Italian scenes from sketches made by others. He visited Milan, Venice, Rome, Naples, Sorrento and Paestum, before turning northwards and probably spending Christmas in Florence. His return journey took place in late January 1820, when he crossed the Mont Cenis pass, where his coach overturned during a snowstorm (wasting nothing, he later pictorialised the experience in a vivid watercolour now in Birmingham Art Gallery). He arrived back in London loaded down with some 2000 sketches and studies, and immediately started one of his largest paintings ever (reproduced here). This is a view from the loggia of the Vatican, showing the Renaissance painter Raphael in the foreground. It was displayed in the 1820 Royal Academy exhibition, obviously to commemorate the Italian master who had died exactly three hundred years earlier.

Although Turner was increasingly busy making small watercolours for the engravers during the 1820s (such as the jewel-like drawing of Portsmouth discussed below), perhaps the most impressive watercolour achievements of the first half of the decade were the large and superbly wrought drawings made for the 'Marine Views' scheme (of which two examples are reproduced below). No less impressive are the oil paintings *The Bay of Baiae, with Apollo and the Sybil*, shown at the Academy in 1823, and *The Battle of Trafalgar* created between 1822 and 1824 to hang in St James's Palace.

In *The Bay of Baiae* (reproduced here) Turner again expressed his profound sense of irony, for the picture shows the god Apollo bestowing endless life upon the Cumaean Sibyl in exchange for her favours. Unfortunately the poor lady forgets to request the eternal good looks necessary to accompany her longevity. The derelict buildings in the background hint at her forthcoming physical ruin, while the beauty of the surrounding landscape puts that decay into ironic perspective. It is not suprising that *The Battle of Trafalgar* is impressive, for it was the largest picture Turner would ever paint and fully captures the enormous forces unleashed by war. The trouble the artist had with the work, and its sorry fate, are related in the detailed discussion of the painting that appears below.

In 1825 Turner embarked upon yet another ambitious set of watercolours destined for engraved reproduction. This was the 'Picturesque Views in England and Wales' series, a group of drawings that has quite aptly been termed 'the central document of his art'. Like the 'Richmondshire' series, the 'England and Wales' scheme was to have comprised 120 designs, but this time the project floated long enough for the painter to create some 100 of the constituent images. Sadly the enterprise was terminated in 1838, due to the failure of the prints to sell and other factors that rendered their publication uneconomic.

In 1829 Turner exhibited a fairly large group of 'England and Wales' watercolours in London, and he did so again in what must have been a dazzling show in 1833, when 67 drawings went on display. In the 'England and Wales' designs almost all aspects of British scenery and life are depicted, while Turner's unrivalled mastery of the medium of watercolour is everywhere apparent. And throughout the 1820s and '30s the painter was frantically busy producing marvellous watercolours for a host of other engraving projects as well. These included topographical surveys of the ports, rivers and east coast of England; explorations of the rivers of France (part of a scheme to survey the rivers of Europe that never got further than forays along the Seine and the Loire); and illustrations for books of the collected poetry of Sir Walter Scott, Lord Byron, Samuel Rogers and Thomas Campbell.

Moreover, Turner also found the time to produce illustrations for Scott's collected prose works, and to depict the landscapes of the Bible. Although he had never visited the Holy Land, he elaborated these works from sketches made by travellers who had. Well might he have complained, as he had done in the mid-1820s, that there was 'no holiday ever for me'.

As we have seen, early on in his career Turner had of necessity evolved a production-line method for making his watercolours. Naturally, such a procedure proved of enormous benefit when creating large numbers of watercolours for engraving. Two accounts of the artist's watercolour technique have come down to us from the same witness:

> There were four drawing boards, each of which had a handle screwed to the back. Turner, after sketching the subject in a fluent manner, grasped the handle and plunged the whole drawing into a pail of water by his side. Then quickly he washed in the principal hues that he required, flowing tint into tint, until this stage of the work was complete. Leaving this drawing to dry, he took a second board and repeated the operation. By the time the fourth drawing was laid in, the first would be ready for the finishing touches.

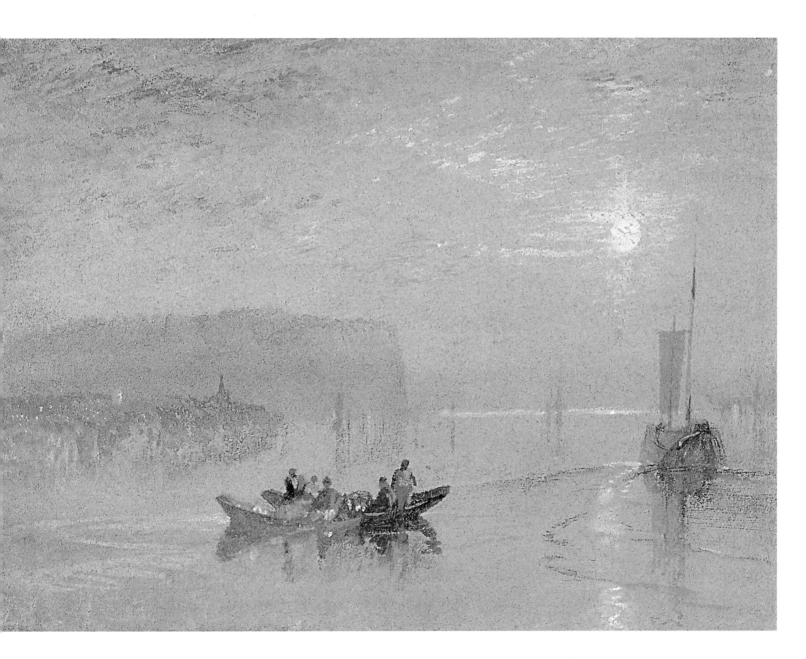

J.M.W. Turner, *Scene on the Loire (near the Coteaux de Mauves)*, c. 1828-30, watercolour and gouache with pen on blue paper, 14 x 19 cm, Ashmolean Museum, Oxford. This work was made for engraved reproduction in *Turner's Annual Tour – The Loire*, 1833.

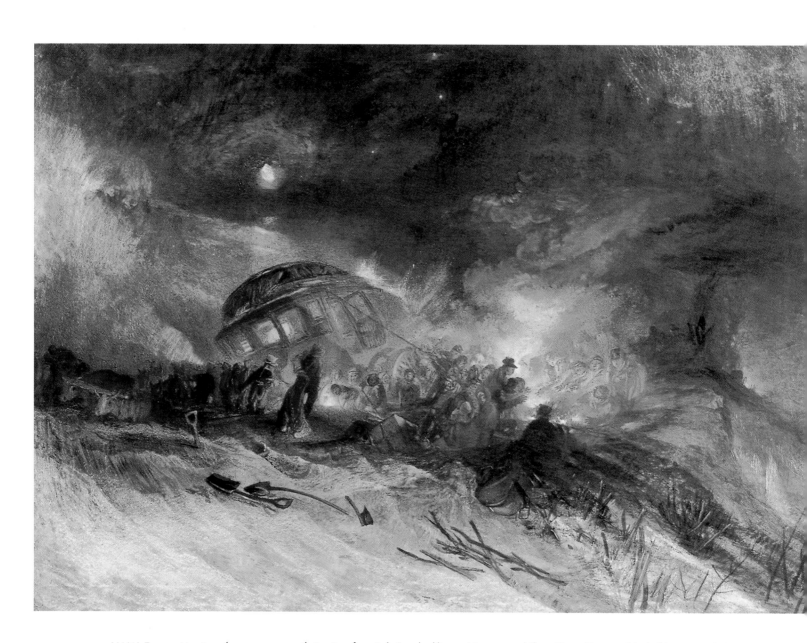

J.M.W. Turner, *Messieurs les voyageurs on their return from Italy (par le diligence) in a snow drift on Mount Tarrar – 22nd of January, 1829,*
RA 1829, watercolour, 54.5 x 74.7 cm, British Museum, London.
Tuner is the seated man wearing a top hat to the right of centre.

....[Turner] stretched the paper on boards and after plunging them into water, he dropped the colours onto the paper while it was wet, making marblings and gradations throughout the work. His completing process was marvellously rapid, for he indicated his masses and incidents, took out half-lights, scraped out highlights and dragged, hatched and stippled until the design was finished. This swiftness, grounded on the scale practice in early life, enabled Turner to preserve the purity and luminosity of his work, and to paint at a prodigiously rapid rate.

Judging by the results of such speedy and creatively economical working processes, the intense pressures put upon Turner by the engravers seems to have stimulated his inventive powers rather than hindered them.

In August 1828 Turner again travelled to Italy. He stayed principally in Rome where he both painted and exhibited his productions. The show attracted over 1000 visitors, most of whom were utterly mystified by what they saw. On his journey home in January 1829 his coach was again overturned by snow (as it had been some nine years earlier), this time on Mont de Tarare near Lyons in France. Again permitting no wastage, the artist recorded the experience in a watercolour exhibited in the 1829 Academy Exhibition (reproduced here). This time he put himself in the picture, wearing a top hat sitting in the foreground.

Another work that Turner displayed at the Academy in 1829 was *Ulysses deriding Polyphemus* (reproduced below). In connection with this oil, *The Times* commented that 'no other artist living...can exercise anything like the magic power which Turner wields with such ease.' John Ruskin later called *Ulysses* 'the central picture in Turner's career'. In colouristic terms at least, one can see why he did so, for by now the artist was achieving a beauty of colouring that was entirely commensurate with the 'Ideal Beauties' of form he had earlier mastered. This ideal colour derived from the fundamentals of painterly colour itself, for it was based upon the primaries of yellow, red and blue, with all kinds of wonderfully subtle modulations between them.

Naturally, Turner was always profoundly interested in colour theory, and that involvement was greatly stimulated by his investigation of the science of optics undertaken in connection with the perspective lectures. In 1818 he had introduced the subject of colour into those talks that were ostensibly about spatial and pictorial organization. A subtle change took place in Turner's colour around that time. Thereafter a greater reliance upon the primaries and a more intense luminosity became apparent in his work. And Turner's sense of the vivacity of colour was enormously stimulated by his visit to Italy in 1819, which seems natural, given that the colour sensibilities of most northern European artists are transformed by their contact with Italian light and colour. Certainly a change in Turner's colour was recognized by 1823, when an encyclopedia published in Edinburgh stated that Turner's 'genius seems to tremble on the verge of some new discovery in colour'. By the end of the 1820s, when *Ulysses deriding Polyphemus* appeared, such a 'discovery' had been thoroughly consolidated, and Turner began habitually creating ranges of colour that have never been matched by any other painter, let alone surpassed.

In October 1825 Walter Fawkes died. Turner subsequently refused ever to visit Farnley Hall again; it held too many memories for him. Clearly he was shattered by Fawkes's death, and he had good reason to be, for he was only six years younger than the Yorkshireman.

Early in 1827 Turner wrote to a friend:

Alas! my good Auld lang sine is gone ... and I must follow; indeed, I feel as you say, near a million times the brink of eternity, with me daddy only steps in between as it were...

In September 1829 that brink moved appreciably closer when William Turner died, leaving the painter utterly bereft; as a friend remarked, 'Turner never appeared the same man after his father's death; his family was broken up.' The two men had always been especially close, doubtless because of the illness of Mary Turner. William Turner had served for many years as his son's factotum, stretching his canvases and varnishing them when completed, which led Turner to joke that his father both started and finished his pictures for him. That the artist did feel nearer 'the brink of eternity' after his father's death is made clear by the fact that he drew up the first draft of his will less than ten days after the paternal demise.

The deaths of Fawkes and Turner's father were joined by other sad losses around this time, most notably those of Henry Fuseli in 1825 and of Sir Thomas Lawrence PRA early in 1830. Turner portrayed Lawrence's funeral in an impressive watercolour he exhibited at the Royal Academy later that year. This would be the last drawing he would ever display there, for works on paper were generally hung in inferior viewing conditions at the Academy and by this time Turner could show his watercolours more advantageously elsewhere (as he had done in 1829 and would do again in 1833). And because the artist refused ever to visit Farnley again, after 1827 he frequently took to staying at another 'home from home' owned by one of his patrons, namely Petworth House in Sussex. This was the country seat of George Wyndham, the 3rd Earl of Egremont, who was a collector of enormous taste and vigour. He had bought his first painting from Turner early in the century, and by the time of his death in 1837 he owned nineteen of his oils. At Petworth Turner was free to come and go at his leisure, although the age difference between the artist and his patron – the earl was seventy-six when the fifty-two-year-old painter began regularly revisiting the house in 1827 – meant that Turner could never be as close to the aristocrat as he had been to Walter Fawkes. After the earl died in 1837, Turner would shun Petworth, just as he had earlier shunned Farnley Hall, and for the same reason: death slammed certain doors in his life.

Turner came into conflict with John Constable RA (1776-1837) during the hanging of the 1831 Royal Academy Exhibition. The two painters had known each other since 1813 when Constable had sat next to Turner at an Academy dinner and was both entertained by his personality and impressed by his intellect. And Constable had a very high regard for Turner's works, praising their visionary qualities in 1828. But in 1831, when Constable was on the Academy hanging committee, he replaced Turner's painting of *Caligula's Palace and Bridge* (Tate Britain) with one of his own works, *Salisbury Cathedral from the Meadows* (National Gallery, London). The painter David Roberts RA (1796-1864) was present at a meeting of the two men soon afterwards, and he recorded what happened in his rather ungrammatical prose:

Constable a conceited egotistic person...was loud in describing to all the severe duties he had undergone in the hanging the Exhibition. According to his own account nothing could exceed his distineredness or his anxiety to discharge that Sacred Duty. Most unfortunately for him a Picture of Turners had been displaced after the arraingment of the room in which it was placed....Turner opened upon him like a ferret; it was evident to all present that Turner detested him; all present were puzzled

William Henry Hunt (?), *Portrait of J.M.W. Turner*, c. 1845, Lady Lever Art Gallery, Port Sunlight, U.K.

S.W. Parrot, *Turner on Varnishing Day*, 1846, oil on wood panel, Collection of the Guild of St George, Ruskin Gallery, Sheffield.

what to do or say to stop this. Constable wriggled, twisted & made it appear or wished to make it appear that in his removal of the Picture he was only studying the best light or the best arraingment for Turner. The latter coming back invariably to the charge, yess, but why put your own there? – I must say that Constable looked to me and I believe to every one else, like a detected criminal, and I must add Turner slew him without remorse. But as he had brought it upon himself few if any pitied him.

However, Turner had his revenge in the Royal Academy the following year; as C.R. Leslie noted:

In 1832, when Constable exhibited his Opening of Waterloo Bridge *[Private Collection] it was placed in…one of the small rooms at Somerset House. A sea-piece, by Turner, was next to it – a grey picture, beautiful and true, but with no positive colour in any part of it [*Helvoetsluys;– the City of Utrecht, 64, going to Sea, *Tokyo, Fuji Museum]. Constable's 'Waterloo' seemed as if painted with liquid gold and silver, and Turner came several times into the room while [Constable] was heightening with vermilion and lake the decorations and flags of the city barges. Turner stood behind him looking from the 'Waterloo' to his own picture, and at last brought his palette from the great room where he was touching another picture, and putting a daub of red lead, somewhat bigger than a shilling, on his grey sea, went away without saying a word. The intensity of the red lead, made more vivid by the coolness of his picture, caused even the vermilion and lake of Constable to look weak. I came into the room just as Turner left it. 'He has been here,' said Constable, 'and fired a gun.'…The great man did not come again into the room for a day and a half; and then, in the last moments that were allowed for painting, he glazed the scarlet seal he had put on his picture, and shaped it into a buoy.*

Turner greatly enjoyed playing these kinds of visual games on the Academy walls, where pictures were hung frame to frame. However, he did not always win such contests. His great friend, George Jones RA (1786-1869), recalled that in the 1833 Exhibition:

The View of Venice with Canaletti painting *[by Turner, now Tate Britain] hung next to a picture of mine which had a very blue sky. [Turner] joked with me about it and threatened that if I did not alter it he would put it down by bright colour, which he was soon able to do by adding blue to his own…and then went to work on some other picture. I enjoyed the joke and resolved to imitate it, and introduced a great deal more white into my sky, which made his look much too blue. The ensuing day, he saw what I had done, laughed heartily, slapped my back and said I might enjoy the victory.*

Turner also demonstrated his virtuosity in public during the 1830s, sending to Royal Academy and British Institution exhibitions rough underpaintings which he elaborated to a state of completion during the days permitted for varnishing pictures. Perhaps the most spectacular recorded instance of this practice occurred on the walls of the British Institution in 1835 when, in a single day, Turner painted almost the entirety of *The Burning of the Houses of Lords and Commons* (a picture analysed below). He had begun work at first light and painted all day, surrounded by a circle of admirers and without once stepping back to gauge the visual effect of his labours. Finally the picture was completed. As an eyewitness recorded:

Turner gathered his tools together, put them into and shut up the box, and then, with his face still turned to the wall, and at the same distance from it, went sidelong off, without speaking a word to anybody, and when he came to the staircase, in the centre of the room, hurried down as fast as he could. All looked with a half wondering smile, and Maclise, who stood near, remarked, 'There, that's masterly, he does not stop to look at his work; he knows it is done, and he is off.'

It has plausibly been suggested that Turner was led to demonstrate such virtuosic insouciance by having seen the violinist Paganini take London by storm with similar artistic equanimity in the early 1830s.

Turner continued to tour during the 1830s. An especially important trip took place in 1833. After exhibiting the view of Venice he had heightened with blue in competition with George Jones, Turner revisited the city, obviously to find out more about it (he had not stayed there long in 1819). From 1833 onwards the place would increasingly dominate Turner's Italian subject-matter, clearly because its frequently ethereal appearance struck a profoundly imaginative chord in him. He would return there in 1840. Another important peregrination took place in 1835, when Turner embarked on a grand tour of Europe. After sailing to Hamburg he then went on to Copenhagen, Berlin, Dresden, Prague, Nuremberg, Würzburg and Frankfurt-am-Main before travelling down the Rhine to Rotterdam. A secondary purpose of this tour may have been to examine some of the leading Continental museums and art collections in order to advise a government committee then drawing up plans for a combined National Gallery and Royal Academy building to stand on a site in Trafalgar Square.

After 1833 a new companion entered the painter's life. Turner had continued to visit Margate down the years, and had latterly taken to staying with a Mrs Sophia Caroline Booth and her husband, who died in 1833. Slightly later the artist embarked upon a physical relationship with the widow, and eventually, in the 1840s, he moved her up to London to live with him in a cottage she purchased in Chelsea. David Roberts talked to her shortly after Turner's death in 1851, and later recorded (in his imperfect prose):

...for about 18 years...they lived together as husband & wife, under the name of Mr & Mrs Booth....But the most extraordinary part of her naritive is that, with the exception of the 1st year he never contributed one Shilling towards their mutual support!!! – But for 18 years she provided solely for their maintenance & living but purchased the cottage at Chelsea from money she had previously saved or inherited...Turner refusing to give a farthing towards it....She assures me that the only money She has belonging to him during this long term of years was three half crowns She found in his pocket after death, black, She says with being so long in his pocket & which she keeps as a souvenir...

Turner had earned a reputation as a miser early on in life. Doubtless he had guarded every penny because in childhood he had often witnessed the destructive effects of poverty in the slum-infested Covent Garden area. Yet even when he became wealthy he maintained his penny-pinching habits. However, with the creation of his first will in 1829 a noble motive emerged from his habitual stinginess. Turner was well aware of the precariousness of artistic fortune. That perception had led him to become one of the founders of the Artists' General Benevolent Institution upon its creation in 1814, as well as an early Chairman and Treasurer of the charity. Following disagreements over its spending policy – Turner was not happy disbursing money – he attempted to set up his own charitable foundation. This was to be funded by his estate and to be known as

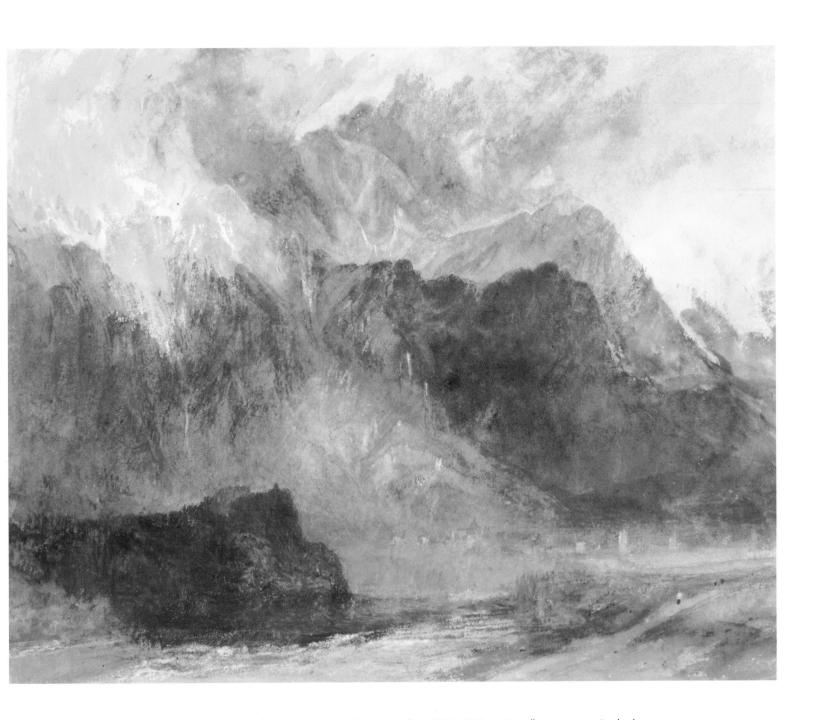

J.M.W. Turner, *A scene in the Val d'Aosta*, c. 1836, watercolour, 23.7 x 29.8 cm, Fitzwilliam Museum, Cambridge.

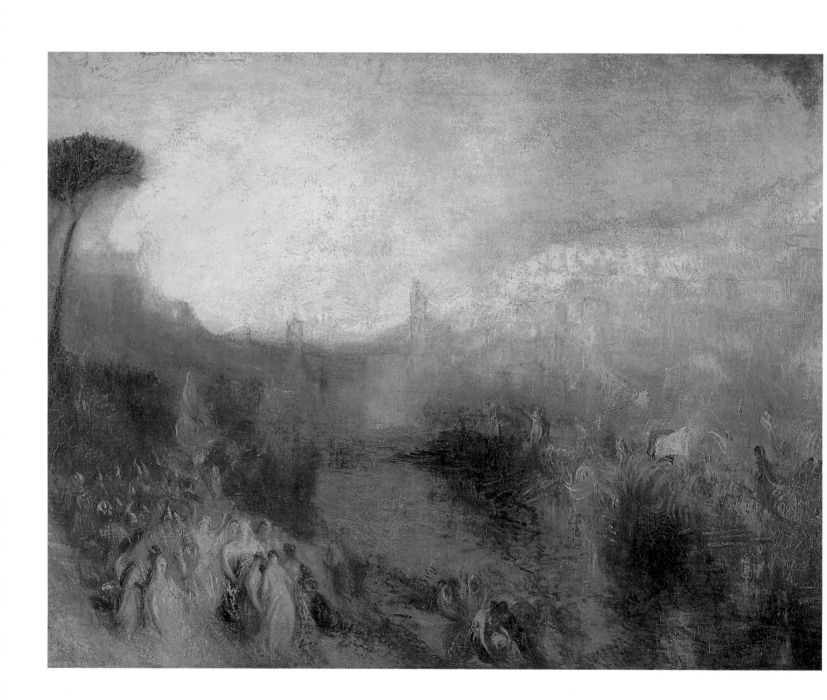

J.M.W. Turner, *The Departure of the Fleet*, RA 1850, oil on canvas, 91.5 x 122 cm, Turner Bequest, Tate Britain, London.

'Turner's Gift'. It was designed to support old and penniless artists in almshouses to be built on land the painter also provided in Twickenham. Sadly, such a charity would never become a reality, as we shall see.

Throughout the 1830s and '40s Turner kept up a steady flow of masterpieces in both oil and watercolour. The public could not always read the images or fathom their meanings but that incomprehension did not lead the painter to make his depictions of things more visually approachable or simplify what he had to say – if anything the lack of understanding led him to make things even more difficult for his audience. Yet if pictures like the Venetian scene showing *Juliet and her nurse* of 1836 (Private Collection, Argentina) proved hard to understand – for why should Juliet be placed in a city she never visits in Shakespeare's play? – nonetheless the public had little if any difficulty in understanding an even finer masterpiece exhibited in 1839.

From the start *The Fighting 'Temeraire'* was interpreted as a wistful comment upon the passing of the age of Sail and the coming of the age of Steam. If we do indeed read it wholly in such terms it would be unusual, for more frequently the painter welcomed technological change. Thus in the 1820s he had celebrated the advent of Steam in a view of Dover that is discussed below, while five years after painting *The Fighting 'Temeraire'* he would again make evident his excitement over the arrival of the modern industrial epoch in *Rain, Steam, and Speed – the Great Western Railway* of 1844, which is also reproduced below. During the 1840s the painter even became intrigued by polar exploration, yet another indication of his abiding interest in the opening up of the world around him. But in *The Fighting 'Temeraire'* Turner not only commemorated the passing of an age; he also welcomed the era that was supplanting it, for in the picture he subtly celebrated the physical power of steam, as can be seen below.

The favourable reception accorded to *The Fighting 'Temeraire'* must have been gratifying to Turner, especially as hostility to his works had been frequently voiced in newspaper reviews during the 1830s. The artist's 'indistinctness', his responsiveness to paint, his complex and often baffling meanings, and his increasingly high-keyed colour ranges (especially his love of yellow) were not calculated to win the hearts and minds of Victorians who preferred photographic realism to indistinctness, smoothness to painterliness, sentimentality to academic idealism, and saccharine colouring to the dazzling hues that Turner often presented to the eye. Yet from 1839, and particularly because of the vituperation poured on *Juliet and her nurse* in 1836 by one petty-minded critic, public understanding of what Turner was about was greatly helped by a new supporter. This was John Ruskin, who between 1843 and 1860 published a five-volume appraisal of Turner's works entitled *Modern Painters*. In addition to matters already touched on, Ruskin's book was intended to demonstrate that 'We have had, living amongst us and working for us, the greatest painter of all time.' Turner was clearly not too displeased by Ruskin's advocacy, and indeed, it must have afforded him much comfort during the final years of his life.

The late 1830s and the 1840s were otherwise not an altogether happy time for Turner. He became bitter at having been passed over for a knighthood when lesser figures such as Augustus Wall Callcott RA (1779-1844) and William Allan RA (1782-1850) had been so honoured. (However, that lack of preferment was perhaps inevitable, given that Queen Victoria thought Turner to be quite mad.) And, as time passed, his despair at the thought of death increased. This resulted in somewhat unbalanced behaviour, such as becoming very secretive about his second home with Mrs Booth in Chelsea, where he was content to be known as 'Admiral Booth'. He also took to drink, albeit in a relatively mild way.

An obsession with hoarding impressions of his prints led him to purchase all the remaining stock of the 'England and Wales' engravers when it was auctioned off in 1839, and then to let it rot in his house in Queen Anne Street West. Moreover, although by the late 1840s Turner had begun to form his wish that all his finished oil paintings should go to the National Gallery upon his death (a desire he formulated in final codicils to his will in 1848 and 1849), nonetheless he did little to ensure they were maintained in good condition. Yet despite his fear of dying – an apprehensiveness that was unleavened by any belief in an afterlife – the artist did not let those anxieties and the eccentricities they produced darken his work. Instead, his late paintings and drawings became ever more beautiful as their creator used them to fend off his fears and bring the idealism of a lifetime to a triumphant conclusion.

In 1841, and during the following three summers, Turner returned to Switzerland. Four sets of watercolours resulted from those trips. They are among the painter's greatest creations, for in the immensity, beauty and solitude of the Alps he clearly found some solace at the thought of dying. In the final set especially, drawings that were possibly made between 1846 and 1850, we can apprehend a continuous pulse running behind the appearances of discrete objects. As a result, the visible universe becomes filled with a primal energy. These characteristics are equally evident in a group of oil paintings made after about 1845 from the old *Liber Studiorum* images, works in which light, colour and energy are all intensified to the utmost degree, dissolving forms in the process. The 'Late Liber' paintings do not celebrate just the physical world: their pulsating energies, intensities of light and dissolutions of form are clearly expressions of something beyond the physical realm. Given Turner's lifelong attraction to academic idealism, at whose core lay a Platonic metaphysical system he had openly accepted at an early age, there can be no doubt that in his late, radiant images he was projecting a supernal reality, one corresponding to the world of the Ideas delineated by Plato. And there is no inconsistency between Turner's lifelong identification with such a metaphysical system and his supposed statement that 'The Sun is God', for the brilliant light in these late paintings is far more than simply the hedonistic sunshine that would later be so beloved of the French Impressionists. Instead, we are looking at Turner's deity, the essence and source of creation, the godhead itself, whose energies run through everything.

In 1845 the painter officially presided over the Royal Academy for a period when the elected President, Sir Martin Archer Shee (1769-1850), was too ill to carry out his duties. And also in that same year Turner made the last of his sketching tours, this time visiting northern France and calling upon King Louis Philippe, an old friend from Twickenham days. But Turner's health began to break down in 1845, and by the end of the following year it had become very bad indeed. It was not helped by the fact that he was losing all his teeth; in his final years he had to gain sustenance simply by sucking his food. He continued to show a few works every year at the Academy (although not in 1848, the first time since 1824 he had not exhibited), but gradually he began to lose the physical co-ordination necessary for painting. However, in 1850 he summoned forth his last vestiges of strength to complete four oil paintings on the Dido and Aeneas theme. The subject may have had a personal significance, for Turner's commitment to his art paralleled Aeneas's devotion to duty, an obligation that had led the Trojan prince to abandon Queen Dido in order to sail to Italy and found Rome. Like Aeneas, Turner had also forsworn an easy life, the enjoyment of wealth, marriage and the delights of the senses for a higher calling, while Queen Dido symbolised everything he had renounced.

J.W. Archer, *House of J.M.W. Turner at Chelsea*, 1852, watercolour, British Museum, London.

Turner's death mask, National Portrait Gallery, London.

After displaying these last four works at the Royal Academy in the late spring of 1850 it appears that Turner was physically too feeble to paint any further. He awaited death over the following eighteen months rather apprehensively and sadly. Occasionally he would be helped onto the flat roof of the Chelsea house to see the sun rise over the level pastures of Battersea across the river – what he called the 'Dutch view' – or watch it set behind the hills upriver in the distance – his 'English view'. But that was all; the rest was silence.

Joseph Mallord William Turner died on 19 December 1851 and was buried in St Paul's Cathedral, almost next to Sir Joshua Reynolds, as he had requested. In addition to more than two thousand paintings and watercolours in private hands, he left an immense body of work in the Queen Anne Street West and Davis Place, Cremorne New Road, Chelsea studios – some 282 finished and unfinished oil paintings and 19,049 drawings and sketches in watercolour, pencil and other media (in addition to tens of thousands of prints, which were sold off in 1874). The estate was valued at £140,000, a sum whose exact modern value is incalculable but which might conservatively be approximated if we multiply it a hundredfold. The will contained two main provisions: that a gallery should be built to house Turner's works; and that 'Turner's Gift' should be created. However, the will was contested by Turner's relatives and unfortunately overthrown on a legal technicality. As a result, the relatives obtained the money and the charity was aborted. On the positive side the nation gained not only the finished oil paintings but all the unfinished oils as well, plus all the watercolours, sketchbooks, sketches and studies still gathering dust in the two studios. However, not until 1987 would a gallery be created specifically to house them. Only then would it come into existence through private largesse, and mainly because of pressure applied by an action group, the Turner Society.

The triumph of private greed over the realization of 'Turner's Gift' was brutally ironic, given that the painter had been so selfless in accruing wealth for the purpose of creating his charitable foundation. Eventually, of course, the Welfare State would take over the care of old, impoverished artists, so the failure of the charity to come into existence would not matter all that much. But ultimately Turner's supreme gifts were his bequest of works to the British nation, and his art in general. Both enormous legacies live on in a body of work that may have been equalled in size and quality, but which has never been surpassed for its beauty, power and insight.

Turner's art often takes us to the very heart of appearances and natural behaviour, and it was intended to forge all kinds of alliances with imaginative reality. But Turner was most decidedly not just a landscape and marine artist; equally he was a painter of mankind. As such he afforded us profound insights into the nature of the human condition, and the conditions in which we live. That he did so by means of a wholly innovative pictorial language should not blind us to the fact that his new visual direction in art was based upon extremely traditional aims. Turner stood on the very threshold of our present artistic epoch, for he was the last of the Old Masters and the first of the Moderns. Not until we see him in both of those roles together, and simultaneously appreciate his vast pictorial, intellectual and painterly complexity, will we then be in a true position to gauge the extraordinary scope of his genius, which still remains fully to be discovered.

THE MASTERWORKS

The Archbishop's Palace, Lambeth
1790
Watercolour on white paper, 26.3 x 37.8 cm
Indianapolis Museum of Art.

Lambeth Palace is the official residence of the Archbishop of Canterbury, the highest prelate of the Church of England. The oldest parts of the building date from the twelfth-century. In the middle-distance we see the gatehouse built in the 1490s, with the Swan Inn on the right and, beyond it, the tower of St Mary's Church, Lambeth, which was replaced in 1851-2.

This watercolour was Turner's first exhibited work, being displayed at the Royal Academy in 1790, when he was just fifteen. Given that most of the buildings are aligned at differing angles to one another, the youth may well have chosen the subject to show off his precocious mastery of perspective, for even experienced artists can find such complex architectural relationships difficult to project.

Stylistically the work shows the influence of Thomas Malton, Jr, to whom Turner had loosely apprenticed himself while officially studying at the Royal Academy Schools, where painting was not taught. Malton's influence can especially be detected in the marked perspective of the buildings on the right, the shaping and tonal definition of the clouds, the elongation of the foreground figures, and the role of those people in establishing both the character and scale of the proceedings. From left to right we see a boatman, with Westminster Bridge beyond; some boys playing with a hoop; a washerwoman making her way down to the Thames, presumably to ply her trade; a dandy and his fashionable young lady taking the evening air; two people talking through a side window of the Swan Inn; and a covered gig, perhaps coming up from the market gardens to the south.

It seems entirely characteristic of the young Turner to have chosen a viewpoint looking towards the brightest area of light, thus maximising the tonal range of the scene. The control of light and shade is already masterly. And in the shadowed side of the buildings on the right we can equally perceive Turner's powers of observation, for the tones are distributed unevenly, being affected by stainings on the walls themselves and by reflections off the old Lambeth Road in front of them. Turner would later devote one of his annual Royal Academy perspective lectures to the study of reflections, and we can detect his interest in the subject even when he was only halfway through his teens.

Interior of King John's Palace, Eltham

c.1791
Watercolour on white paper, 33.2 x 27 cm
Yale Center for British Art, New Haven, Conn.

From the reign of King Henry III (1216-72), the Royal Palace at Eltham was often used as the principal residence of the kings of England, the name 'Eltham' deriving from the words Eald ham or 'the old home or dwelling'. Any link of the palace with King John (1199-1216) is not historically correct, for it probably derived from association with a son of King Edward II (1307-27), who was called John of Eltham because he was born there. The Great Hall was built by Edward IV (1461-83). Around 1527 King Henry VIII moved the royal seat to a new palace at Greenwich. After the Restoration in 1660 Eltham Palace became merely a farm, and its Great Hall was ignominiously turned into a barn, which is how we see it here. In 1933 the millionaire Stephen Courtauld linked the Great Hall to a new house built in the Art Deco style. The entire property was recently restored by English Heritage.

Turner exhibited a view of King John's Palace at Eltham in the Royal Academy Exhibition of 1791, and stylistically the present drawing looks to date from the same time. The medieval single hammerbeam roof is depicted in the slightly square-cut way that is also to be seen in other, contemporaneous works by the artist. However, in one important respect this watercolour is remarkably innovative.

The work is clearly unfinished, for much of its lower part has merely been indicated by preliminary underwashes and is therefore contained within a very narrow tonal band from light to dark. Yet it seems feasible that Turner abandoned the drawing because of this very restriction of tone, for it undoubtedly helps with the suggestion that the farm labourer, horse, vehicles and implements are all being lit by bright light flooding into the dark interior. This supposition receives support from the fact that the paper to the left of the horse was evidently rubbed hard in order to make it grainier, and thus seem more intensely glaring, as though it were being burnt by the sun. Several other Turner watercolours contain unfinished areas that project the brilliance of sunlight by means of tonal narrowness within those sectors, but this was surely the first drawing in which the artist discerned the possibilities of such a limitation. The lesson would not be lost on him, for eventually he would employ similarly restrictive tonal ranges to convey a brilliance of light that has never been matched.

The warm yellow-orange of the haystack on the right not only suggests the intrinsic colour of the hay: equally it conveys the heat of the sunlight, pulls the eye to the right and complements the blues and grey-browns distributed elsewhere.

Tom Tower, Christ Church, Oxford

1792
Pencil and watercolour on white paper, 27.2 x 21.5 cm
Turner Bequest, Tate Britain, London.

Turner made two views of this subject, and based both upon a pencil drawing created in the summer of 1792 (TB XIV A). The other drawing is slightly larger, and is now in a private collection. The architectural detailing and human figures of the present work make it clear that the seventeen year-old artist intended it for public display, although he never exhibited or sold it, which is why it has remained in his bequest to the nation.

This is one of Turner's many early drawings in which lessons recently learned from looking carefully at Michael Angelo Rooker's water-colour *Battle Abbey* in the 1792 Royal Academy Exhibition were put into practice. Throughout the work we see the artist employing the scale practice of tonal distribution that is discussed in the introductory essay above. Initially he laid down a wash of very pale yellow over the entire sheet. When that had dried he added a wash of light grey for the areas to be covered by clouds and by the shadowed parts of the buildings to left and right. For the masonry slabs of the building on the right he then employed a scale of eight tones of light brown-grey to dark blue-grey, some of which he also drew upon for the depiction of the buildings on the left and for the horse and cart. He also laid an ochre wash over the entire group of buildings on the left, as well as across the foreground and diagonally over the structures at the lower right. Some touches of pale red were used for the horseman on the right, the man pushing a barrow around the distant corner, and across the street to the left. Finally the foreground buildings and street were finished off with dots and lines drawn in indigo. Turner's grasp of a larger tonal sweep can be witnessed in the subtle halo of reflected light distributed around and below the upper window of the sunlit wall on the right, behind all the differently-toned slabs of masonry.

For the distant Tom Tower and gateway of Christ Church, Turner employed a much narrower, lighter and slightly warmer scale of tones. Here he gradually evolved on his palette six separate tones of yellow-grey to blue-grey. Additionally, he applied several small touches of unadulterated yellow for the clockface, and of clear blue for the windows above the gateway. (He also placed touches of the yellow and blue on the figures and horse in the foreground.) For the sky he worked up a narrow scale of four tones of blue and blue-grey, some of which were also used for the depiction of Tom Tower and for the building on the right.

In total, therefore, Turner used three colour scales comprising around twenty-five separate tones in this drawing. He did not create the image from top to bottom. Instead, in successive work sessions he placed all his gradually darkening tones of colour at widely-separated locations across the sheet, pretty much as one might put together the various fragments of a jigsaw puzzle over a period of time. Yet despite this necessarily fractured approach, the result is a work that is wholly coherent and entirely persuasive spatially. This is especially the case with the depiction of Sir Christopher Wren's Tom Tower which looks utterly solid and yet ethereal in the late afternoon sunlight.

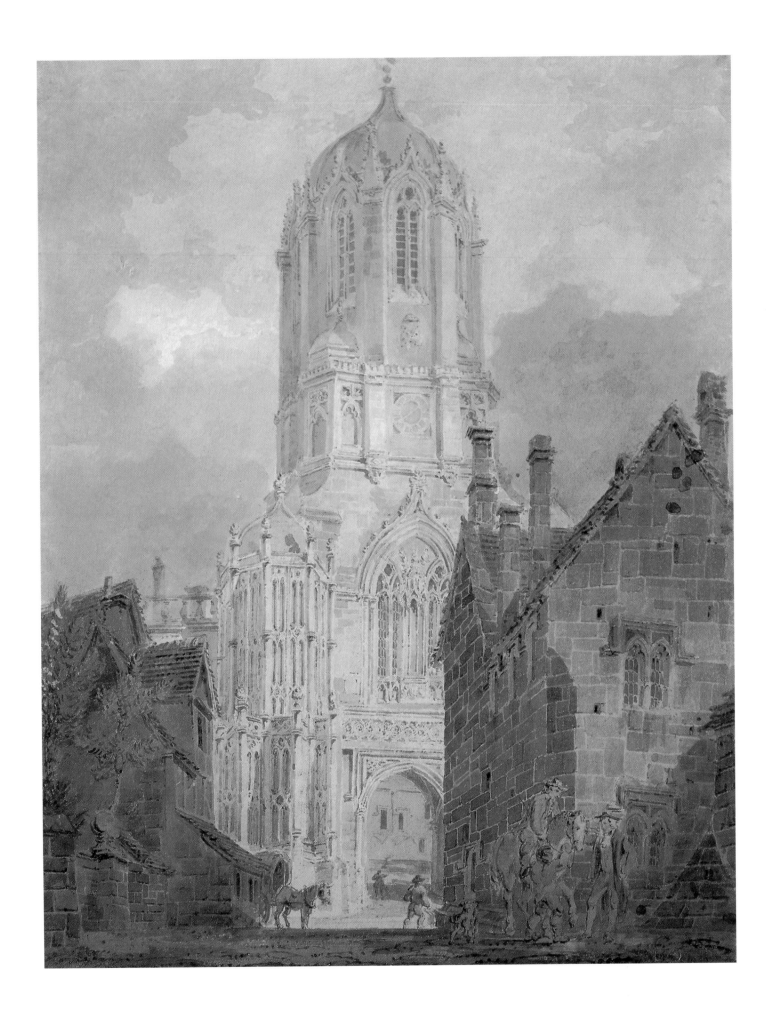

St Anselm's Chapel, with part of Thomas-à-Becket's crown, Canterbury Cathedral

1794
Watercolour on white paper, 51.7 x 37.4 cm
Whitworth Art Gallery, University of Manchester.

Sketches made in either 1792 or 1793 probably formed the basis of this watercolour, which was exhibited at the Royal Academy in 1794. We look from the south-east corner of Canterbury Cathedral towards the octagon known as the 'corona' or crown in which were once entombed the remains of the head of Saint Thomas-à-Becket, who was murdered elsewhere in the cathedral in 1170. In the later Middle Ages this part of the building was the leading pilgrimage shrine in England, as *The Canterbury Tales* attests.

Due to its physical complexity, the south-east corner of Canterbury Cathedral is a very difficult structure to represent, for its main bulk turns through a range of angles, from which buttresses and towers jut in various directions. But Turner has not only made sense of the jumble; he has also unified all the multitudinous reflections, highlights and shadows distributed across the building in the early morning sunshine. And no less evident is his comprehension of the underlying dynamics of the architecture, its volumes, masses, stresses and other physical interdependencies. At the tender age of just nineteen the artist was already mastering both the externals and internals of architecture.

Some notable alterations to the proportions of the cathedral have been made, however: its width has been halved, and its height doubled. Obviously Turner fashioned this change in order to make the cathedral seem even more overtowering and grand than it is in reality. The adoption of a low viewpoint helps this aggrandizement. And to emphasize the sophistication of the architecture even further, Turner made the figures, animals and cart look extremely clumsy and characterful, thus maximising the contrast between the two.

The tonal variety employed to depict the masonry shows the influence of Michael Angelo Rooker, whose outstanding talents at capturing the varied tones of buildings are discussed in the introductory essay above. This influence may especially be detected on the shadowed side of the corner of the cathedral on the left. Here each slab of masonry is tinted in a slightly different tone from its neighbours, within an overall tone that gradually darkens towards the top. Such minute and broad control of tone would confer crucial long-term benefits upon the artist.

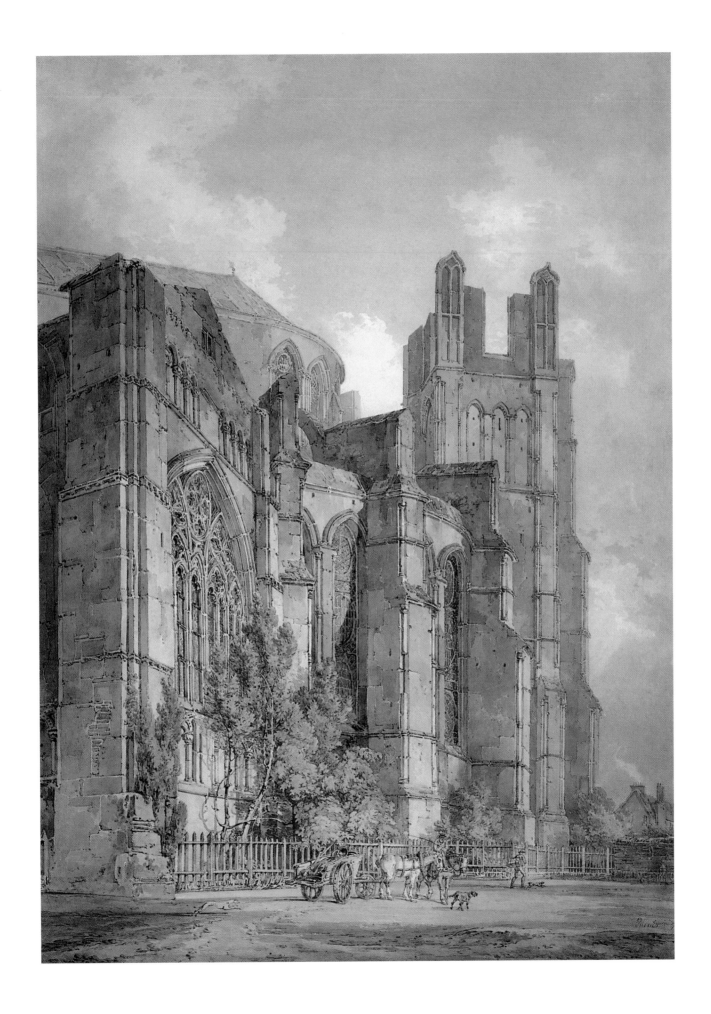

Fishermen at Sea

1796
Oil on canvas, 91.5 x 122.4 cm
Turner Bequest, Tate Britain, London.

Turner made his debut as an oil painter with this picture, which was shown in the Royal Academy Exhibition of 1796. In the work we look across Freshwater Bay, near the south-western end of the Isle of Wight. Turner had visited the island in 1795 and made pencil sketches of the bay in his *Isle of Wight* sketchbook (TB XXIV), although no one drawing represents the topography portrayed here.

The painting demonstrates the assimilation of a number of artistic influences. In overall terms it is reminiscent of works by the French marine painter Joseph Vernet (1714-1789). The night effect connects with the moonlit scenes of Wright of Derby (1734-1797), while the shaping of the clouds demonstrates the influence of Philippe Jacques de Loutherbourg. At the time Turner painted this picture he is also known to have been strongly drawn to Rembrandt, being particularly attracted to a night scene by the Dutch master, the *Holy Family resting on the flight into Egypt* which was then owned by one of his patrons, Sir Richard Colt Hoare, but is now in the National Gallery of Ireland, Dublin. However, although the intense chiaroscuro of the scene may have derived from Rembrandt, Turner has made the brilliance of lighting and sense of bobbing movement completely his own.

With its fine depiction of an underlying swell, the painting demonstrates how far the young artist had already developed in his comprehension of how large bodies of water ebb and flow. The moon was originally glazed over the clouds, but time has allowed the overpainted forms to peek through.

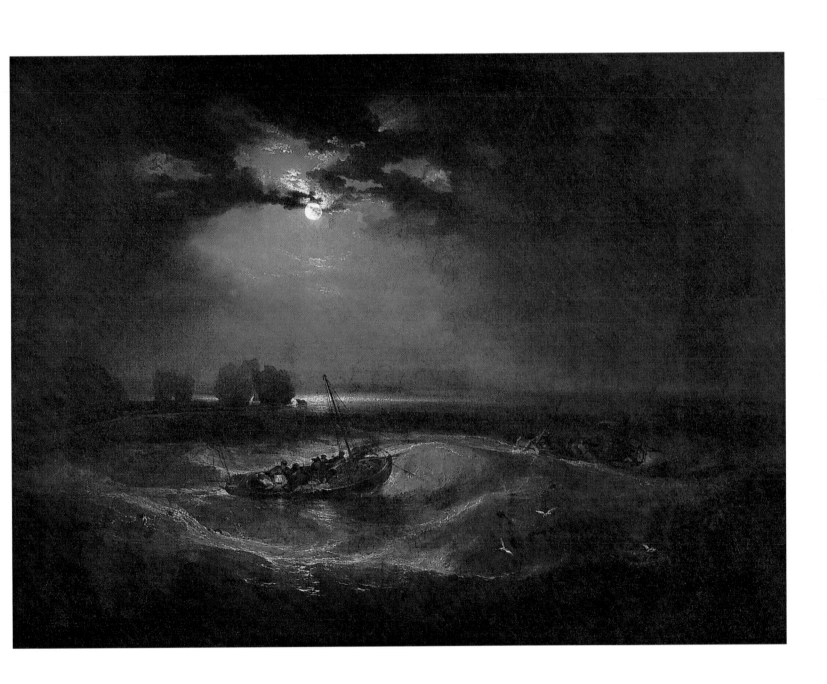

Wolverhampton, Staffordshire

1796
Watercolour on white paper, 31.8 x 41.9 cm
Art Gallery and Museum, Wolverhampton.

This watercolour was based upon pencil drawings made on folios 21 and 22 of the 1794 *Matlock* sketchbook, TB XIX. It was exhibited at the Royal Academy in 1796. The work abundantly demonstrates Turner's desire to marry the representation of place with the emphasis upon humanity extolled by Sir Joshua Reynolds. It also shows that the young painter had already been looking at the works of David Teniers the younger, if not even the pictures and prints of Hogarth, whose *Southwark Fair* the image resembles.

Ever since the Middle Ages a fair has been mounted each July on High Green, Wolverhampton. Turner must have spent some time carefully scrutinising the fair on one or more of the eight days it lasted after 8 July 1794, for the pencil drawings upon which he based this work outline the buildings but only contain four figures – clearly the artist already possessed an enormously retentive memory. He indulged in his customary aggrandizement of scale here, for in relation to the populace of High Green, all the buildings in the finished watercolour are much larger than they are in the preliminary drawings or were in reality.

Two clocks fix the time forever. Turner has placed a sign reading 'SMITH FOREIGN Spirituous Liquors' in the centre of the southern facade of the sunlit timber-framed building to the right of centre; this is known to have been a brandy tavern, Bevan's Tot Shop. On the left a showman's tent sports the legends '[L?]ION FROM AFRICA' and 'SURPRISEING', while nearby a banner bears the words 'THE [IRON?] GIANT'; these details suggest that Turner had witnessed a travelling zoo, Wombwell's Menagerie, at the fair in 1794. A further banner representing an elephant 'TO BE SEEN ALIVE' is being hauled aloft near the sunlit corner of the Tot Shop, possibly also to attract people to the same collection of exotic creatures.

In the distance, at the western end of High Green, Turner comes closest pictorially to Hogarth's *Southwark Fair*. Here he gives us a travelling theatre, complete with huckster, drummer, tambourinist and customers mounting an outside staircase to gain admittance. Turner may have derived this mobile theatre from Holloway's combined vaudeville, pantomime and music hall which regularly erected its boards at the High Green fair. Further entertainment is provided in front of the Tot Shop by a trainer in harlequin costume whipping his dogs into begging positions; simultaneously a woman in the foreground gets her dog to perform the same trick without duress and for nothing. Next to the harlequin dog-trainer, a drummer and tambourinist not only draw attention to the showman but also compete with their counterparts working for the travelling theatre; if we could hear the rhythmic cacophony created by the two identical pairs of musicians, it would surely prove excruciating. On the right two women gaze at a waxworks through spyholes, while an adjacent stall sells gingerbread, game, spice and nuts. Out of an upstairs window of the Tot Shop a forthcoming political meeting is about to be advertised by a banner captioned 'KING AND CONSTITUTION'.

Our sense of the tumultuous chaos of mankind is enhanced by all the contrastingly stable straight lines created by the zig-zag edges of the pub's roof, and by the diagonals and verticals of the other buildings. Turner leads our eye to the warm tones in the centre of the composition by surrounding them with the cool tones of the tents on the left, the shadowed side of the Tot Shop, and St Peter's parish church in the distance.

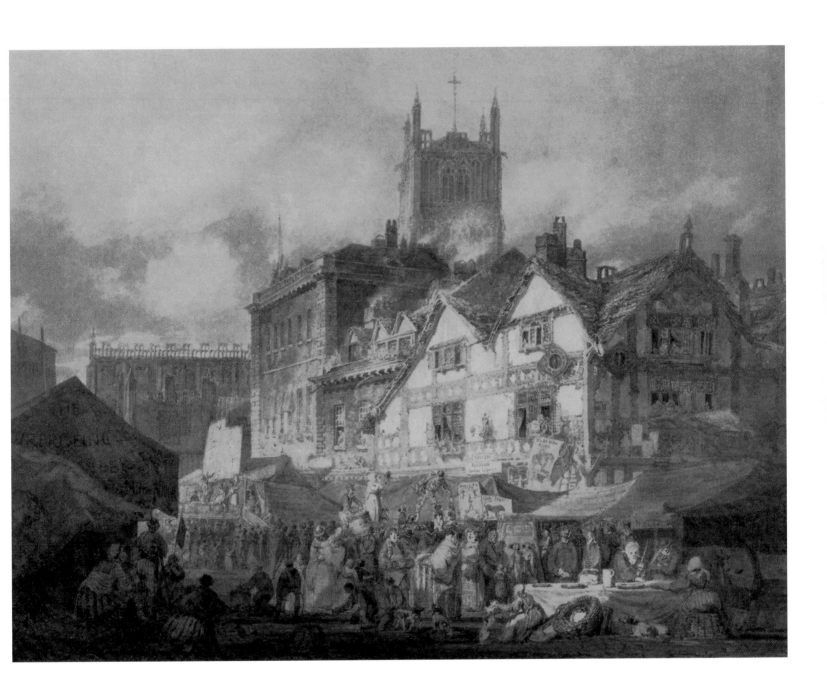

Trancept of Ewenny Priory, Glamorganshire

1797
Pencil and watercolour with scratching-out on white paper, 40 x 55.9 cm
National Museum of Wales, Cardiff.

Here we see the young Turner developing the notion of moral landscape painting, as befits an adherent to the Theory of Poetic Painting expounded by Sir Joshua Reynolds. The watercolour was based on a pencil drawing made on the Welsh tour of 1795 (see the *Smaller South Wales* sketchbook, TB XXV, f.11), and it was exhibited at the Royal Academy in 1797. A Benedictine monastery situated near Bridgend in Glamorganshire, Ewenny Priory was founded in 1141 and suppressed in 1539. When Turner drew its transept in 1795, he made a point of carefully studying the twelfth-century tomb effigy of Sir Paganus de Turbeville of Coity that stands in that entrance space, although when he came to make this watercolour he turned the resting figure through 180 degrees. Why did he effect that reversal?

The tomb and effigy are situated within the brightest area of the image, which pulls our eye towards them. To direct our attention further, the nearest end of a makeshift hen-house placed directly opposite our perspectival viewpoint in the foreground forms a triangle that points our eye to the sepulchre. As none of the animals, people or objects appear in the original pencil drawing, we can safely infer that they were introduced for a purpose. Given their character we can quickly deduce their creation of an ironic historical point: Sir Paganus de Turbeville of Coity may have sought eternal peace in Ewenny Priory church but he can hardly be currently enjoying it, for the church is now being used as a pigsty, and the transept as a chicken and turkey coop, as well as a toolshed for farm implements. By implication then, Turner was here commenting on the long-term destructive effects of the sixteenth-century Reformation that had brought the building to its present sad state. Just like the effigy, the religious hopes of Sir Paganus have been utterly reversed.

This drawing makes it clear that by 1797 Turner's grasp of the essentials of architecture was complete, for we not only see the intersection of great arches – even more forcefully we can experience the intense physical pressure which holds them up. Again in evidence are the balancing of cool and warm colours resulting from the influence of Rembrandt's *Holy Family resting on the Flight into Egypt*. One of Piranesi's prison scenes, with its dramatic tonal contrasts, architectural stresses and 'offstage' light sources, also probably boosted Turner's imagination here. His awareness of the way that intense light entering a dark interior creates a glare that exists within a very narrow tonal range – which we have already seen in the Eltham Palace view – is further evident in the exceedingly delicate tones playing across the wall behind the tomb-effigy. The light penetrating the windows on the right, and the forms of the pigeons just taking off, were all scratched out from the immensely strong rag-made paper Turner used, while the distant highlights within the church on the left were created with the help of stopping-out varnish, a temporary coating that protects the paper from overpainting and is then removed to reveal the untinted or less tinted support beneath.

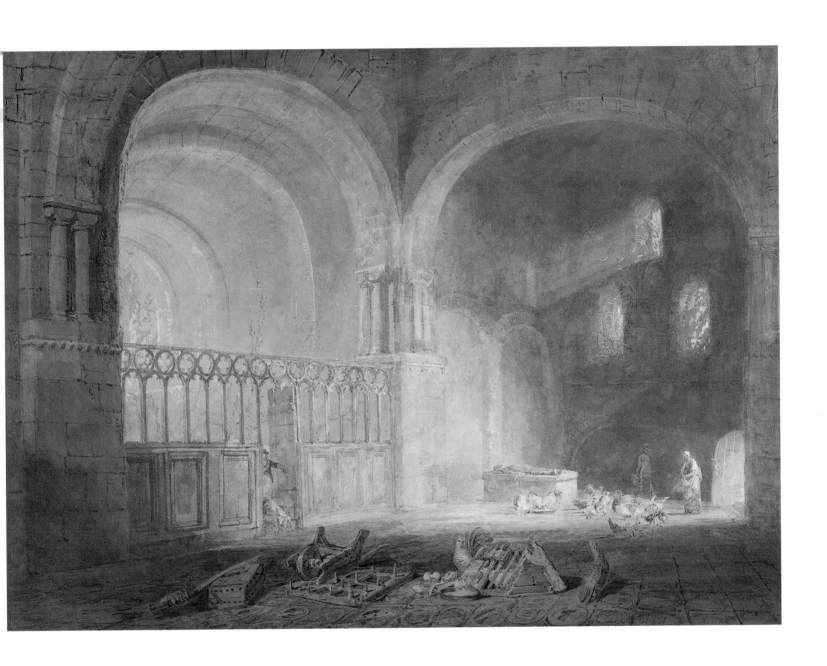

Dolbadern Castle, North Wales

1800
Oil on canvas, 119.5 x 90.2 cm
Royal Academy of Arts, London.

Dolbadarn Castle was probably built in the early thirteenth-century by Llywelyn the Great (1173-1240). Here we view it from the north-west at dawn, looking towards Llanberis Pass from the shores of Llyn Padarn, the lake visible on the left. Turner visited the castle both in 1798 and 1799, drawing it in his *Hereford Court*, *North Wales* and *Dolbadern* sketchbooks (TB XXXVIII, XXXIX and XLVI respectively). The 1799 *Studies for Pictures* sketchbook (TB LXIX) contains six studies in pastel for the lighting and composition of this painting, while a further, small study in oil on panel belongs to the National Library of Wales, Aberystwyth. When the canvas was exhibited at the Royal Academy in 1800, its title was accompanied in the Exhibition catalogue by the following anonymous verses possibly written by Turner himself:

> *How awful is the silence of the waste,*
> *Where nature lifts her mountains to the sky,*
> *Majestic solitude, behold the tower*
> *Where hopeless OWEN, long imprison'd, pined*
> *And wrung his hands for liberty, in vain.*

The 'hopeless OWEN' referred to is Owain Goch who was incarcerated by his brother in Dolbadarn Castle between 1255 and 1277, when he was liberated by Edward I of England. The foreground figure under guard with wrists bound behind his back is surely 'hopeless OWEN' sunk in despair as he is led to the prison indicated by the pointing figure next to him. The fact that prisoner and prison are exactly aligned vertically reinforces their connection. Possibly the alignment was also intended by Turner the Poetic Painter to parallel the consonant line-endings frequently encountered in poetry.

Turner took enormous topographical liberties in this picture. In reality the sides of Llanberis Pass slope far less precipitously than they do here. By transforming them into overtowering crags whose verticality is reinforced by the upright format of the canvas, and by greatly narrowing the pass, Turner has made the landscape seem very claustrophobic indeed. Clearly this claustrophobia articulates Owain Goch's entrapment. Similarly, the implied circle running around the edges of mountains and clouds encloses the castle and intensifies our sense of Owain Goch's imprisonment. His subjugation is projected by the overtowering placement of the castle in relation to our low viewpoint and that of the prisoner.

The conjunction of profound darkness and intense light might stand for the opposition between imprisonment and liberty. Turner would frequently connect dawns with hope or renewal, and sunsets with the decline of fortunes, as we shall see, so he could have used light associatively here. Although Owain Goch's fortunes are on the wane, eventually he will be freed, as the phrase 'long imprison'd' (but not 'forever imprison'd') in the 1800 verses tells us. The returning sunlight that the castle bars from both the prisoner and ourselves might therefore represent the eventual regaining of that liberty.

Two years after exhibiting this picture Turner would be required to give the Royal Academy a painting or watercolour as his Diploma Work upon being elected an Academician. He would offer a choice of two pictures; this one was selected.

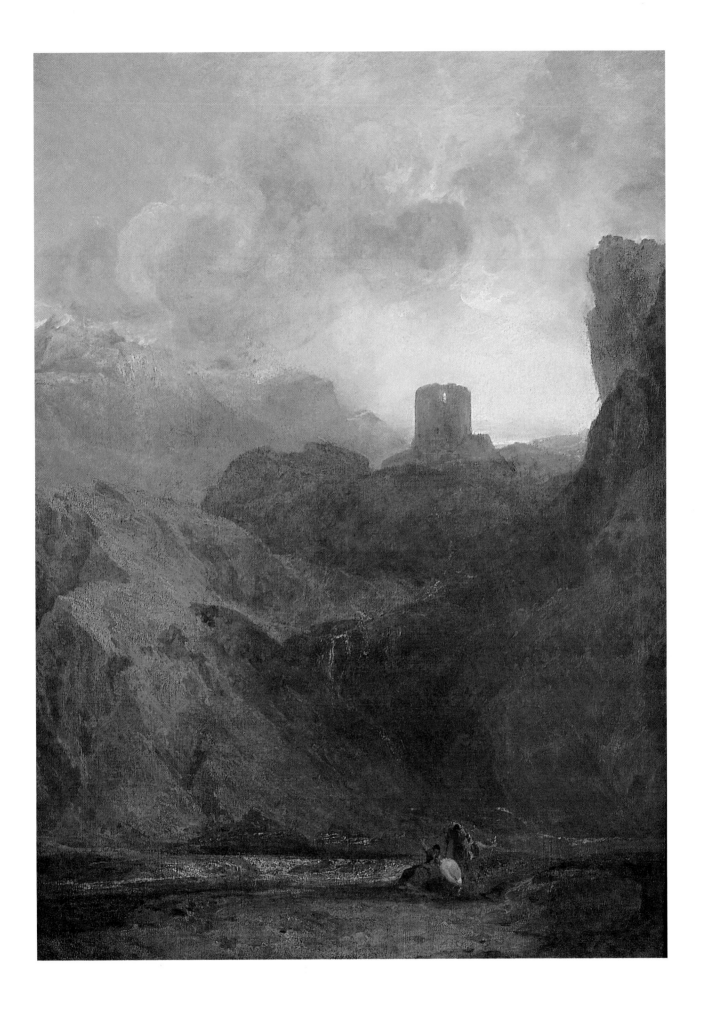

Caernarvon Castle, North Wales

1800
Watercolour on white paper, 66.3 x 99.4 cm
Turner Bequest, Tate Britain, London.

Although by 1800 this watercolour was Turner's most ambitious homage to Claude le Lorrain to date, he had larger issues in mind when he created it. He exhibited it in the 1800 Royal Academy Exhibition. In the catalogue its title was accompanied by anonymous verses possibly written by the painter himself:

And now on Avon's haughty tow'rs
The Bard the song of pity pours,
For oft on Mona's distant hills he sighs,
Where jealous of the minstrel band,
The Tyrant drench'd with blood the land,
And charm'd with horror, triumph'd in their cries.
The swains of Arvon round him throng,
And join the sorrows of his song.

The Bard to which the verse refers sits at his harp and points towards the distant castle built by King Edward I of England (1239-1307) to crush the Welsh. Turner was well aware of Thomas Gray's renowned poem *The Bard* of 1757 which treats of the supposedly last of the medieval Welsh poets, and that epic undoubtedly inspired this watercolour. It is safe to infer that both Gray's Bard and Turner's Bard are one and the same person, and that the poet will eventually commit suicide after hurling insults at the invading monarch.

The pine tree under which the Bard laments leans in the direction of the castle, and thereby amplifies the protagonist's despairing gesture, while the curve of its trunk echoes the curve of his harp. We view the panorama in evening light, a timing that fully meets the need for Decorum: just as the Bard's historical day approaches its end, so too the terrestrial day moves towards its close.

Turner exhibited three works dealing with liberty and its curtailment at the Royal Academy in 1800: an implied statement about a people in bondage, in the form of a portrayal of the seventh plague of Egypt (which the artist wrongly identified as the fifth plague); the view of Dolbadarn Castle discussed above; and the present watercolour. Connectively the latter two works enact an historical irony, for whereas a king described here as a 'Tyrant drench'd with blood' is destroying Welsh culture, in the Dolbadarn view he will ultimately bring freedom to Owain Goch. Liberty was very much a relevant political issue in 1800, when Napoleon was enslaving peoples abroad and the British government was curtailing freedoms at home. Naturally there was much alarm over both issues within the Royal Academy, but especially the latter one. Turner might therefore well have been trying to advance his Academic as well as his artistic status by appealing to those of like mind within the institution through the creation of works that subtly deal with the loss and renewal of freedom in Britain.

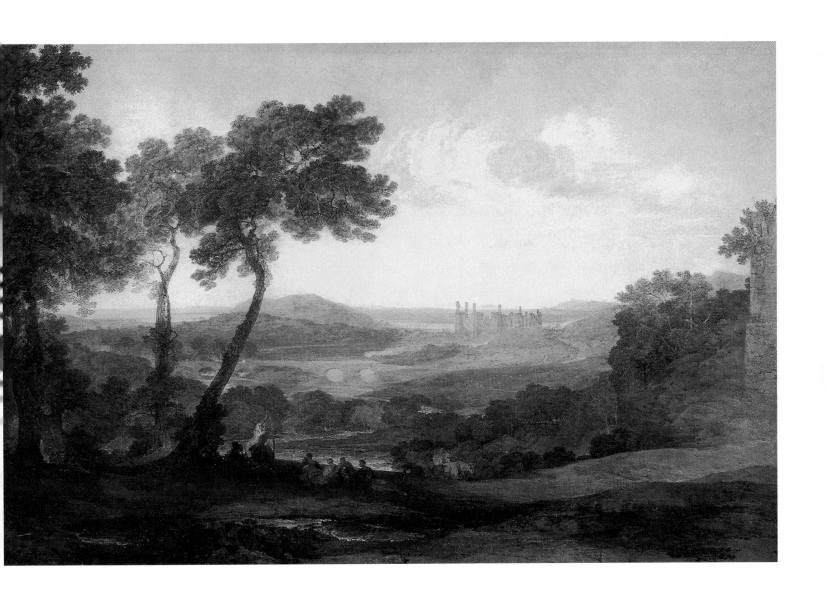

Dutch Boats in a Gale:
Fishermen Endeavouring to put their Fish on Board

1801
Oil on canvas, 162.5 x 222 cm
Private Collection, on loan to the National Gallery, London.

One of Britain's leading collectors, the third Duke of Bridgewater, commissioned this painting, which is why it is also called 'The Bridgewater Seapiece'. The aristocrat wanted the work to hang in his gallery at Bridgewater House alongside a painting by Willem van de Velde the younger, entitled *A Rising Gale* (now in the Toledo Museum of Art, Toledo, Ohio). A marked feature of the latter work is the stress van de Velde accorded to a sprit or diagonal spar supporting the mainsail on a nearby Dutch fishing vessel. In 'The Bridgewater Seapiece' Turner cleverly reversed that diagonal. Although the sprit on his fishing boat is not visible, being masked by its sail, nonetheless its existence is implied and it enjoys an identical visual stress, albeit in the opposite direction. These opposing diagonals must have forged a strong complementary link between the two works on the walls of Bridgewater House. The composition is further unified by the diagonal line of approaching storm-clouds and the rising line of shadow on the sea. In the water we can witness Turner's grasp of the fundamentals of hydrodynamic movement, the 'qualities and causes, effects and incidents' governing its motion.

In the far distance on the right may be seen a partly sunlit lee-shore, or area of land towards which a wind is blowing. Such shores were the bane of nautical existence in the days of sail, for many a vessel was wrecked on them. Virtually the only certain way of obviating the risk they posed was to turn into the wind, drop anchor, and ride out any ensuing storm. Such a course of action has prudently been taken by the three large ships in the distance.

This painting caused a sensation when it went on display at the Royal Academy in 1801, and it thereby set the seal on Turner's growing reputation. The President of the institution, Benjamin West, remarked that the picture was the kind of seascape that Rembrandt had wanted to paint but could not achieve (he was probably thinking of a famous Rembrandt showing Christ in a small boat on the Sea of Galilee which was then in England but is now owned by the Isabella Stewart Gardner Museum in Boston, Massachusetts). Nor was West the only person to compare Turner to Rembrandt. The Royal Academy Professor of Painting, Henry Fuseli RA, similarly made the link and additionally praised this picture as being the best work in the exhibition. He also remarked that its figures were 'very clever'. He may or may not have realised that Turner had painted the nearby sailors in the manner of Teniers the younger, but he must certainly have relished the decorum of making them look like salty Lowlands seadogs, in keeping with the avowedly Dutch subject.

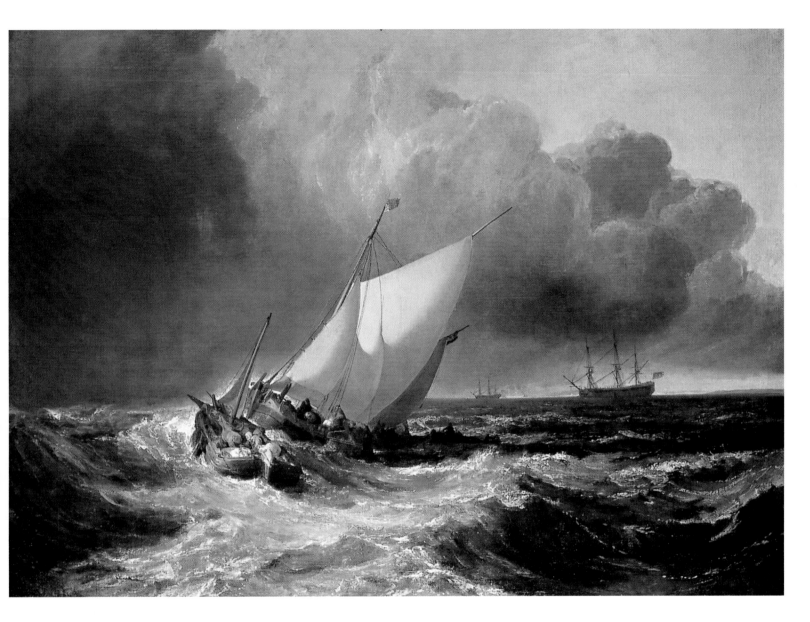

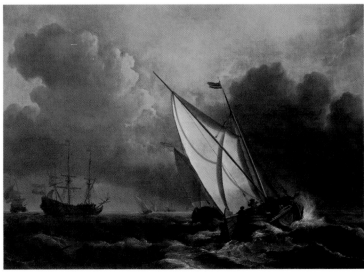

Willem van de Velde the younger, *A Rising Gale*
Oil on canvas, 129.5 x 189.2 cm, Toledo Museum of Art, Toledo, Ohio.

Interior of Salisbury Cathedral, looking towards the North Transept

c.1802-5

Watercolour on white paper, 66 x 50.8 cm

Salisbury and South Wiltshire Museum.

Here Turner transformed his love of architecture into the lifeblood of great art.

Around 1797 a prominent banker, landowner, antiquarian and amateur artist, Sir Richard Colt Hoare, commissioned the painter to make ten large watercolours of Salisbury Cathedral and ten smaller drawings of buildings in and around Salisbury for use as illustrations to a history of Wiltshire he was planning to write. However, the publication failed to materialize, and consequently none of the designs were ever engraved. The first of the watercolours was made in 1797, but Turner never completed the commission, only finally delivering eight drawings for the larger set (of which this is one) and nine of the smaller designs. Colt Hoare hung the larger drawings in a single room in his country seat at Stourhead, and regarded them as 'unsurpassable', as well he might.

In the late afternoon sunlight flooding the interior, choristers make their way towards the organ loft for Evensong. Turner's love of reflected light can be witnessed in the abundant reflections that brighten every shadowed corner of the building, thereby clarifying its innate intricacy and grandeur. The structure is doubled in height in relationship to the figures (or, alternatively, the people are halved in size), while the elaborate lines of the organ, and of the traceries, columns, ribs and vaults, build up to the pictorial equivalent of a complex musical fugue.

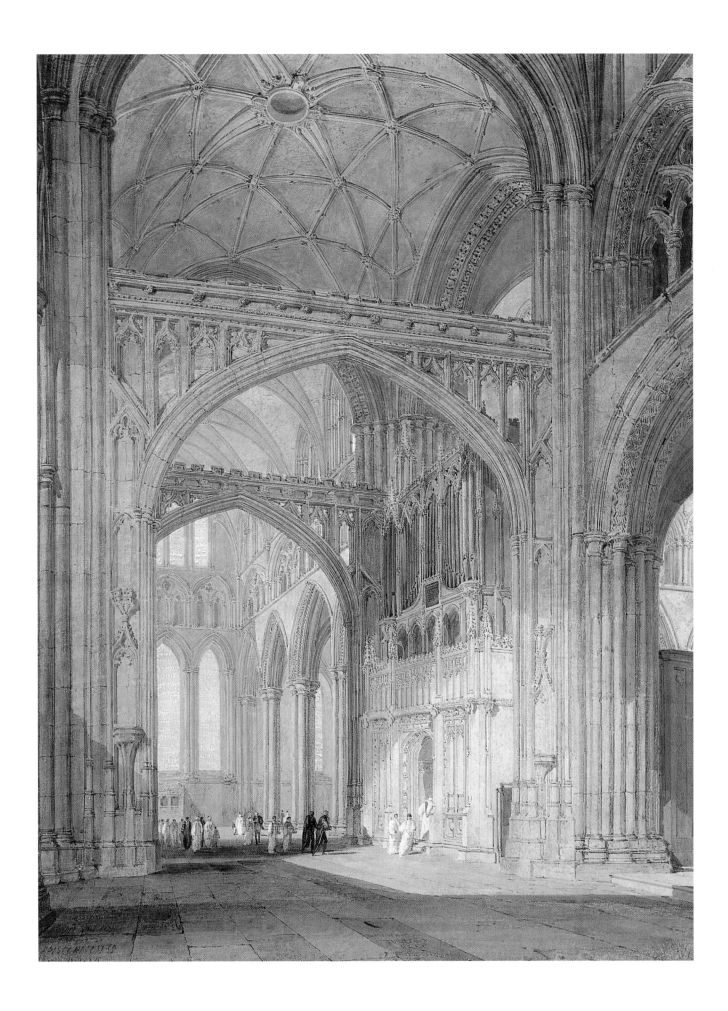

Calais Pier, with French Poissards preparing for Sea:
an English Packet arriving

1803
Oil on canvas, 172 x 240 cm
Turner Bequest, National Gallery, London.

As a result of the peace agreement concluded between Britain and France in March 1802, Turner was able to visit the Continent for the first time later that year. He landed in Calais en route for Switzerland, and had to transfer from the cross-channel packet-boat or ferry to a lesser craft because the tide prevented his ship from immediately entering the harbour; according to a note in one of his sketchbooks, the smaller boat was 'Nearly swampt' in the process. However, what he actually experienced at Calais in 1802 and what he depicted here are not necessarily the same thing.

To the left of centre is the English packet entering harbour, the Union flag flying from its headmast. Bedraggled passengers crowd the deck, and they might well feel seasick, for in those days the 21-mile (33.8 km) crossing could take up to a week, depending on the winds and tides. Just in front of the packet and taking strong evasive action to avoid collision is one of the 'French Poissards preparing for sea' mentioned in the title (the word 'Poissard' being Turner's corruption of the word 'poissarde', meaning fish-wife). The possibility that the foreign vessel might be involved in a collision so soon after casting off from the pier is surely Turner's witty, if somewhat jingoistic, comment upon the poor seamanship of the French. Moreover, the figures on the pier also seem to pander to anti-French sentiment, for they are slightly caricatural. They therefore belong to a tradition in British art typified by Hogarth's *Calais Gate (The Roast Beef of Old England)*, which Turner surely knew in either painted or engraved form (or both).

Turner worked on this oil in the autumn, winter and spring of 1802-03 and exhibited it at the Royal Academy in May 1803. During that period, and especially from 8 March 1803 onwards, there was an intensive awareness in Britain that hostilities with France would shortly resume. Such fears might well have determined the imagery of this picture. Thus the incident in the centre could allude to the fact that until recently the British and the French had been on a 'collision' course but had finally averted that clash by agreeing to a peace. If Turner's ships do escape collision, then their avoidance could remind us of such a peace. That possibility is suggested by the location of the boats beneath the only peaceful area in the entire work, the glimpse of blue sky immediately above them. Yet Turner might also have been hedging his bets here, for the image could equally suggest the resumption of hostilities: if the French fishing vessel and English packet do shortly collide, then that might parallel an impending collision between France and Britain. This possibility is certainly supported by the clouds, for if they are closing – which seems likely, given the storm approaching from the west (as indicated by the flags) – then the peaceful sky will disappear. In fact France and Britain did resume hostilities just sixteen days after this work first went on display at the Royal Academy, so Turner covered both his war and peace options most ingeniously.

The representation of the sky seems somewhat theatrical, for the clouds are rather reminiscent of the 'flats' of stage scenery; within a couple of years Turner would express their spatial complexity and meteorological dynamics with more certainty. But the sea is filled with an immense sense of energy, while the understanding of its ebb and flow is absolute. Turner's contemporaries found the definition of things rather too vague in this work, but that very 'indistinctness' surely adds to the veracity and power of the image.

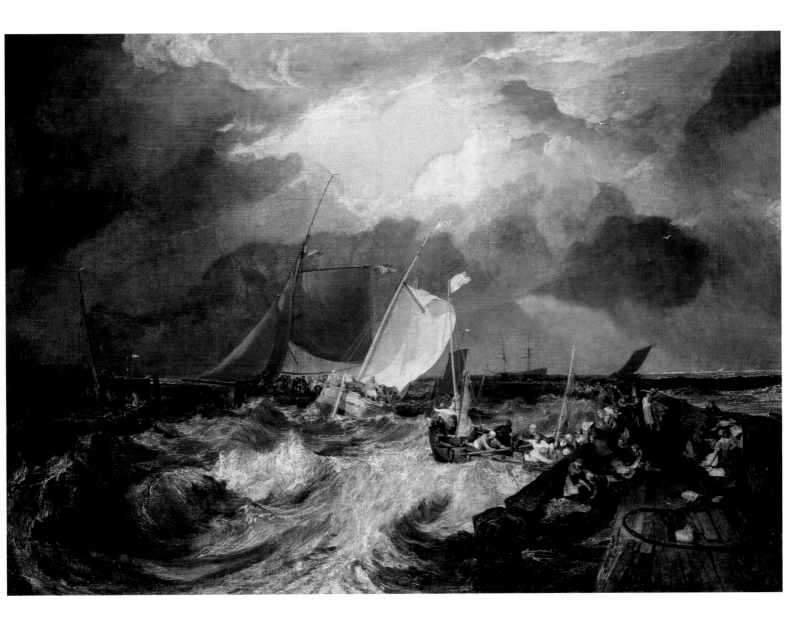

Fall of the Reichenbach, in the valley of Oberhasli, Switzerland

1804
Watercolour on white paper, 102.2 x 68.9 cm
Cecil Higgins Art Gallery, Bedford.

The spelling of the title given here was the one used for the watercolour when it was exhibited for the second time, at Walter Fawkes's London residence in 1819. Clearly, on that occasion the opportunity had been taken to correct two printer's errors that had crept into the title when the drawing was first exhibited at the Royal Academy in 1815 (where it was named *The Great Fall of the Riechenbach, in the valley of Hasle, Switzerland*).

The Reichenbach waterfall, in the upper Hasli valley near Meiringen, was a popular tourist attraction and therefore an obvious subject for Turner's art. The painter created two highly detailed watercolours of the cataract, the other, smaller work showing it from a much nearer viewpoint and at a more oblique angle. The present drawing was based upon a monochromatic study dating from 1802 that is now in the National Gallery of Ireland.

This is perhaps the most magnificent watercolour to have been created immediately after the first Swiss tour. Its upright format enhances the immense scale of the landscape. That vastness is boosted by the contrasting tiny figures gathered distantly around a fire on the left, and by the solitary goatherd clambering after strays on the hillside opposite. The inclusion of these wandering goats was an especially ingenious move on Turner's part, for subliminally they remind us that disorientation can easily prove the norm in this landscape.

The fundamental geological verities of the escarpment are apparent. At the base of the falls we can perceive how large bodies of water cascading from a very great height give off a fine spray. In the foreground all 'the rubbish of creation' is sharply detailed without losing any of the rawness and chaos of nature in the wild. And by making the river drop out of the bottom of the image, Turner suggests that we are on the edge of a precipice, thus furthering our awareness of the intense spatiality of the scene.

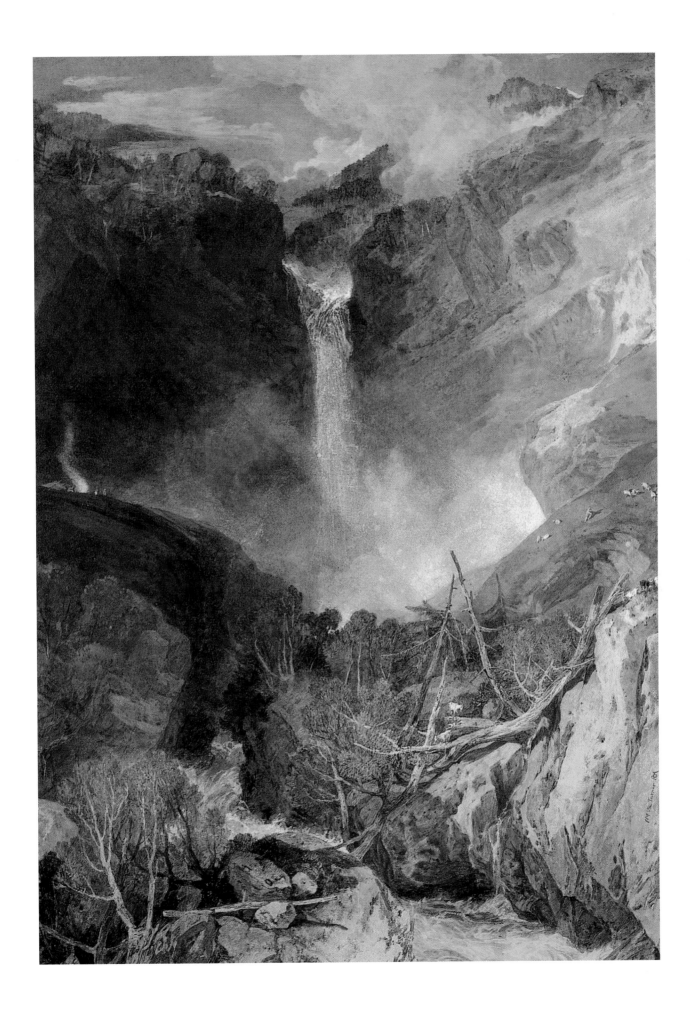

The Shipwreck

1805

Oil on canvas, 170.5 x 241.5 cm

Turner Bequest, Tate Britain, London.

Given the sad fact that passenger vessels still frequently capsize with great loss of life, this tragic work remains most relevant today. Turner exhibited it in his own gallery in 1805 and sold it the following year to Sir John Leicester. However, the baronet exchanged it for another painting in 1807, as he had recently lost a relative by drowning and found the subject too painful to live with.

The sea is a mass of boiling foam, in which the artist's complete grasp of hydrodynamic motion and internal energy is abundantly evident. It has been suggested (see Venning 1985) that Turner here depicted the foundering of a specific vessel, *The Earl of Abergavenny*, in January 1805 (in which case he would have had to paint the work in about six months, which seems just about possible). The *Earl of Abergavenny* was an East Indiaman whose hull was ripped open when she was piloted onto the Shambles, some reefs near the Isle of Portland, with the loss of 263 lives. One of the casualties was the captain of the vessel, John Wordsworth, who was the poet William Wordsworth's brother. However, *The Earl of Abergavenny* did not capsize, as the large vessel in the distance on the right is doing here; she went straight down in fairly shallow waters, leaving her masts exposed vertically, and with the majority of the survivors clinging to them (Turner instead represents people clinging to bowsprit rigging, tops and decks). Because the visual evidence does not therefore precisely correspond to reality, the exact identity of this shipwreck must consequently remain in doubt.

The capsized merchantman is partially masked by a fishing boat whose crew are attempting to rescue the passengers of a lifeboat. Turner often juxtaposed his shipping in this way, sometimes putting as many as five vessels in a single line stretching away from us. He probably did so because of his responsiveness to form: such alignments create confused shapes and Turner loved making shapes.

The painting contains a relevant moral dimension. As in several of his earlier seascapes, including 'The Bridgewater Seapiece' and *Calais Pier*, Turner fashioned many of his figures in the style of Teniers the younger (the man in the small boat at the lower-centre, with his red cap and back to us, looks especially like a figure by Teniers). By contrast with their surroundings, such intentionally gauche-looking people remind us of all the 'littleness of man', and thereby underscore the futility of our attempts to overcome the vast forces of Nature.

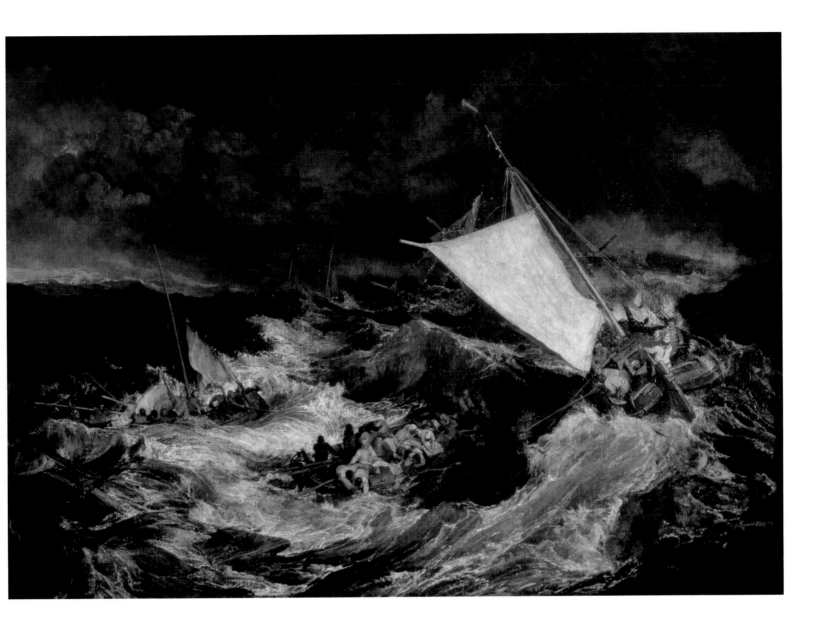

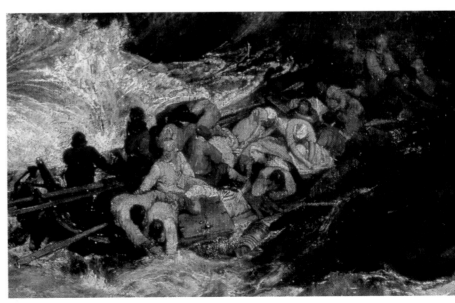

The Thames near Walton Bridges

c.1805
Oil on mahogany veneer laid down on panel, 37 x 73.5 cm
Turner Bequest, Tate Britain, London.

In 1805 Turner rented Syon Ferry House at Isleworth, to the west of London, as a temporary home-from-home. At that time he also possibly had a boat made to his own design. This was a clinker-built dinghy of around 15 feet (4.5 metres) in length, with a single mast. And evidently he used the boat as a floating studio, judging by the numerous works he made around 1805 from viewpoints along the Thames and its tributary, the Wey. These include eighteen oil sketches painted on thin mahogany veneer, which wood may have been left over from the construction of the boat. The present oil belongs to that group. In it we look south-westwards in evening light towards part of the long double bridge at Walton-upon-Thames which was built in 1786 and replaced in 1863.

In sketches like this, Turner was at his most impressionistic, brushing in the forms with the greatest broadness and vigour, and capturing the passing light and weather effects with enormous spontaneity. Naturally, because of the artist's direct contact with nature when painting such works, and the free, painterly technique he employed while doing so, such pictures prefigure French Impressionism. However, one should not infer from them that Turner was himself an Impressionist, for he never exhibited any of the relatively small number of *plein air* sketches he created outdoors (for example, the present work was not shown publicly until 1949, almost a century after the painter's death). Certainly in oils like this Turner clearly had a wonderful time painting in front of nature; he heightened his perceptions, especially of transitory light and weather effects; and he explored the making of new kinds of marks with which to depict things, especially foliage. Yet there can be no doubt that he regarded this type of oil sketch merely as a means to an end, not as an end in itself. Monet and Pissarro may have claimed Turner as one of their own, and critics like Clive Bell might have asserted in the 1930s that Turner was 'The First of the Impressionists', but such linkages are forced. Undoubtedly the French Impressionists were influenced by Turner but it is wrong to infer the opposite from this, that the English painter would have shared their aims. Whereas painting in the open air directly from the subject was a central tenet of Impressionism, for Turner painting was predominantly a studio-based idealising practice, in which the processes of imagination, historical and social consciousness, visual metaphor, memory and pictorial synthesis played a central role. Because of this belief Turner was far removed aesthetically from the Impressionists. Only a superficial pictorial similarity links his works to those of the later landscapists (let alone to the pictures of the American Abstract Expressionists).

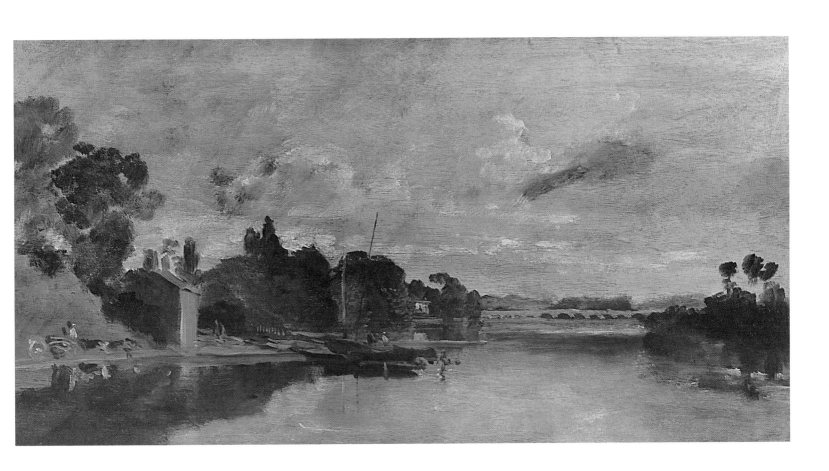

Sun rising through Vapour; Fishermen cleaning and selling Fish

1807
Oil on canvas, 134.5 x 179 cm
Turner Bequest, National Gallery, London.

Turner exhibited this dawn scene at the Royal Academy in 1807, and again the following year at the British Institution. In an 1810 letter to Sir John Leicester (to whom he would sell the canvas in 1818) the artist described its subject as being 'Dutch Boats'. In stating this, he had clearly forgotten that the sun does not rise off the entirely westwards-facing coast of Holland. However, the solecism is understandable, given that by 1810 Turner had never visited the Netherlands.

It has plausibly been suggested that the pier on the right was based upon the old pier at Margate, and that in actuality Turner was here depicting the panorama across the Thames estuary looking in a north-easterly direction at dawn. That he should have transformed such a prospect into one of 'Dutch Boats' entirely follows the dictates of the Theory of Poetic Painting. The style of the figures again reflects the influence of David Teniers the younger, and calls forth appropriate Lowlands associations. The red-capped man to the right of centre standing with his hands clasped behind his back especially resembles a figure in a Teniers painting that was in an English private collection to which Turner enjoyed access when he painted this work.

The depiction of hazy dawn sunlight is especially felicitous. Yet the contrast between natural beauty and rough-hewn humanity is not the only opposition here, for the peacefulness of the scene has just been shattered by the firing of the morning gun of a man-of-war in the far distance. The fishermen on the right arguing among themselves must also be adding to the hubbub.

When Turner first drafted his will in 1829 he left two paintings to the National Gallery on condition that they hang alongside specified paintings by Claude le Lorrain. They were *Dido building Carthage; or, the Rise of the Carthaginian Empire* and *The Decline of the Carthaginian Empire*, both of which are discussed below. However, in a second version of his will drawn up in 1831 the artist substituted the present painting for the decline of Carthage picture, probably because he wanted to show the Dutch side of his art rather than two exercises in the Claudian, Italianate manner. Both *Dido* and this work are sunrises (the decline of Carthage is a sunset), and maybe that also had something to do with the substitution, for by 1831 Turner had come to associate sunsets with death. Perhaps he preferred to hang alongside Claude in a wholly upbeat manner.

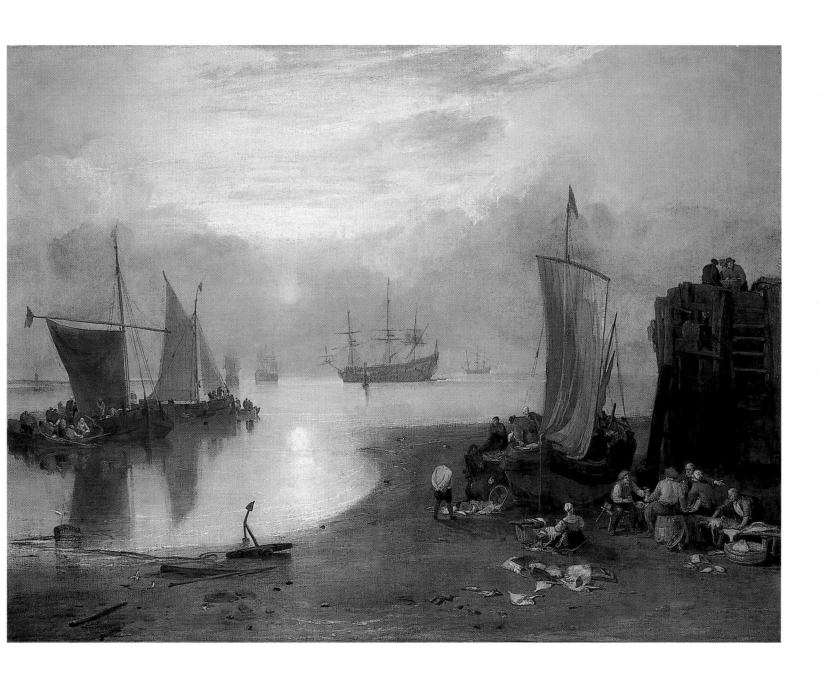

Pope's Villa at Twickenham

1808
Oil on canvas, 91.5 x 120.6 cm
Sudeley Castle, Winchcombe, Gloucestershire.

This painting was exhibited in Turner's gallery in 1808, and bought by Sir John Leicester. The villa of Alexander Pope (1688-1744) was demolished in November 1807 by Lady Howe who had been annoyed both by the constant stream of visitors to the poet's old house, and the smallness of the residence which could not accommodate her large family and busy social life. The demolition caused national outrage, with Lady Howe being called the 'Queen of the Goths'. However, in the days before historic buildings were protected by legislation, nothing could be done to save the property.

We know from a letter Turner wrote in 1811 regarding the engraved reproduction of this picture that he intended the dead tree lying in the foreground to allude to a famous tree that had been planted by Alexander Pope. This was believed to have been the very first member of the species *salix babylonica* or weeping willow ever to have been grown in Britain. (According to a legend known to Turner, Pope had been present at a soirée at Marble Hill House in Twickenham when a box of books from Spain was opened; amid the packing material the poet spied a live twig which he subsequently planted.) The tree was maintained by successive owners of Pope's villa until it died in 1801, whereupon it was bought by an enterprising London jeweller who made a fortune selling pieces of it to admirers of the dead poet.

Only a very rough sketch of this scene exists in a sketchbook (TB XCVI, f.45). However, it does not make evident the time of day or type of weather in which the artist witnessed the demolition. Yet obviously he took his dramatic cue from the fact that the building was demolished during the autumn of 1807. He further complemented the melancholy mood of the scene by portraying it in evening light (for we view the house looking in a north-easterly direction, with the light coming from the west).

All of these factors contribute to the profound sense of Decorum in the work: we behold the dying house of the dead poet, in the dying part of the day and the dying part of the year, with a dead tree that alludes to Pope's own dead willow in the foreground. This attunement of all the contributory pictorial factors towards the central meaning of the image points up the artist's desire to enhance the Theory of Poetic Painting by fully meeting its demand for such appropriateness.

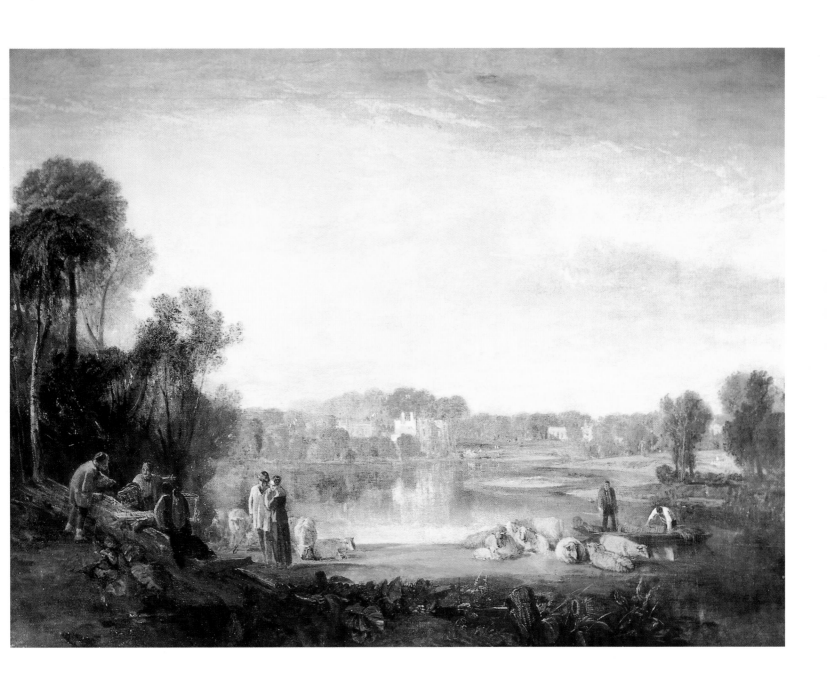

The Fall of an Avalanche in the Grisons

1810

Oil on canvas, 90 x 120 cm

Turner Bequest, Tate Britain, London.

The artist exhibited this work in his own gallery in 1810, and appended the following verses to its title in the catalogue:

The downward sun a parting sadness gleams,
Portenteous lurid thro' the gathering storm;
Thick drifting snow on snow,
Till the vast weight bursts thro' the rocky barrier;
Down at once, its pine clad forests,
And towering glaciers fall, the work of ages
Crashing through all! extinction follows,
And the toil, the hope of man – o'erwhelms.

Although anonymous, these lines were almost certainly written by Turner himself and are not unlike a passage from 'Winter' in James Thomson's poem *The Seasons*. Both in style and sentiment they prefigure verses that the painter would quote in 1812 from his own supposed epic entitled 'Fallacies of Hope' (see *Hannibal and his Army crossing the Alps* below).

Although Turner had visited Switzerland in 1802, he never travelled as far east as the Grisons. It has plausibly been suggested that he obtained the idea for this painting from a newspaper account of an avalanche that occurred in December 1808 at Selva in the Grisons, in which 25 people were killed in one cottage alone. Further inspiration may have derived from two avalanche scenes by de Loutherbourg, although the French-born artist did not represent the plummeting of a vast boulder, but only massive deluges of snow; as Ruskin declared in 1856, 'No one [before Turner] had conceived a stone in flight.'

Turner was at his most expressive here, blocking out the composition with starkly simple shapes and huge slabs of paint, matching form to content by wildly brushing in the sky, using his fingers to blend colours when portraying the centre-distance on the left, and wielding his palette knife with unusual dexterity. In lesser hands this tool usually just smears the paint around, making surfaces look very plastery and weakening form. Turner the marine painter had employed the palette knife for the depiction of white water a good deal during the early-to-mid-1800s, but not always to convincing effect – even he had fallen prey to its pitfalls. But not here. By means of the knife he convincingly modelled large areas of white and grey paint to give us huge cascades of falling snow; later he glazed those areas with yellow ochre before scraping them back to their original colour with the side of the blade to allow the ochre to remain in the runnels and enrich the surface. The staggered path taken by the huge snowfall in the distance is suggested by angular lines incised into the paint with that selfsame edge of the knife.

When Turner created this work he was very busy reading in preparation for the perspective lectures he would start delivering in 1811. One of the books he studied was Charles Alphonse du Fresnoy's *De Arte Graphica* which was appended to his copy of Reynolds's complete works published in 1797. In 1831 he would quote from the following passage by du Fresnoy in connection with the title of one of his paintings but he must have already known the verses by 1810:

White, when it shines with unstain'd lustre clear
May bear an object back or bring it near.
Aided by black, it to the front aspires;
That aid withdrawn, it distantly retires;
But black unmix'd of darkest midnight hue,
Still calls each object nearer to the view.

Turner may have been making that point here as well. The intense blacks on and around the giant boulder force the whites of the avalanche forward optically, onto the same plane as the rock. As a result, the many angular emphases within the faraway cascade prove doubly useful, for they equally suggest both the downwards flight of the boulder and its further descent. That Turner intended this alternative reading is proven by his exact alignment of the avalanche and boulder. The final line of the 1810 verse makes it clear that this snowfall is a man-killer. We are therefore entirely justified in thinking that people are about to die within the cottage being crushed.

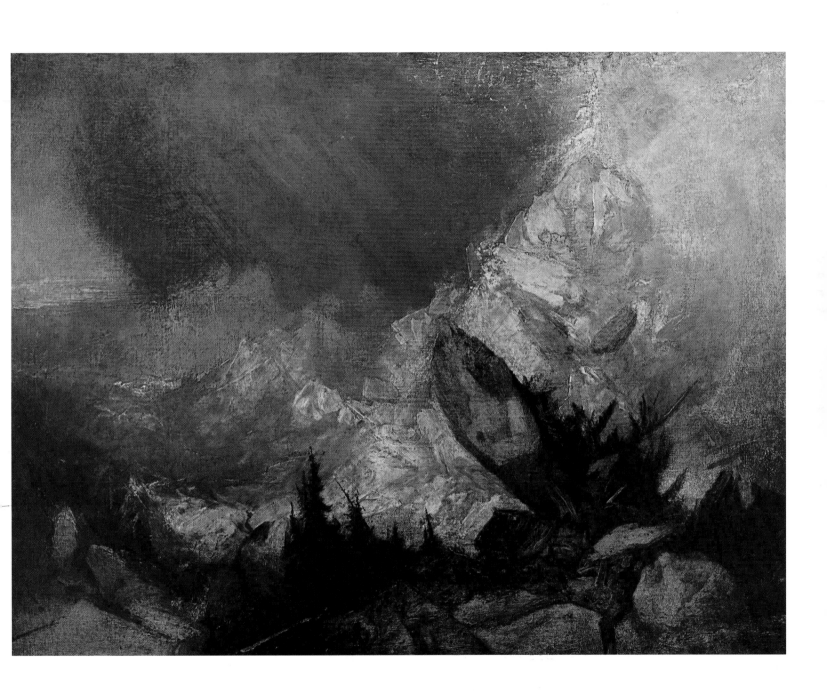

Snow Storm: Hannibal and his Army crossing the Alps

1812

Oil on canvas, 146 x 237.5 cm

Turner Bequest, Tate Britain, London.

A thunderstorm witnessed in Yorkshire in 1810 provided the imaginative spur for this painting (see the introductory essay). When the work was exhibited at the Royal Academy in 1812, its title was accompanied in the exhibition catalogue by the following verses:

> *Craft, treachery, and fraud – Salassian force,*
> *Hung on the fainting rear! then Plunder seiz'd*
> *The victor and the captive, – Saguntum's spoil,*
> *Alike, became their prey; still the chief advanc'd,*
> *Look'd on the sun with hope; – low, broad and wan;*
> *While the fierce archer of the downward year*
> *Stains Italy's blanch'd barrier with storms.*
> *In vain each pass, ensanguin'd deep with dead,*
> *Or rocky fragments, wide destruction roll'd.*
> *Still on Campania's fertile plains – he thought,*
> *But the loud breeze sob'd, 'Capua's joys beware!'*

These verses were the first to have appeared in the Academy catalogue openly from Turner's pen, being notionally drawn from his supposed epic entitled 'Fallacies of Hope', which only appears to have existed in fragments in the Royal Academy catalogues. Naturally the extract casts much light on Turner's thinking in the picture.

The first line introduces the keynote of the work – 'Craft, treachery, and fraud' – and then indirectly tells us that Turner subscribed to the belief that Hannibal had crossed the Alps by the Little Saint-Bernard Pass, for the territory of the Salassi was that part of the upper Val d'Aosta which the painter had visited in 1802. These Salassians are attacking both the Carthaginians and their captives from Saguntum, the Greco-Iberian city whose capture by Hannibal in 219 BC had brought about the second Punic war with Rome. However, Hannibal does not care what is happening to his rearguard. He presses on, hoping to beat the approach of winter and reach the south where he might defeat the Romans.

The wind warns Hannibal to beware of 'Capua's joys'. These will ultimately cause his downfall, for the fifteen years he is to spend luxuriating in Capua will sap his capacity to beat Rome and give the Romans the necessary time in which to regain their strength and defeat him. Ultimately the painting is therefore a comment upon the irony of Hannibal's wasted efforts in crossing the Alps, and the futility of territorial aggrandizement. In the context of the war with Napoleon that was still in full spate when this picture was painted, Turner's moral must have been directed at contemporary French expansionism, as well as at those many members of the British upper classes who put personal pleasure above duty to the state.

On the right is an avalanche; in the foreground the Salassi pick off stragglers and pitch boulders onto the Carthaginians. In the sky the sun is masked by the storm-clouds. This effect is both naturalistic and metaphorical, for the clouds double as 'clouds of war' bringing a human darkness to Italy. Such a metaphor is commonly encountered in poetry, as Turner was well aware, for he often used it pictorially.

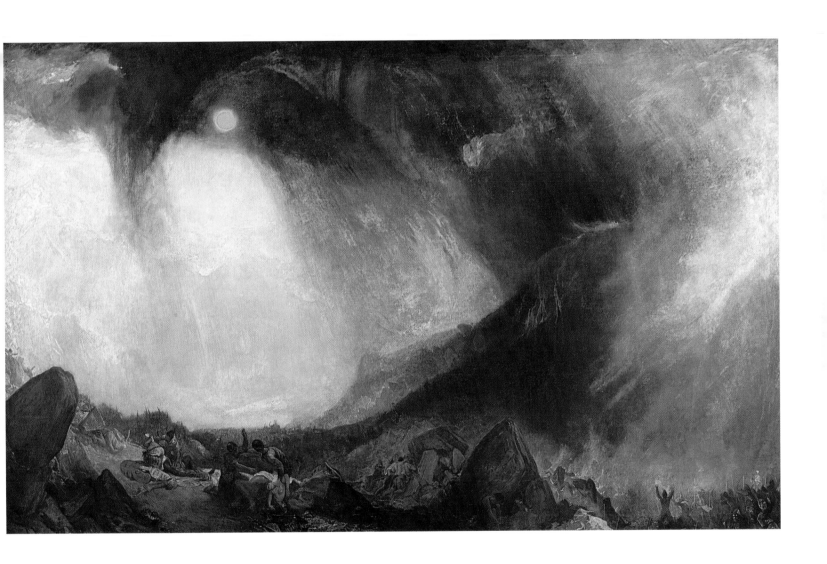

Mer de Glace, in the Valley of Chamouni, Switzerland

c.1814
Watercolour and scratching-out, 68.5 x 101.5 cm
Yale Center for British Art, New Haven, Conn.

Until recently this work was thought to date from 1803, quite simply because its title had long been confused with that of another representation of the Mer de Glace in watercolour exhibited at the Royal Academy in 1803. However, research by the present writer has disproved that assumption, thus permitting a re-dating of the image that is more commensurate with its appearance stylistically (see Shanes 2000). The drawing of the shattered firs on the left, especially, suggests a dating of around 1814, when Turner began investing his arboreal forms with an increased degree of sinuousness in their trunks and branches, and a superior degree of spatial complexity in their leafage. The artist's great patron, Walter Fawkes, exhibited the watercolour in the exhibition he held in his London residence in 1819, and it was again put before Turner's public in Leeds in 1839. The design was possibly based on a very rough black chalk drawing dating from 1802 (TB LXXIX-L).

Judging by his title, it appears Turner had forgotten that the area depicted lies entirely within French Savoy. Beyond the base of the leftmost tree in the foreground may be seen the source of the river Arveyron. The goatherder emphasizes the solitariness of the mountains, while the snake sunning itself exemplifies the danger that lurks within such high places.

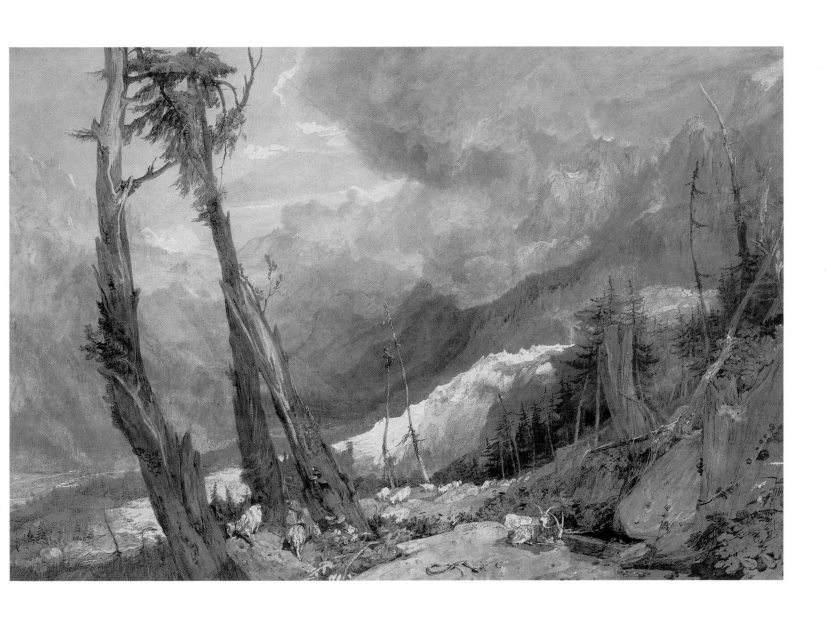

Crossing the Brook

1815
Oil on canvas, 193 x 165 cm
Turner Bequest, Tate Britain, London.

Turner was familiar with at least two images by Claude le Lorrain that compositionally look very like the present work, which was exhibited at the Royal Academy in 1815. It is likely that one of those Claudes – the *Landscape with the Rest on the Flight into Egypt* now in the Cleveland Museum of Art but which Turner most likely knew from its mezzotint reproduction – inspired the layout of this painting. The desire to populate it with a girl crossing a brook may have been influenced by more recent artists, namely de Loutherbourg, Henry Thomson RA (1773-1843) and Sir Joshua Reynolds. Each of them had painted pictures showing girls crossing brooks, and Turner was definitely acquainted with at least two of those works (moreover, the de Loutherbourg and the Reynolds depict girls accompanied by animals, which is what we also see here).

One of Turner's friends identified the girl on the left of this canvas as the painter's daughter, Evelina (but as we have seen in the introductory essay, she may instead have been his half-sister). Evelina would have been about fourteen when the work was created. It has been suggested that the picture is an allegory of female puberty:

> *Knowing the way [Turner's] fancy worked, we may take Evelina's brook-crossing to symbolize her arrival at womanhood. Another girl (Georgiana) remains on the bank: Evelina steps into the flowing waters and crosses into the new life of maturity. (Lindsay, 1966, p.152)*

As Georgiana would only have been about four years of age when this work was painted, she cannot have been the model for the girl sitting on the right bank. However, many of the other pictorial details support this interpretation. Thus on the right is a deeply shadowed and necessarily mysterious opening, which could be a grotto. If that is the case, then it would be the only such structure Turner ever painted. As he was certainly aware, ever since ancient times grottos have been regarded as sacred well-springs and sources of life, so it may be that the cavern was here intended to suggest just such a place of origins. Because its mouth closely resembles a dilated aperture, of the type from which we all issue, it fulfils that aim admirably.

To the left of the opening a girl sits with a white cloth across her lap, and a large white bag and red, stoppered bottle next to her; the pure tones and blood-coloured but sealed bottle may allude to a pre-menstrual state. Mid-stream is a dog which, Lindsay further suggests, is a reminder of 'the animal life of Evelina'. This interpretation receives support immediately above the dog, for the cleft in a boulder suggests the female sexual cleft. Next is the girl who has almost crossed the brook. Under her arm perches a large, red bag which, by terminating at her lap, may allude to the womb. Inexplicably, between her legs on the water a reflection that has no visible cause is red in colour and phallic in shape. Just as the other girl sits, so this girl stands, a difference that could signify growth. Further associations of progression are engendered by the placing of the distant bridge beyond the girl who has crossed the brook. And finally we arrive at the tall trees on the left. These are undoubtedly the most graceful and florescent arboreal forms Turner had created to date in oils. Because their beauteous unfolding certainly expresses burgeoning natural forces, they could easily have been intended to amplify any human development beneath them.

We know from an 1845 letter referring to this very canvas that Turner thought of life as a brook to be waded. It therefore seems very possible that he here expressed his awareness of the organic existence that humankind shares with the rest of the natural world. And why not? For an artist who had openly avowed his allegiance to the Theory of Poetic Painting by the time he had painted this picture, there could surely be no better way of uniting the representation of landscape with some universal aspect of human experience, given that sexual development necessarily lies at the very core of our existence.

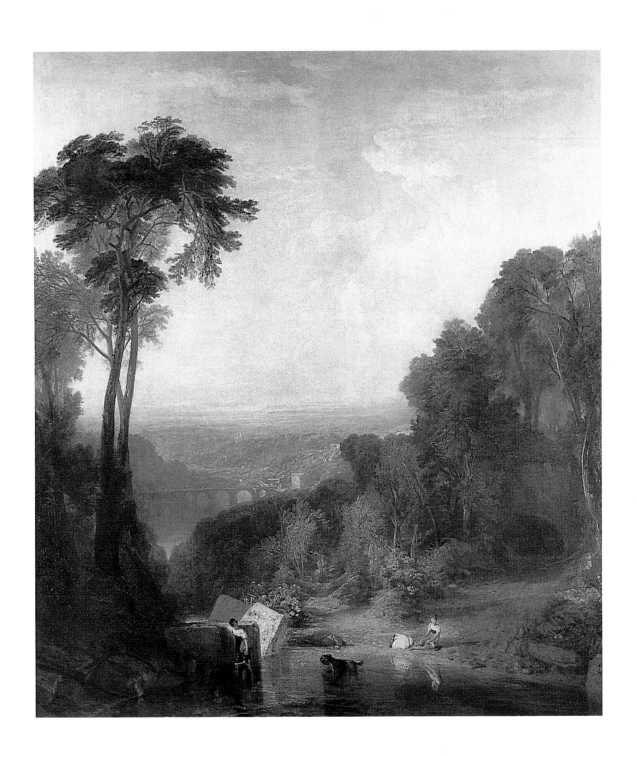

Dido building Carthage; or, the Rise of the Carthaginian Empire

1815

Oil on canvas, 155.5 x 232 cm

Turner Bequest, National Gallery, London.

Turner also exhibited this painting at the Royal Academy in 1815. Just as *Crossing the Brook* pays homage to Claude the landscapist, so this work follows Claude the painter of seaport scenes. Although Turner had toyed with the idea of painting such a picture around 1806, not until much later was he ready to do so, with this canvas. He considered it to be his masterpiece and for a time requested that he should be buried rolled up in it when he died (see the introductory essay). To that end he never sold it but eventually bequeathed it to the National Gallery to hang in perpetuity alongside Claude's *Embarkation of the Queen of Sheba*, which was surely the canvas he had wept in front of years earlier because he thought he would 'never be able to paint anything like that picture.'

Queen Dido had fled from Tyre with the remains of her dead husband, Sychaeus, who had been murdered by her brother. On the shores of North Africa she founded a new city. Her husband's tomb is on the right, with a *cloaca* or drain conduit beneath it. In ancient times the construction of proper sewers had symbolized the future greatness and longevity of cities, as Turner undoubtedly knew. Near the tomb is a dead tree, while from it grows a sapling, indicating the growth of Carthage from the death of Sychaeus. Further off is the stately grove of trees that stood in the centre of Carthage, according to Virgil's *Aeneid* (from which Turner derived this subject).

On the left are Queen Dido and a retinue of architects, builders and masons planning the new city which arises beyond them. In front of the queen, wearing a dark cloak and helmet but separated from her by a slab of masonry, is the only man standing in her presence. Almost certainly he is Aeneas, for at the point in Virgil's poem that inspired this painting the Trojan prince tours the rising Carthage but has yet to meet its queen; perhaps the block that lies between them signifies their lack of acquaintance. The two masts that are vertically aligned with Dido and the man in military garb furthers the identification of the two as the major protagonists of the scene, for the masts dominate the harbour just as Dido and Aeneas rank above everyone in it.

In front of this group some boys playing with toy boats are watched by two nubile girls. These lads and lasses may respectively personify power and generation, for the youths now playing with toy boats will surely soon sail the real vessels that will spread Carthaginian hegemony in the Mediterranean, just as the maidens will doubtless provide them with the children that will later maintain that dominance. And in keeping with the fact that the city is rising, the sun also rises; such a dramatic match is another observance of the Decorum that Turner derived from the Theory of Poetic Painting and frequently pictorialised.

On the left everything teems with life and energy; on the right all is deserted and still, a contrast that augments the dramatic power of the image. The picture is underpinned by an implied linear structure of taut, crossing horizontals, verticals and diagonals not unlike that of the basic layout of the Union Jack. Such straight lines impart an entirely appropriate tension and strength to the view of a growing city.

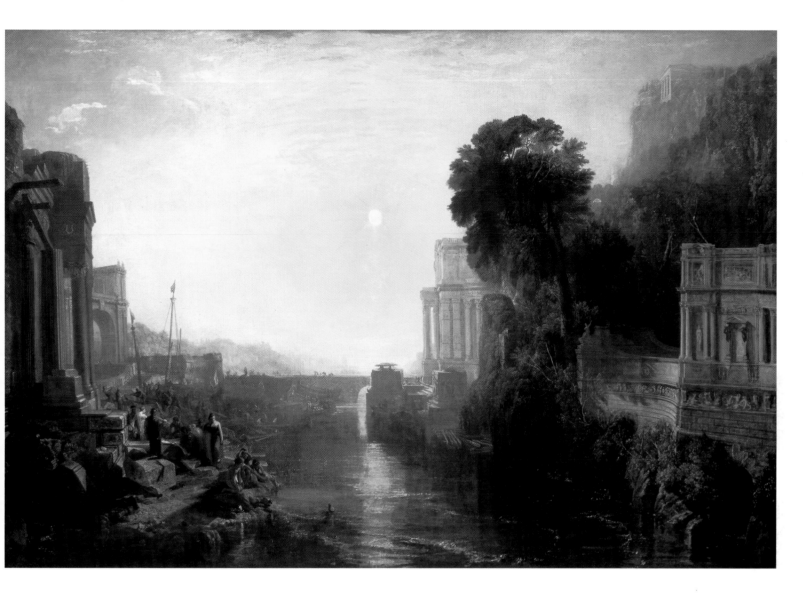

The Decline of the Carthaginian Empire – Rome being determined on the Overthrow of her Hated Rival, demanded from her such Terms as might either force her into War, or ruin her by Compliance: the Enervated Carthaginians, in their Anxiety for Peace, consented to give up even their Arms and their Children.

1817
Oil on canvas, 170 x 238.5 cm
Turner Bequest, Tate Britain, London.

Although this painting was exhibited at the Royal Academy in 1817, it forms a pendant to the *Dido building Carthage* displayed there two years earlier. Its title was further lengthened in the Academy catalogue by lines from Turner's 'Fallacies of Hope':

> *At Hope's delusive smile,*
> *The chieftain's safety and the mother's pride,*
> *Were to th'insidious conqu'ror's grasp resign'd;*
> *While o'er the western wave th'ensanguined sun,*
> *In gathering haze a stormy signal spread,*
> *And set portentous.*

Here Turner depicted the moment between the second and third Punic wars when the Carthaginians, enfeebled by fifty years of peace, no longer had the will or military strength to stand up to the Romans; instead, they handed over 300 of their children as hostages. Grieving mothers aptly dot the scene. Luxury goods – including a garlanded painter's mahlstick – litter the foreground and advance the associations of materialism, the cause of Carthaginian enervation.

As in *Dido building Carthage*, the underlying compositional structure matches the central dramatic point of the image. The earlier painting is underpinned by straight lines whose tautness projects the strength of Carthage. Here, however, feelings of muddle and slackness are respectively projected by the alignment of all the buildings in different directions, and by the flaccidity imparted to the entire image by the multitude of circles, semi-circles and ellipses formed by those structures.

In the distance the sun sets 'portentous' on Carthaginian power. According to Ruskin, the sky was originally much redder than it is today, and thus introduced even more powerful and wholly appropriate associations of blood and death.

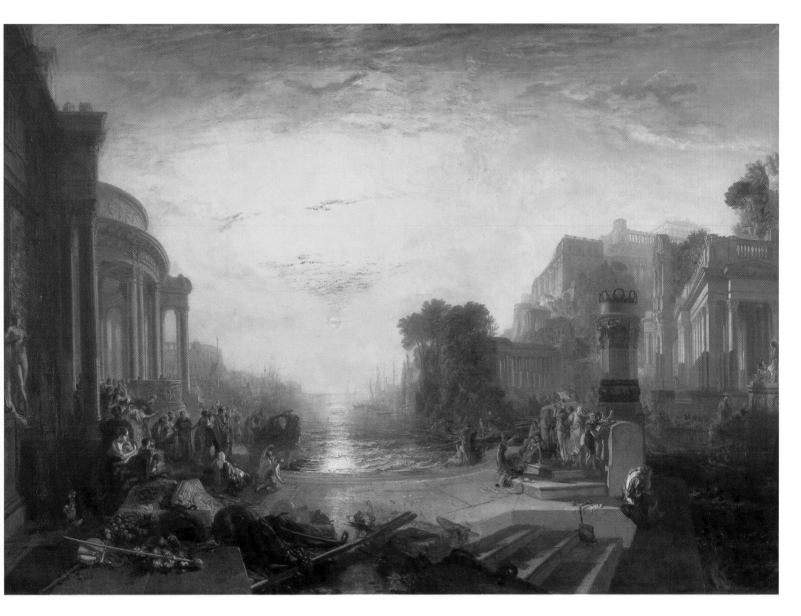

Mount Vesuvius in Eruption

1817
Watercolour on white paper, 28.6 x 39.7 cm
Yale Center for British Art, New Haven, Conn..

The inscription 'Mount Vesuvius in Eruption JMW Turner RA 1817' appears on the back of this drawing, which was made about two years before the artist ever visited Italy. It is not known who supplied him with the topographical material upon which he based the design. However, there can be no doubt that he determined the correct geographical direction in which we are looking when he elaborated the image, for on the left the moon lit down its left-hand edge – and thus viewed before dawn – is correctly located in the east, just where we should expect to see it prior to daybreak in relationship to Vesuvius.

This is undoubtedly the most explosive conflagration Turner ever created in watercolour, and surely one of the most incandescent scenes ever painted or drawn by anyone. Turner may have been acquainted with one or more of the portrayals of Vesuvius erupting by Joseph Wright of Derby but he far outdid his predecessor in terms of the brilliance of the light, the dynamic showerings of magma falling through the sky and the rhythmic movement of the clouds. On the left is a fine example of the way Turner characteristically thought through the implications of natural behaviour, for between the volcano and Naples the lower part of the sky is filled with a thin haze of dust. Many of the crazed patternings of molten rock and lightning distributed across the top of the image were created by dragging semi-dry crimson pigment over areas that had been previously masked with stopping-out varnish, the fluid that protects the paper from over-painting and is subsequently removed. This use of stopping-out explains why the discharges of fire, magma, rock and electricity enjoy such crisp edges and innumerable highlights.

The curves of the hull and the semi-circular sails of the boat surmounting a wave at the lower-right reinforce similar curves made by palls of smoke issuing from the side of Vesuvius, by the larger sweep of clouds to the right of the volcano's summit, and by the long circular lines of fire and magma streaming from its mouth. On the Bay of Naples in the centre the red glare does not mirror any reds ranged directly above it, while the brilliance of the white reflection is greatly heightened by the placement of a dark accent against it. Turner would again use this device in an 1827 view of Mortlake Terrace that is discussed below.

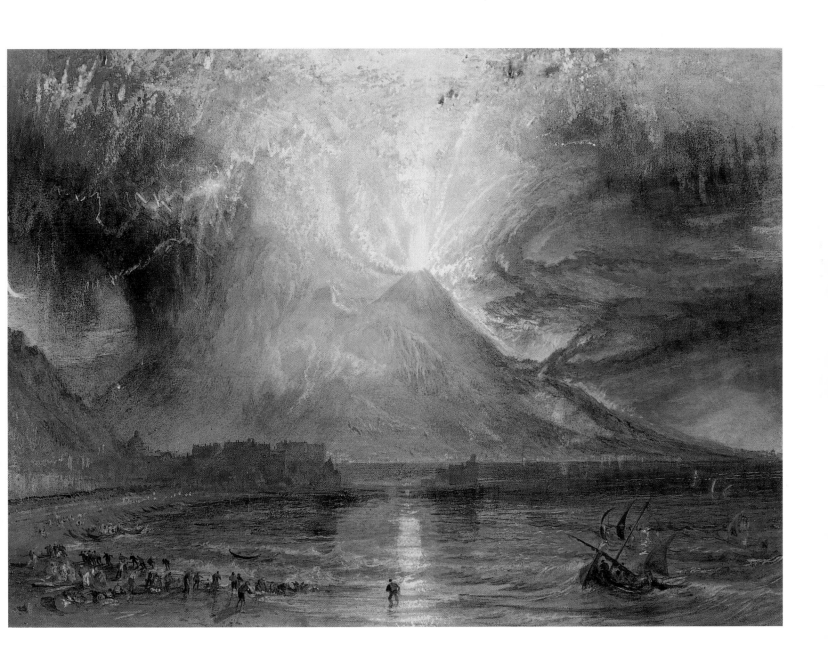

Crook of Lune, looking towards Hornby Castle

c.1817
Watercolour on white paper, 28 x 41.7 cm
Courtauld Institute of Art, University of London.

Turner made this watercolour for line-engraved reproduction in the 'History of Richmondshire'. This ambitious part-work was written by the Rev. Thomas Dunham Whitaker, a Lancashire cleric, antiquarian and tree-planter. Although 120 watercolours were commissioned from the artist, only twenty-one were made before the scheme was cancelled for lack of public support.

About four miles upstream from Lancaster the river Lune winds back on itself, and here we view that 'crook' looking northwards in evening light. In the far distance, near the top-right, is Ingleborough hill (2373 ft/723 m). Slightly nearer and directly opposite our viewpoint is Hornby Castle, which Turner also represented in two other 'Richmondshire' series images. Our eye is led to the building by the vertical alignment of the gentle V-shape formed by the sides of the lane in the foreground, in which a man wielding a pick is standing; by a man on a horse riding along the Lancaster road beyond him; and by a group of feeding cattle on the opposite bank of the Lune.

The opposed shallow diagonals of the nearby lane pull the eye into the scene, while the shape of the roadway is amplified by more steeply-angled diagonals near the left and right-hand edges of the image. The twisted shape of a branch at the lower-right reiterates the 'crook' of the river, and thus reinforces our awareness of that bend. Just above the branch, the overall horizontality of the scene is usefully broken by some saplings whose budding sense of organic growth is not only expressive of their own inner life but typifies the ideal beauty of the landscape more generally.

The Field of Waterloo

1818
Oil on canvas, 147.5 x 239 cm
Turner Bequest, Tate Britain, London.

Often Turner is cited as a proto-modernist because of his use of light and colour, but he anticipated the future in moral terms as well, for the highly negative, anti-war stance of this painting strongly anticipates the attitudes of a much later age. When the canvas first went on view at the Royal Academy in 1818, Turner appended lines 28 to 36 from the Third Canto of Byron's *Childe Harold's Pilgrimage* to its title in the exhibition catalogue:

> *Last noon beheld them full of lusty life;*
> *Last eve in Beauty's circle proudly gay;*
> *The midnight brought the signal – sound of strife;*
> *The morn the marshalling of arms – the day,*
> *Battle's magnificently stern array!*
> *The thunder clouds close o'er it, which when rent,*
> *The earth is covered thick with other clay*
> *Which her own clay shall cover, heaped and pent,*
> *Rider and horse – friend, foe, in one red burial blent!*

Turner may have been stimulated to paint this picture by his attendance at a meeting of the Royal Academy Club on 7 February 1816 in which proposals to commemorate the battles of Waterloo and Trafalgar were discussed. Another stimulus may have been the competition held by the British Institution in 1816 for a 'Grand Historical Painting' to celebrate the defeat of Napoleon by Wellington and Blücher at Waterloo on 18 June 1815. Turner certainly made the site of the recent battle virtually his first stopping place on his 1817 Continental tour, probably riding all over the Waterloo area on a hired horse, and creating a large number of pencil drawings. Many of these were annotated with details of the participants in the battle, their relationship to particular positions, and the numbers of casualties. Obviously such tragic multitudes worked their way into his psyche, for instead of depicting glorious feats of arms and the like (as painters entering the competition had done), he gave us a scene of utter carnage.

From foreground to distant horizon the entire battlefield is littered with corpses. The only live occupants of the vista are three women looking for their menfolk; one of them holds a baby and has fainted, obviously because she has just found her man. Burning fiercely on the right is the Chateau of Hougoumont, a pivotal position in the battle. In the far distance a rocket illumines the scene, as happened on the night following the battle, when rockets were often fired to prevent the pillaging of the dead.

The cool colouring of the distant rocket contrasts subtly with the warm hues of the flare being held aloft by one of the women. Clearly this polarity shows the influence of Rembrandt, from whose *Holy Family resting on the Flight into Egypt* Turner had first assimilated the effect and many of whose paintings he had recently seen in the Riksmuseum in Amsterdam when he created this canvas.

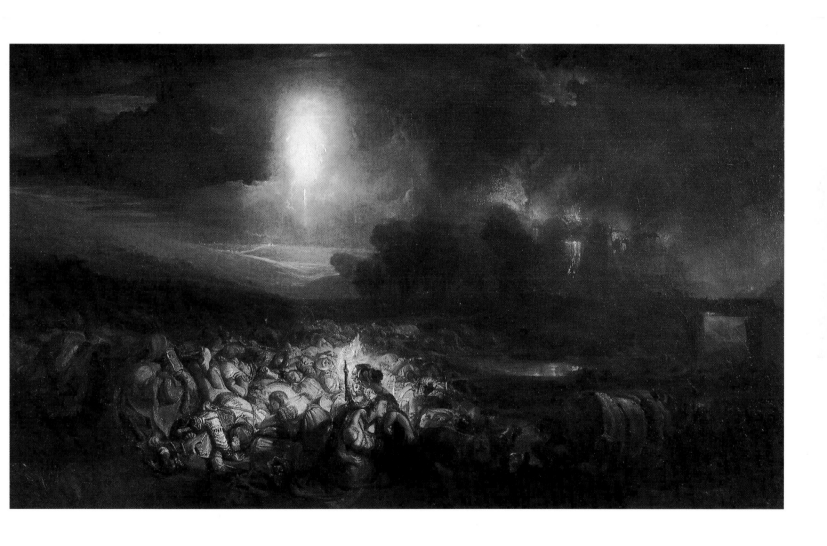

Dort, or Dordrecht, the Dort Packet-Boat
from Rotterdam becalmed

1818
Oil on canvas, 157.5 x 233 cm
Yale Center for British Art, New Haven, Conn..

Like *The Field of Waterloo*, this work was also exhibited at the Royal Academy in 1818. If Turner paid homage to Rembrandt in the war pic-ture, in this complementary scene of absolute peacefulness he extended the sincerest form of stylistic flattery to another of his favourite Dutch painters, Aelbert Cuyp (1620-91), who hailed from Dordrecht. As the Englishman had stated in one of his perspective lectures, he especially prized the Dutchman's ability '...to blend minutiae in all the colour of ambient vapour', and he certainly put what he valued into practice here. In order to do so, he might well have drawn upon a number of similar views of Dordrecht by Cuyp that were then in English private collections to which he enjoyed access.

We look southwards in dawn light, from the river leading to Rotterdam, De Noord, near its confluence with the Oude Maas and Merwede rivers. In the centre-distance may be seen the Groote Kerk at Dordrecht. Successive Rotterdam-Dordrecht packet boats or ferries were named *De Zwann* ('The Swan'). At its masthead the nearby, becalmed packet boat from Rotterdam therefore flies a flag bearing the like-ness of such a bird. Cuyp had similarly represented a swan-flag on a portrayal of a Dordrecht packet boat, and those flags had probably been flown on the vessels since long before the Dutchman's time. Turner has also represented a carved swan at the head of the boat's tiller. The large area of reeds on the right called the Biesboch or Buitenland was only roughly sketched by Turner when he visited Dordrecht in 1817, so memory evidently played a large part in its detailed elaboration here. A boat has just emerged from a waterway run-ning through the reeds, and another is about to do so. The painting is signed on a log at the bottom-right but a second, more surrep-titious signature may be contained in the Mallard duck skittering across the Noord, for it could visually pun upon the second of Turner's forenames, Mallord. (In an undated letter to his friend Augustus Wall Callcott, the artist once replaced the Mallord in his full signature with a sketch of a Mallard, so we know he visually punned in this way.) To the left of the solitary bird floats a cabbage, a vegetable Turner had noted on page 92 of the *Dort* sketchbook from whose pages he developed this painting. Clearly the vegetable has a bearing on the representation of a vessel that often carried such produce to market. On the small, nearest boat a girl scoops water from the river; possi-bly she intends to sell it to passengers on the ferry, and therefore hides her action from their sight. Like her, the other people in the boat wear the 'shovel' hats Turner had witnessed around Dordrecht.

The flatness of much of the Lowlands always serves to emphasize the immensity of the sky. Obviously Turner responded to such vast-ness, judging by this painting and several of his other Dutch scenes in which the pictorial compositions are greatly dominated by their skies. It has been suggested that the 'becalmed' in the title of this 1818 picture alluded to the extreme slowness with which Callcott was still painting a view of Rotterdam that had been commissioned some two years earlier. The Noord is absolutely calm and serene, as is the sky with its pristine light and idyllic cloud formations, all of which compares very well with the 'ambient vapour' of Cuyp.

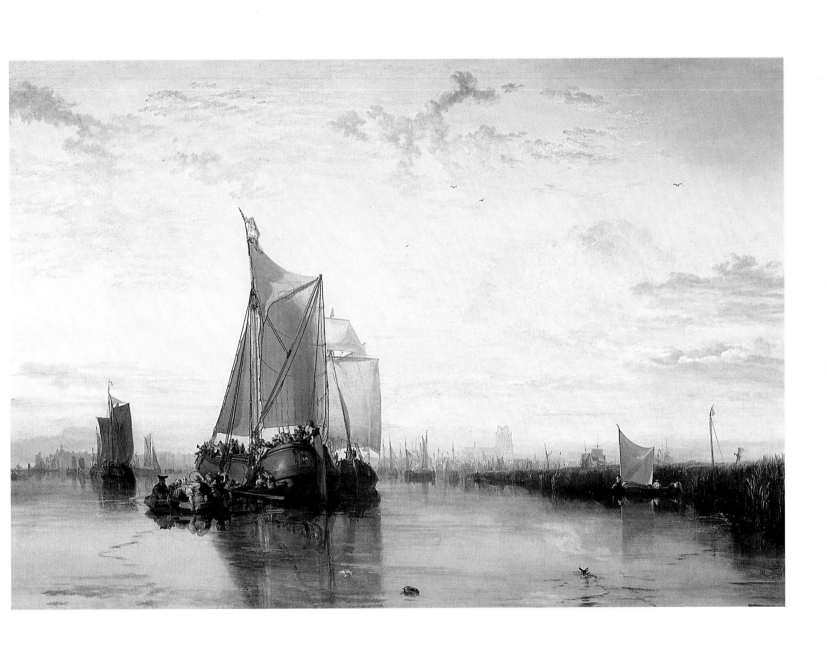

First-Rate, taking in stores

1818
Watercolour on white paper, 28.6 x 39.7 cm
Cecil Higgins Art Gallery, Bedford.

In Turner's day warships were rated according to the number of guns they carried; a 'First-Rate' was a ship of the line of battle armed with more than 110 cannons.

Turner made this watercolour for his great patron and friend Walter Fawkes. According to an account handed down in the latter's family, the work came into being after the painter was told one day at breakfast 'I want you to make me a drawing of the ordinary dimensions that will give some idea of the size of a man of war'. Turner accordingly set to work, and by lunchtime carried down this drawing in triumph. As breakfast might well have been served at about 7 a.m. and lunch as late as 4 p.m., the artist must have made the work within a maximum period of nine hours.

Because we view the man-of-war from such a low level and only see part of it – thus being forced to imagine the rest – it towers over us and seems enormous. Judging by the seamen leaning out from its lowest line of gun-ports, Turner has made those apertures about 9 feet (3 metres) in height, whereas in reality they would only have been a third that size in order to prevent the entry of enemy projectiles. As the eye ascends, the upper lines of gun-ports greatly diminish in size and thus subtly augment the scale of the ship. Distance makes two other men-of-war look small by comparison with the First-Rate, thereby boosting its size further. The faraway ships are softly outlined, and one of them glistens in the moist air. Turner vividly conveys their vast, lumbering bulk as they drift at anchor. Next to the First-Rate some small boats offload stores. One of them flies a Dutch flag. This detail tells us that the world is at peace, for British men-of-war had been unable to sail into Dutch waters during the Napoleonic wars, which finally ended just over three years before this drawing was made.

Turner created a companion watercolour for the present work and probably did so while he was waiting for the latter to dry. The pendant shows a merchantman sinking in tempestuous waters, with great loss of life. By complementing this view of a warship at peace with a portrayal of a ship dedicated to peaceful pursuits warring with the elements, Turner created characteristic moral and dramatic contrasts.

In the white water can be witnessed extensive use of stopping-out varnish, the masking fluid that is painted on and worked over before being rubbed off to reveal the virgin paper beneath. Highlights were also sparingly added with gouache or scratched out with Turner's thumbnail, which he kept especially sharpened for the purpose.

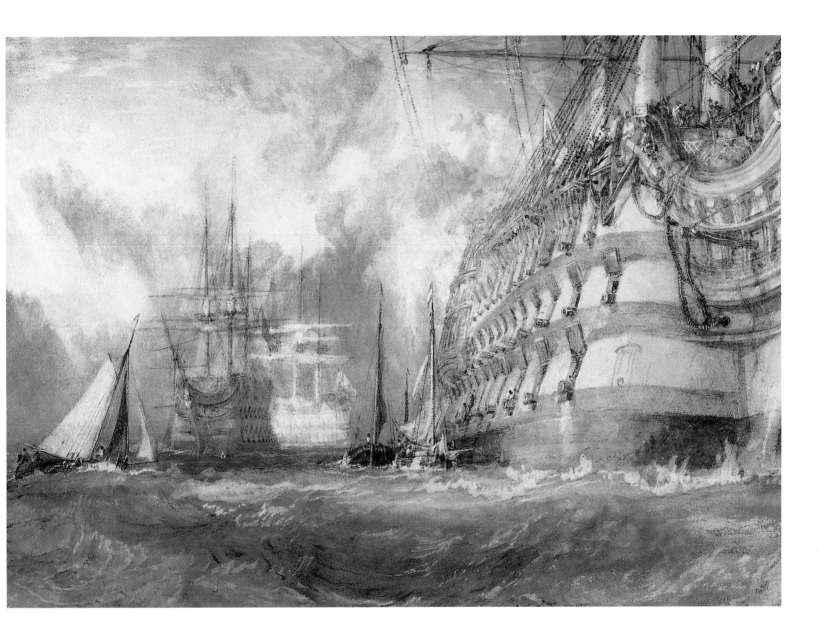

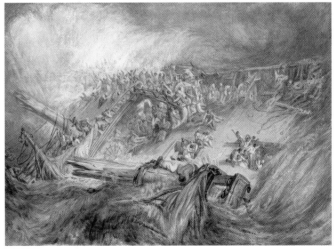

Loss of an East Indiaman, c. 1818, Watercolour, 28 x 39.5 cm
Cecil Higgins Art Gallery, Bedford, U.K.

England: Richmond Hill on the Prince Regent's Birthday

1819
Oil on canvas, 180 x 334.5 cm
Turner Bequest, Tate Britain, London.

Turner had known the vista from Richmond Hill ever since boyhood, and he made many watercolour depictions of the view both before and after creating this painting, which he exhibited at the Royal Academy in 1819. In the catalogue its title was accompanied by the following lines drawn from 'Summer' in James Thomson's poem *The Seasons*:

> *Which way, Amanda, shall we bend our course?*
> *The choice perplexes. Wherefore should we chuse?*
> *All is the same with thee. Say, shall we wind*
> *Along the streams? or walk the smiling mead?*
> *Or court the forest glades? or wander wild*
> *Among the waving harvests? or ascend,*
> *While radiant Summer opens all its pride,*
> *Thy hill, delightful Shene?*

In Turner's day these verses were inscribed on a board affixed to a tree standing at the summit of Richmond Hill.

It has been demonstrated that this painting portrays a garden party given on Tuesday, 12 August 1817 in private grounds on Richmond Hill by the Dowager Countess of Cardigan to celebrate the Prince Regent's birthday (see Golt 1987). Turner could not have been present at the party as he had sailed for the Continent two days earlier. However, preparations had involved large numbers of people for several weeks beforehand both in Richmond and the adjacent Twickenham (where Sandycombe Lodge is located), and naturally the newspapers reported the event in great detail. Turner could therefore have easily heard of the soirée in advance, or learned of it after returning from abroad. Given that by 1817-19 he had created Greek, Carthaginian and Roman scenes, he would certainly have encountered no problems in reconstructing far more recent occurrences on his own doorstep.

The Prince Regent attended the 1817 party, as did other members of the Royal Family and the Lord Mayor of London. Although none of those dignitaries are visible, the Lord Mayor's barge is discernible on the Thames. Turner's own indirect presence in the landscape is indicated far above the discarded drum in the right-foreground, for the top of a cypress tree just intersects with the horizon at the exact point at which Sandycombe Lodge is located.

In the centre some people seem to be gossiping about a woman who stands staring out at us. She may allude to the estranged wife of the Prince Regent, Princess Caroline, who was the subject of much gossip in the late 1810s. On the right a man in military uniform greatly resembles the Duke of Wellington. This identification is supported by the placement of some 'petararoes' or small cannon near the man. At the 1817 garden party such guns were fired in honour of the Prince of Wales. Also present are retainers in court dress and a soldier drumming up interest in an army recruitment drive. Artistic associations are introduced by a cello and a portfolio respectively waiting to be used or perused.

The landscape enjoys an obvious link with Claude, while the elongated necks of a great many women viewed from behind are reminiscent of similar forms encountered frequently in the works of Watteau and Fuseli. The connection with Watteau is particularly appropriate, for the French painter had often projected an earthly paradise, and that appears to be Turner's intention here too. The inner, organic life of trees is expressed especially well in this painting, and they are surely the arboreal equivalent of the perfected human forms of, say, Praxiteles or Michelangelo.

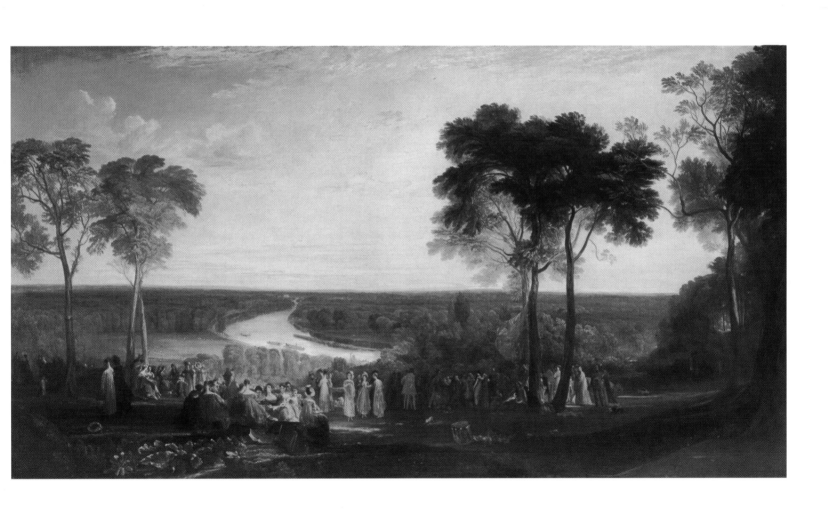

MARXBOURG and BRUGBERG on the RHINE

1820
Watercolour on white paper, 29.1 x 45.8 cm
British Museum, London.

The title given above, with its mixed upper and lower case spelling, was inscribed by Turner on the drawing itself. He also dated the work. His gallic 'Marxbourg' is Marksburg Castle, seen in the distance, while his 'Brugberg' is Braubach, the village located at its foot. These are situated just below the junction of the Rhine and Lahn rivers, about seven miles (11.2 km) south of Coblenz. Turner had visited the spot on his Rhineland tour of 1817. He then made a watercolour on grey paper (reproduced opposite) from which he later developed this drawing for a member of the Swinburne family.

The artist was at his most imaginative and idealistic here. We view the scene in evening light. On the right two young people taking a break are being chided by a harvester for their relative idleness. Beyond them the Rhine can just be made out across a much wider expanse of fields than existed in reality. And this is not the only liberty Turner has taken with the scale of things here, for in actuality Marksburg Castle is much smaller than depicted. Moreover, the vast mountain ranges visible beyond the castle look nothing like the low, gently rolling hills that surround it in reality. Similarly, the rather small hillside on the left has been transformed into a sheer rockface; rather like the man-of-war in *First-Rate, taking in stores*, its disappearance beyond the top of the image makes it seem almost boundless in scale.

The spatiality of the vista is subtly reinforced by the nearby ash trees, some of whose crests also rise beyond the top of the sheet and thus appear to be equally without limits. Judging by the size of the foreground figures, the trunks of these trees below their first branchings are each about 26 feet (eight metres) in height, which would make their total height gigantic. But Turner was not concerned with the truth of the eye here. Instead, he preferred the truth of the imagination, enlarging the landscape and all its constituent elements so as to imbue the scene with the utmost grandeur, and investing all of his elegantly sinuous trees with a vital sense of flowering. By such means he transports us to a world that is infinitely more beautiful than anything apprehensible in reality.

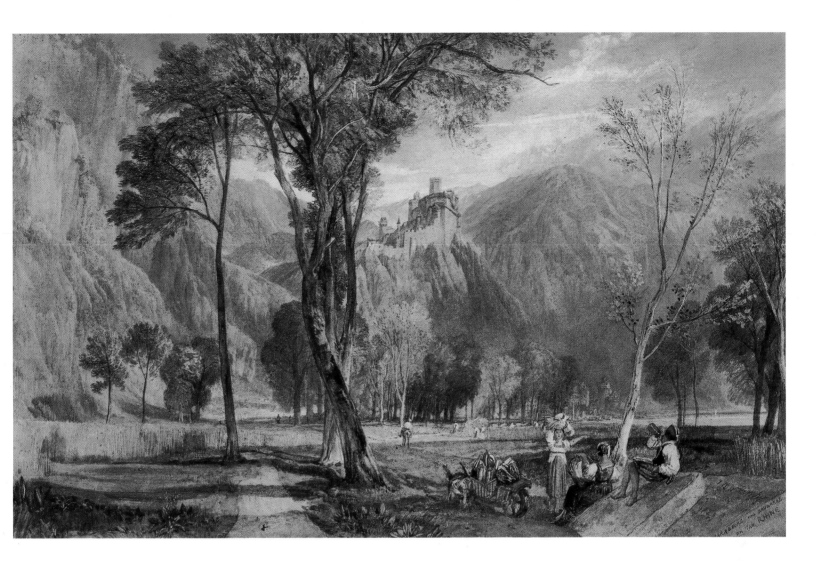

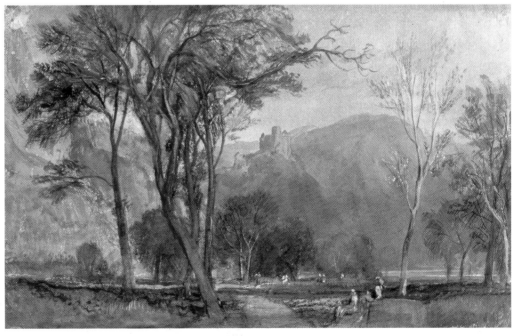

Marksburg, 1817, Watercolour on white paper prepared with a grey wash,
20 x 31.9 cm, Indianapolis Museum of Art.

More Park, near Watford, on the River Colne

1822
Watercolour on white paper, 15.7 x 22.1 cm
Turner Bequest, Tate Britain, London.

This small watercolour is one of seventeen or more designs that were made after 1822 for the engraver W.B. Cooke to reproduce in mezzotint. The prints were published between 1823 and 1825 under the title of 'The Rivers of England'. Turner elaborated the image from a pencil drawing on f. 51 of the *River* sketchbook (TB XCVI) which was in use around 1807.

Moor Park is located to the north-west of London, and its enclosure was sanctioned by King Henry VI in 1426. The house, which was designed by George Nevil, dates from the time of King Edward IV (1461-83), and was once occupied by Cardinal Wolsey. The 500-acre estate was renowned in Turner's day, having been landscaped in the eighteenth-century by James Thornhill and Capability Brown. The mansion now hosts a golf club.

The river that is nominally depicted in this design, the Colne, is barely visible, for it runs at a lower level than the Grand Union Canal, which is the body of water crossing the foreground to the right. (The Colne itself can be made out distantly below the cattle on the left, and meandering beyond Lot Mead lock in the centre.) A series of shallow V shapes lead the eye from the lock gates to the distant house. Evidently it has just rained in the distance, although not in the foreground, judging by the fisherman lying on the ground at the left. As a result of the downpour, the forms of all the faraway trees are still slightly blurred by atmospheric moisture, whereas the trees on the extreme right and the dock leaves in the foreground are all crystal clear. (This effect also appears in other watercolours in the 'Rivers of England' series.) The cool colouring adds to the sense of dampness, while the immobile figures augment the mood of utter repose. In the distance the low Hertfordshire hills look more like the Yorkshire moors, a typical Turnerian enhancement that invests the scene with considerable grandeur.

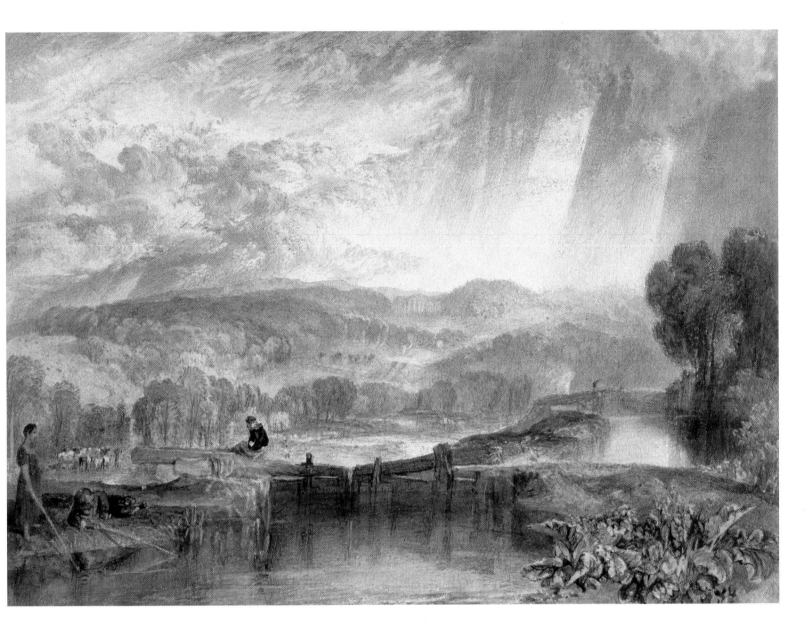

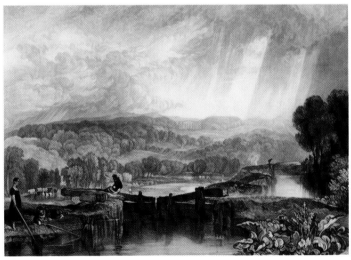

Charles Turner after J.M.W. Turner, *More Park, near Watford, on the River Colne*, mezzotint engraving, 1824, Tate Britain, London.

Dover Castle

December 1822
Watercolour on white paper, 43.2 x 62.9 cm
Museum of Fine Arts, Boston, Mass.

The coming of the age of Steam is the underlying theme of this magnificent drawing. At the mouth of Dover harbour a number of vessels are finding it difficult to enter port because of the prevailing westerly wind whose direction is indicated by several flags. To avoid being blown out to sea these boats are therefore reducing sail, although because there is insufficient room to tack, the craft on the right will either have to wait for the tide to turn or row into harbour. But a newfangled paddle steamer is able to ignore all these problems and simply cut through the wind. On the north pier seated figures wave excitedly at the approaching ship, while two boys with a dog run away from the steamer and thereby reinforce its sense of movement towards the harbour.

Cross-channel steamers were extremely topical when this drawing was made in December 1822. Although the *Margery* had been the first such vessel to make the journey to France in 1816, the *Rob Roy* had pioneered regular, scheduled crossings as recently as 1821. The steamer depicted by Turner had originally been built as a sailing vessel, for she has a beak-head prow and a sailing hull. Just beyond her is a wrecked brig whose juxtaposition with the steamer subtly reminds us of the virtues of replacing wind-propulsion with the new technology. The foremast and funnel of the steamer are aligned with the towers of the Roman Pharos (lighthouse) and the church of St Mary in Castro above them on the East Cliffs. That pairing is repeated by the masts of the wrecked brig and by the twin sails of the lugger in front of the steamer. In the foreground before the steamship, and in a characteristic Turnerian visual pun, a tiller and a partially-submerged rudder resemble an axe in overall shape, perhaps to augment our sense of the steamer cutting through the wind.

The lugger on the left flies a foreign flag and is in trouble, for because her crew have failed to stow sails used previously when fishing, her deck is awash with canvas. As a result, her helmsman is trapped between all that sailcloth and an arched mast support. He therefore has no room to pull the tiller hard to starboard, which action is urgently needed in order to turn the vessel abruptly to port and thus avoid collision with a boat leaving the harbour immediately in front of it. Although his fellow crew members shout at him to do something, there is little he can do, and collision seems sadly inevitable. In the 1803 oil *Calais Pier* we have already seen Turner comment on the poor seamanship of foreigners, and here such a dig points up the nautical advantages conferred by British technological inventiveness.

The castle and cliffs look particularly ethereal in the damp, late-afternoon sunlight. The movement of the sea and its reflections are captured with a grasp of the underlying truths of behaviour and appearances that was customary with Turner by now.

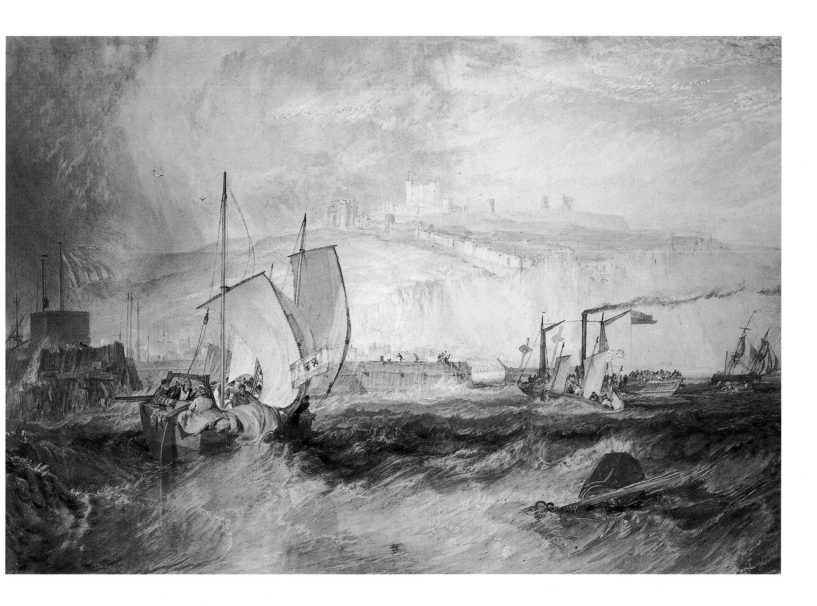

A Storm (Shipwreck)

1823
Watercolour on white paper, 43.4 x 63.2 cm
British Museum, London.

This is undoubtedly the most ferocious seascape Turner ever created in watercolour and it is difficult to believe that anyone could survive such a maelstrom. The plunging surges of the sea, the berserk fury of the sky, the brilliant colouring and dynamic linearity all communicate a world gone mad with energy. A doll-like mankind struggles pathetically to survive, but its chances of success seem tragically limited.

Like the *Dover Castle* discussed above, this watercolour was made for engraved reproduction in a print series entitled 'Marine Views'. Turner created some eight drawings for the scheme between 1822 and 1824, and also allowed an earlier design to be included. However, only two of the engravings were completed during his lifetime.

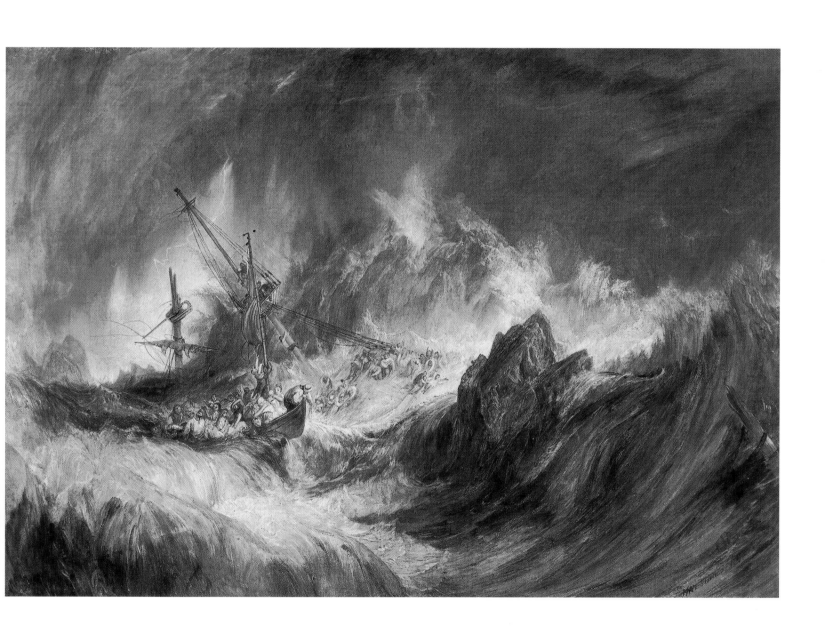

Rye, Sussex

c.1823
Watercolour on white paper, 14.5 x 22.7 cm
National Museum of Wales, Cardiff.

Turner's first great set of topographical prints was the series of forty designs created between 1811 and 1825, and published under the title 'Picturesque Views on the Southern Coast of England'. The present watercolour was made for engraved reproduction in that scheme. Originally the 'Southern Coast' series was to have formed only the first section of a four-part project that would have encompassed the entire coastline of Great Britain. Unfortunately a dispute between Turner and the engravers in 1826 meant that the grandiose publication was never completed. The painter went on to make a number of watercolours for a continuation of the project up the east coast of England, and even had some of the designs engraved himself, although they were never published.

During the Napoleonic wars it was feared that Romney Marsh and the district to the west of it might be the site of an enemy invasion, owing to the flatness of the land and its proximity to France. As a result, between 1804 and 1809 an extensive defence system was built across the whole area. Principally it consisted of forts known as Martello towers, and a watercourse and highway known respectively as the Royal Military Canal and the Royal Military Road. Between Rye and Winchelsea the river Brede served in place of the defensive canal, and it was backed up by the Royal Military Road which ran parallel with it for most of its length; beyond Winchelsea the canal alone continued the defence line westwards. Turner appears to have visited the area around 1805-07 and seen the fortifications under construction.

Here we look eastwards from Winchelsea towards Rye along the Royal Military Road, with the Strand Bridge over the river Brede near Winchelsea on the left. A spring tide surges up the river and under the bridge. This unexpected burst of water has overwhelmed a temporary wooden dam built to facilitate construction work on a further, westwards leg of the Royal Military Canal at the bottom-right. Immediately in front of us workmen cling to the timber shuttering of the demolished dam in order to avoid being carried away by the sudden tidal rush. On the Royal Military Road a carter urges on his horses while men run off in the opposite direction.

In the distance, to the right of Rye, are Camber Castle and the sea. With his usual penchant for the enhancement of scale, Turner has made Rye about twice as big as it was in reality. He has also moved the castle much further to the east in order to include it in the composition. Throughout the image a multitude of flowing, swirling lines not only communicate a powerful sense of energy but also express the panic felt by the men battling to save their lives.

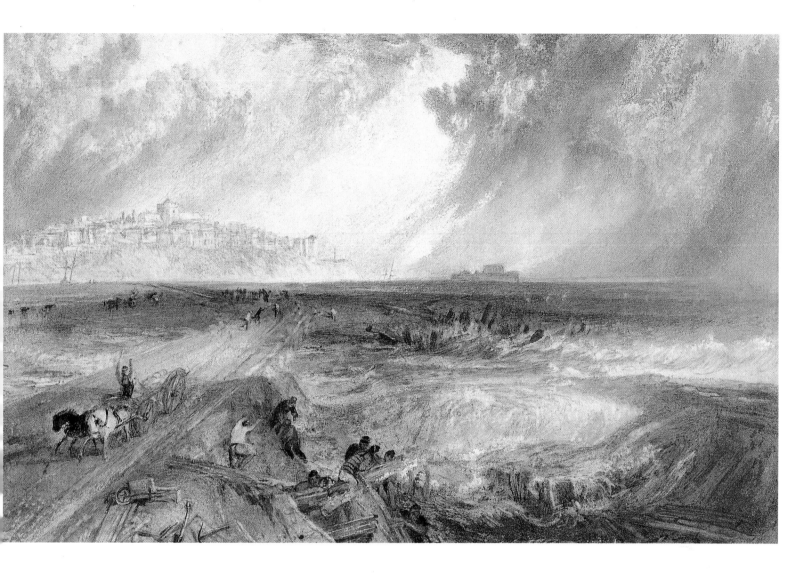

Edward Goodall after J.M.W. Turner, *Rye, Sussex*, 1824, Engraving,
Tate Britain, London.

The Battle of Trafalgar

1822-1824
Oil on canvas, 259 x 365.8 cm
National Maritime Museum, Greenwich.

King George IV commissioned this work, the largest picture Turner ever painted. It was the only such order he would ever receive, and it was probably obtained for him by the President of the Royal Academy, Sir Thomas Lawrence (1769-1830). The King planned to hang the work in St James's Palace alongside de Loutherbourg's *The Glorious First of June* and near to pictures of the battles of Vittoria and Waterloo by Turner's friend, George Jones. In the event the work was not liked, and it was quickly shipped off to hang in the Royal Naval Hospital at Greenwich.

By 1822 Turner already possessed studies of Nelson's flagship, the *Victory*, which he had made when Nelson's body was returned home in 1805. In order to supplement that material and garner further data on the *Victory*, Turner borrowed sketches from another marine painter, J.C. Schetky (1778-1874). However, when *The Battle of Trafalgar* eventually went on show in St James's Palace, Turner then had to spend eleven days correcting it. One of his errors stemmed from Schetky who had drawn the *Victory* at Portsmouth when she was unladen, and thus floated high in the water (as we shall see, this effect was not lost on Turner, for he would put it to positive use in *The Fighting 'Temeraire'* of 1839, to be discussed below). Details of the rigging of various ships and other paraphernalia also had to be amended. But even after such slips had been dealt with, the painting continued to mystify Turner's literal-minded naval contemporaries, who included the Duke of Clarence, later King William IV.

What these detractors failed to understand was the painter's adherence to one of the demands of the Theory of Poetic Painting, namely the need to circumvent the limitations of time. Because a fixed image can only represent a single moment, its creator must resort to one of three ways of circumventing that limitation: he or she can simply ignore temporal constraints completely; they can represent things sequentially; or they can allude to events past and future. In *The Battle of Trafalgar* Turner took the first of these options. Thus he brought together occurrences that took place hours apart. These include the signalling of the last word of Nelson's famous telegraphic message 'England expects every man to do his duty', which had gone up around midday on 21 October 1805; the collapse of the top-mizzenmast of the *Victory* which occurred at 1 pm that day; the *Achille* on fire off the *Victory*, a blaze that occurred late in the afternoon; and the *Redoubtable* sinking in front of the *Victory* which did not take place until the following night (and even then it sank elsewhere). Naturally, such ignorals of the constraints of time and of literal reality were not understood by an audience that simply expected to see the representation of a single moment during the battle, and to witness it painted as factually as possible.

Because of the low viewpoint, the ships tower over us and seem very grand indeed. (Naturally, before Turner raised the sea level to lower the *Victory* in the water, they must have towered even further.) The forefront of the image is filled with blood and corpses, a reminder of the tragic price of military victory. As the day of battle in 1805 was virtually windless, all the ships involved had to deploy the maximum amount of sail (and even then it took hours for them to reach close quarters). Here Turner has given us those acres of canvas, although on the *Victory* the immense billowings clearly double as a metaphor for the stupendous forces unleashed by war.

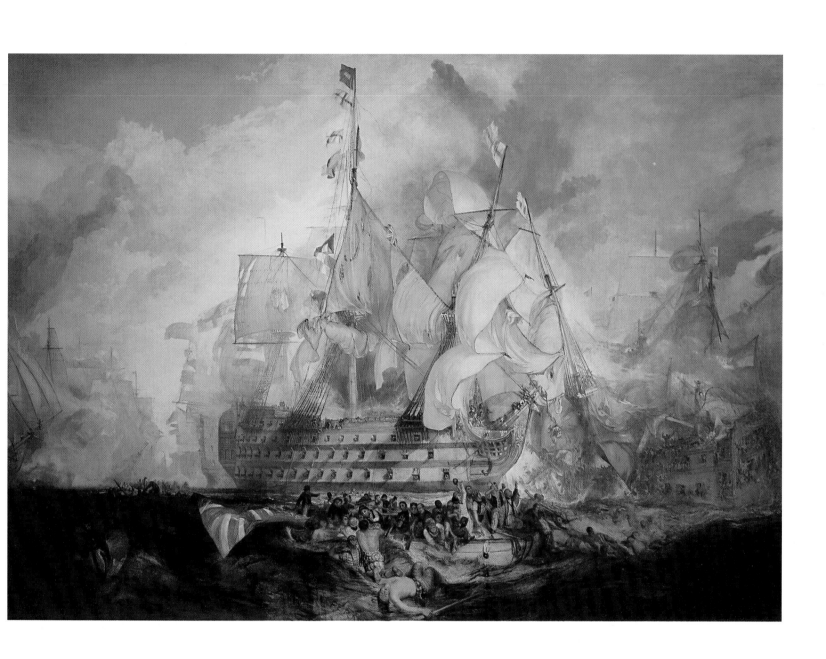

Portsmouth

1825
Watercolour on white paper, 16 x 24 cm
Turner Bequest, Tate Britain, London.

The present work was made for an engraved reproduction scheme entitled 'The Ports of England'. Unfortunately the project was never completed because of a quarrel in 1828 between the painter and the engraver, Thomas Lupton. The artist made at least sixteen water-colours for the series, although only seven of the prints were published during his lifetime. In 1856, five years after his death, the seven engravings and six more prints after drawings made for the project were republished or newly published by Lupton under the title of 'The Harbours of England', with an accompanying text by Ruskin.

In the distance a vast man-of-war prepares to make for sea soon after dawn. Judging by the size of the ship in relationship to the town, it is about twice as large as it would have been in reality, a typical Turnerian enhancement. Our sense of its colossal bulk is further height-ened by its contrast with the smaller vessels that lead the eye to it. Such a powerful dominance makes the man-of-war the very embodi-ment of naval grandeur.

In the centre of the distant harbour-mouth a partially dismasted vessel reminds us of the eventual fate of all warships, great or small. The captain's pennant on the man-of-war, its billowing sails and the canvas of the cutter on the right indicate that a strong north-westerly breeze is blowing. That is why some sails at the prow of the man-of-war have temporarily gotten out of control. Turner's fine under-standing of wave motion is apparent in his differentiation between the choppy water close to the distant harbour, and the wilder move-ment of the sea in the foreground. The circular sweep of a wave on the left is reinforced by the rotundity of a nearby buoy.

On top of a tower to the right, beyond the waving sailor and the cutter with billowing sails, is a shuttering device known as the Admiralty Semaphore. This acted as a signalling mechanism by which messages could be communicated speedily to and from the Admiralty in London via intermediate semaphore stations spaced across southern England. The apparatus had proven especially useful during the Napoleonic wars, when Turner had visited Portsmouth. Our eye is led upwards to the semaphore not only by the raised arm of the near-by seaman but also by the diagonal line of the cutter's main-yard and by the slanting line of shadow in the sky above it. To reinforce the connection, the tower is bracketed by the curves of the sailor's waving arm and the cutter's mainsail.

The waving tar is holding a straw hat, which indicates he is on shore leave (for in Turner's day sailors would make such headgear for their infrequent visits home). By waving to the distant battleship the seaman underlines the naval communication and command capacities rep-resented by the Semaphore to which he is connected visually, just as the battleship demonstrates a reciprocal (if temporary) loss of naval control. By standing and waving happily in a small boat in extremely rough waters, the gesturing sailor displays in equal parts his thorough nautical experience, his total physical confidence, and his feeling of naval pride, qualities that invest the entire image with a sense of buoy-ant optimism.

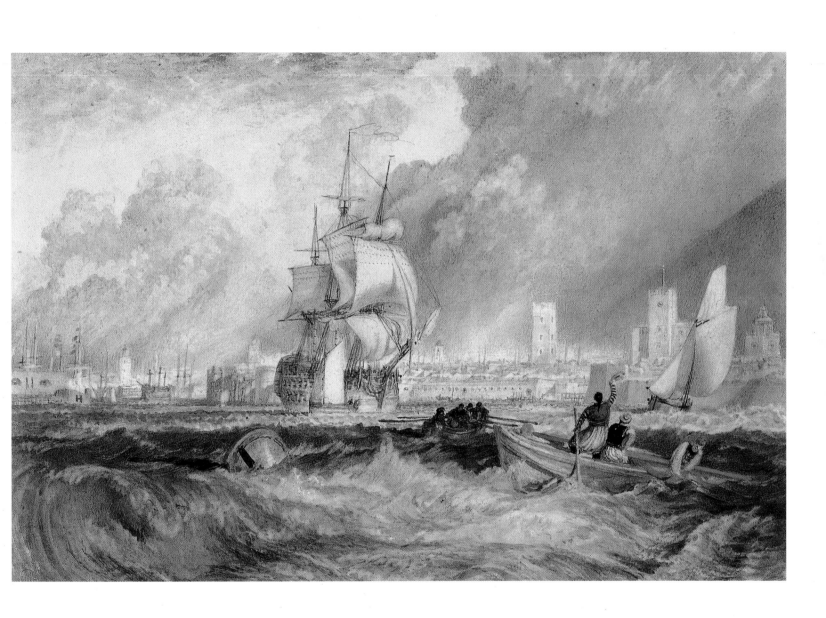

Richmond Hill

c.1825
Watercolour and gouache on white paper, 29.7 x 48.9 cm
Lady Lever Art Gallery, Port Sunlight, Cheshire.

As we have seen with the large oil painting of 1819, Turner loved the celebrated view from Richmond Hill, Surrey, which he had known since boyhood. Pencil drawings on folios 5v, 6, 6v, 9v, 82, 88 and 88v of the *Thames* sketchbook (TB CCXII) of around 1825 probably formed the basis of this further representation of the prospect. The watercolour was commissioned by an engraver, Edward Goodall, for reproduction in his album of poetry and prose, *The Literary Souvenir*, in which the print appeared in 1826.

The commission brought forth another of Turner's outstanding vistas. In front of a landscape teeming with abundance on a late afternoon in high summer, a soldier strolls out with a girl on each arm on the left, some children break off from their play with a hoop and a kite, a group of elegant men and women occupy a grassy knoll, and a lady sits at an easel while another peers over her shoulder. One of the men on the knoll gazes through a telescope at a pall of smoke rising near the horizon on the right, and the smoke might indicate Turner's own hidden presence in the landscape, for it ascends from the very spot occupied by the artist's house at Twickenham. Turner's aged father was living in the house at the time this work was created, and he might well have required some heating even on a warm summer's day. Further pointers to the creator of this image may be the picture obscured from view on the easel, and the paintbox, phials of paint and palette in the foreground.

Clearly the bend in the river inspired the great many circles, semi-circles and ellipses that are formed by the trees, parasols, pall of smoke at Twickenham and cloud to the right of the sun; such formal repetitions both unify and animate the design.

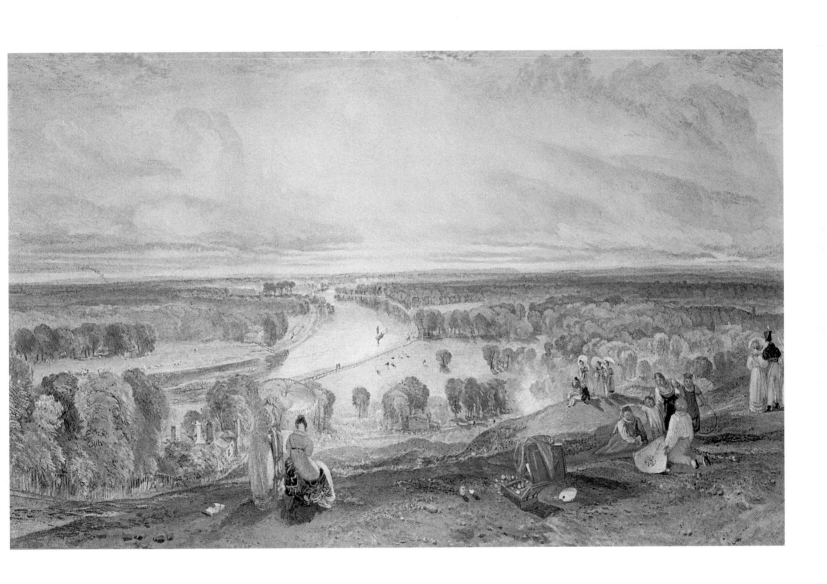

Prudhoe Castle, Northumberland

c.1825
Watercolour on white paper, 29.2 x 40.8 cm
British Museum, London.

The line-engraved reproduction scheme entitled 'Picturesque Views in England and Wales' called forth the finest set of landscape and marine watercolours Turner ever made for engraving. Although 120 designs were commissioned for the venture around 1824 by the print publisher Charles Heath, in the end only 100 watercolours were produced before the project was terminated in 1838 owing to a lack of public interest in the prints (by that time the market for such engravings had become saturated, not least of all by reproductions of Turner landscapes).

Prudhoe Castle is situated about ten miles inland from Newcastle; that distance is indicated in Roman numerals by the 'X' placed on a milestone at the bottom-left hand corner of the image. In a typical Turnerian visual simile the 'X' is repeated by two pieces of wood nearby. The watercolour was based upon pencil sketches drawn in 1817 soon after the painter had returned from Germany, which probably explains why he made a low ruin on the Tyne look more like a towering castle on the Rhine.

Three overlapping triangles subtly structure the composition. One of them comprises the road on the right, while the others divide the river into two channels, the right-hand one denoting the usual course of the Tyne and the left-hand one the direction it took when flooded. Naturally, with such dominant trees on the right, the image invites comparison with a landscape by Claude le Lorrain. As in the French painter's work, dark forms placed in the foreground create a tonal contrast that intensifies brilliant light beyond. All the woodland on the right seems utterly radiant with that light.

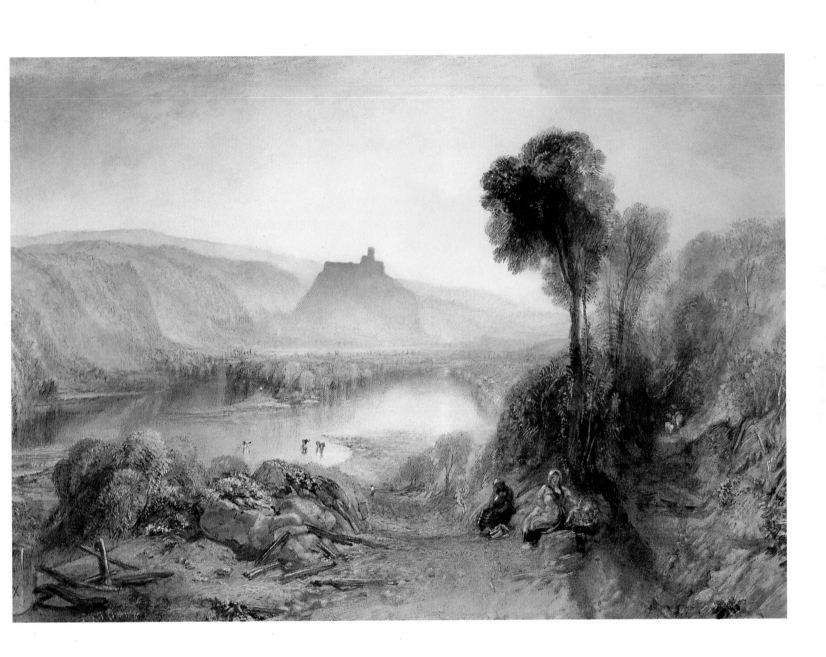

Forum Romanum, for Mr Soane's Museum

1826
Oil on canvas, 145.5 x 237.7 cm
Turner Bequest, Tate Britain, London.

As the title of this canvas indicates, it was commissioned by the architect Sir John Soane RA (1753-1837). However, in the event it proved too large for Soane's house and museum. Although the architect honoured his commitment by paying for the picture with a banker's draft for 500 guineas, the painter did not cash the draft but retained the work instead. Soane later bought a Dutch river scene by Turner. The present painting was exhibited at the Royal Academy in 1826.

We survey the forum in afternoon light. On the left, in front of the Palatine Hill, is the Arch of Titus dating from AD 81. Several buildings normally masked by the arch are brought into view from behind it. Visible through the arch are the three remaining columns of the Temple of Castor and Pollux. On the right is the Basilica of Constantine, with the buildings lining the Via Sacra stretching into the distance. The vaulting across the top of the picture that does so much to unify the composition was wholly invented by Turner.

Within the Arch of Titus a girl kneels in prayer before a monk; in the distance further monks bear holy banners and follow the Host being carried beneath a canopy to the Church of San Lorenzo in Miranda. In front of the procession and attendant kneeling figures, a two-wheeled cart introduces associations of a tumbril, perhaps to allude to the sufferings of the early Christians. (Alternatively it might have been intended to introduce more general but equally appropriate associations of death within such a dead area of Rome.)

In the foreground a girl idly plucks at a discarded lute with one finger. Her apparent mental vacancy aptly personifies the vacancy around her.

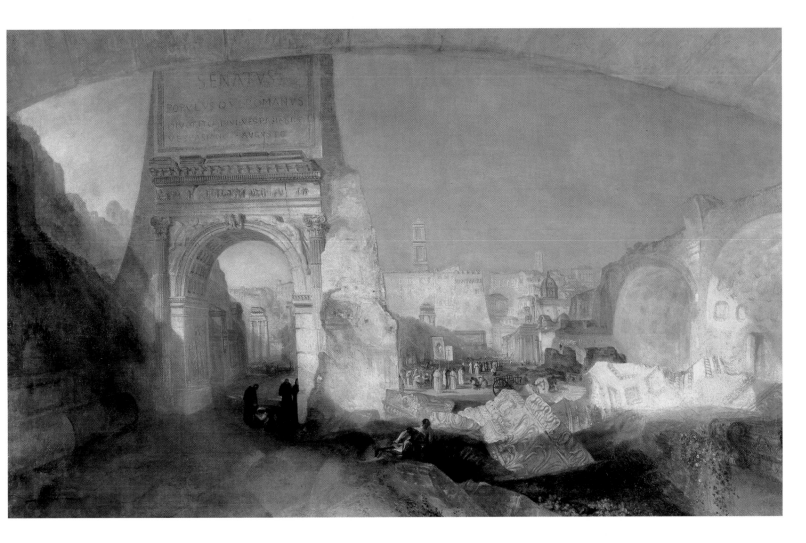

The Seat of William Moffatt Esq., at Mortlake, Early (Summer's) Morning

1826
Oil on canvas, 93 x 123.2 cm
The Frick Collection, New York.

This is the first of a pair of pictures commissioned by a London businessman, William Moffatt (?1758-1831), and it was displayed at the Royal Academy in 1826. The pendant was exhibited at the Academy the following year and is discussed below. Here we see the vista looking towards Moffatt's house, whereas in the companion painting we look from the mansion in the opposite direction at the other end of the day. The building still stands, although it has been considerably altered. Its name, 'The Limes', derived from the avenues of lime trees that stood in front of it; they were all felled in 1896.

Turner based both works on a number of pencil outline drawings contained in the *Mortlake and Pulborough* sketchbook, TB CCXIII. A rough compositional study for the present painting also appears on CCLXIII(a)-3, while CCLXIII(a) nos. 1 and 2 were used for the 1827 painting. In none of these drawings are there any indications of light and weather. This may account for the fact that the dawn sunlight falling across the lawn and pathway in the foreground of the present work is cast from the south, rather than from its correct direction beyond the house. A slightly reddish tinge to the foliage of the trees on the left suggests that we are on the very cusp of autumn.

The artist employed white absorbing grounds for both of the Mortlake canvases. Such grounds rapidly absorb the oil in the paint, and thus make the medium behave like watercolour, which dries far more quickly than oils. The watercolour-like working of the paint can especially be witnessed in the depiction of the boats and reflections on the river. Initially the thinly-worked, absorbed paint must have looked rather flat and lifeless, but the subsequent application of a gloss varnish would have restored its lustre and tonal range.

The London plane trees in both of the Moffatt oils are among Turner's most idealised and beauteous arboreal forms. This is especially true of the 1827 painting where an underlying sense of energy appears to run along every sinuous line of trunk and branch, and the trees seem to flower as we look at them. In both works the foliage is incomparably translucent, spatially complex and filled with life, although the direct sunlight of the later painting makes its leafage seem even more radiant than it is here.

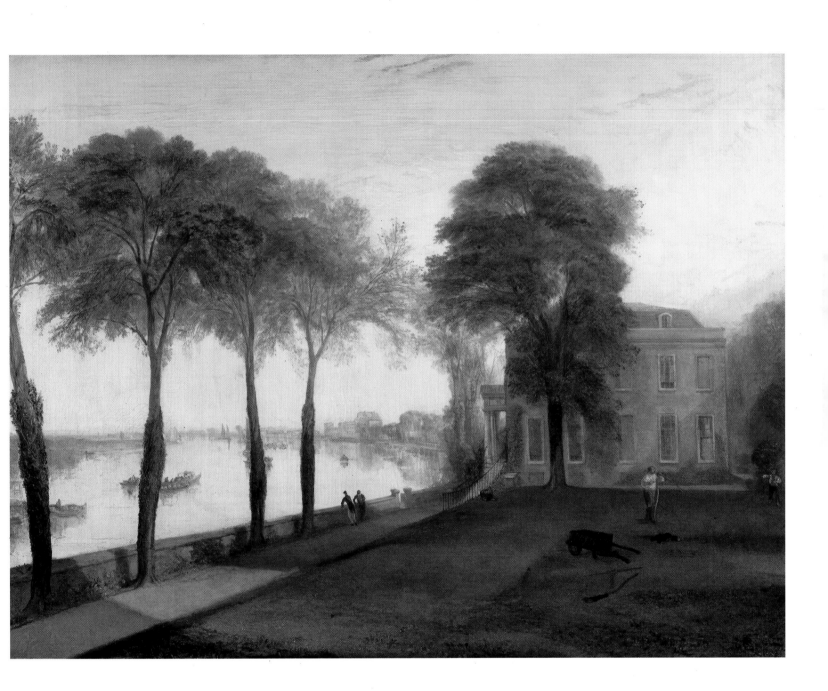

Mortlake Terrace, the Seat of William Moffatt, Esq. Summer's Evening

1827
Oil on canvas, 92 x 122 cm
National Gallery of Art, Washington, DC.

Whereas gardeners prepare to scythe the grass in the 1826 dawn scene, by the other end of the day the same area has obviously been used for genteel walking, children's games and artistic appreciation (as respectively indicated by an abandoned parasol, a hoop and some folios of prints). On the river Turner has subtly analysed the British class structure, for passing State barges convey members of the monarchy and aristocracy, leisure boats carry people in middle-class dress, and working people toil upon Thames barges.

The brilliance of the reflection off the parapet is intensified by its contrast with the dark silhouette of a dog. For many years the story circulated that the painter Edwin Landseer (1803-73) had pasted the animal onto the canvas in the 1827 show because he felt it required a strong focal point. However, at this juncture in his career Landseer was only an Associate Royal Academician, and was thus still hoping for elevation to the status of a full Academician (which honour he would gain in 1831). It therefore hardly seems likely he would have jeopardized his chances by having the temerity to 'improve' a work by one of the most senior and respected of Academicians, let alone a painter more than twice his age.

What must have happened was that Turner himself had originally cut the dog (and the adjacent parasol) out of paper. He then stuck these shapes onto the canvas and painted over them, a procedure he is known to have used on other occasions (for example, see *The Golden Bough* below). Unfortunately the paper dog became detached and fell to the floor on one of the days the Royal Academy permitted artists to retouch or varnish their works. Landseer must have witnessed this occurrence and, wanting to be of service to Turner, temporarily pasted the dog back on again (somebody must have seen this happen and jumped to the conclusion that Landseer had invented the dog). Landseer then went off to find Turner to notify him of what had happened. Turner thereafter returned from lunch, '...went up to the picture unconcernedly, never said a word, adjusted the little dog perfectly, and then varnished the paper and began painting it. And there it is to the present day'. Only this explanation would account for Turner's otherwise surprising lack of concern at somebody of more lowly Academic status tampering with one of his pictures. Moreover, as we have seen with the 1817 *Mount Vesuvius in Eruption*, he had previously placed a dark accent immediately next to a reflection in order to intensify its brightness. That earlier resort to the same ploy reinforces the view that it was Turner himself who originally pasted and then painted the dog here.

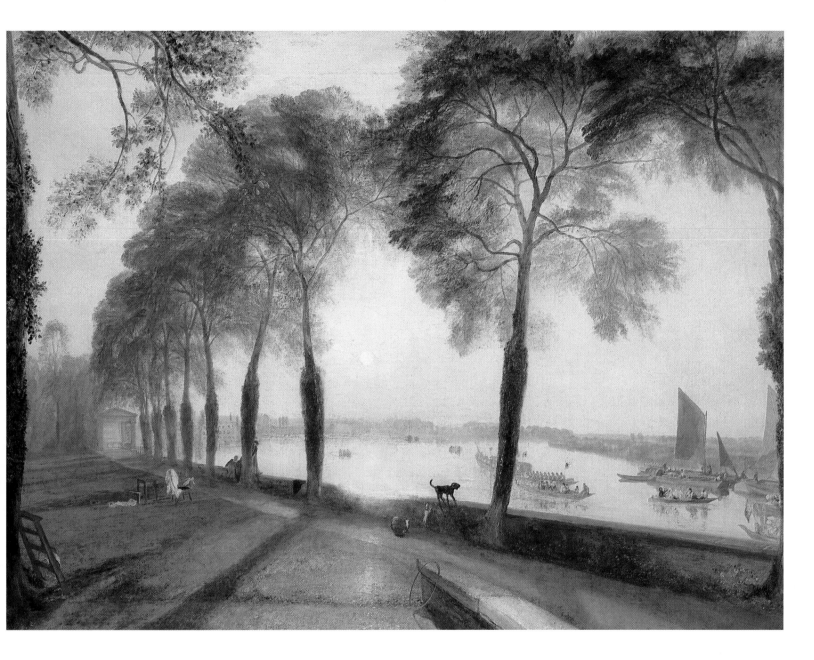

Photo of *Mortlake Terrace* taken from an oblique angle, showing the dog and parasol painted on paper and stuck on the canvas.

Petworth Park, with Lord Egremont and his Dogs; Sample Study

c.1828

Oil on canvas, 64.5 x 145.5 cm

Turner Bequest, Tate Britain, London.

George Wyndham, the third Earl of Egremont and owner of Petworth House in Sussex, was an eccentric, kind-hearted and paternalistic Tory of the old school. His moral views were sufficiently elastic to allow him two long-term mistresses followed by a wife, numerous short-term mistresses, an illegitimate son and heir, and an unknown number of further illegitimate children. Turner painted several views of Petworth Park for the nobleman, as well as depictions of projects in which the earl had invested, such as the newly-built Chichester Canal and the Chain Pier at Brighton. Entirely for his own pleasure, in 1827-8 the painter also made a multitude of gouache watercolours capturing the bustle of daily life at Petworth.

The present work is a study for an oil painting that was commissioned by Lord Egremont. On 19 August 1828 the preparatory canvas was seen hanging in the Carved Room at Petworth by the Member of Parliament and assiduous letter-writer Thomas Creevey. Presumably it had been temporarily placed on the wall to afford the patron a concrete idea of the decorative effect the final picture would create. That subsequent oil contains a cricket match and fighting stags. Here, however, the staffage is much simpler, although it does include someone of vital importance to Petworth. This is the man to the left of centre in the distance. Because of the number of his canine followers he was identified by Creevey in 1828 as 'Lord Egremont taking a walk with nine dogs that are his constant companions'. The fact that Egremont is juxtaposed with a sunset is surely significant, for Turner repeatedly connected sunsets and the approach of night with impending death. Certainly, by 1828 the ageing Egremont was enjoying his last great blaze of life (he would die in 1837).

On the extreme left, just outside Petworth House, stands a chair. By being placed outside a country house in the open air, the seat is therefore located in the country and is, by definition, a 'country seat'. Such a placing of a 'country seat' alongside Lord Egremont's country seat may pictorialise a typically Turnerian play on words.

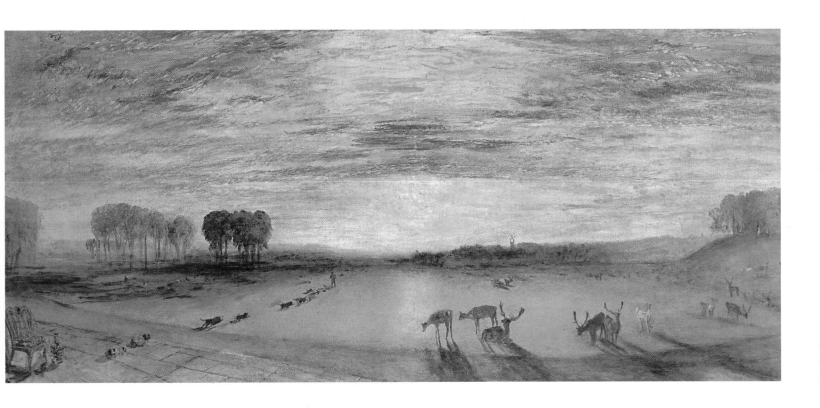

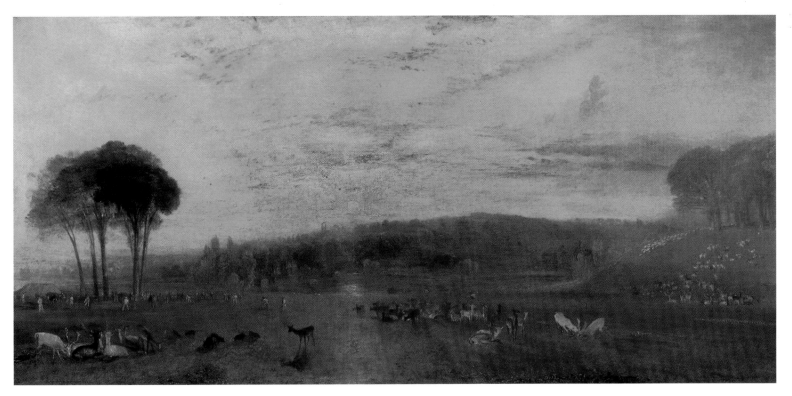

Petworth Park, c. 1828-30, Oil on canvas, 62 x 142 cm
Tate Britain and the National Trust (Lord Egremont Collection), Petworth House.

Ulysses deriding Polyphemus – Homer's Odyssey

1829
Oil on canvas, 132.5 x 203 cm
Turner Bequest, National Gallery, London.

In Book IX of Homer's *Odyssey*, Odysseus – of which name Ulysses is the Latinized form – is trapped with twelve of his men in the cave of the one-eyed giant, the Cyclops. The monster eats two members of the crew every dawn and dusk. After getting their captor drunk, Ulysses and his remaining companions poke out his eye with a sharpened, heated stake. They then escape at dawn by clinging to the undersides of a flock of sheep and rams belonging to their gaoler.

At the top-left the blinded Cyclops clutches his head in one hand and waves in anger with the other; far below him Ulysses stands by the mizzenmast of his ship and 'derides' him in return. On the mainmast of the vessel a flag bears the name of Odysseus in Greek, while another banner represents the Trojan horse. To the left of the ship is a fiery cavern; this was surely intended to link the Cyclops to primordial subterranean forces, which in Turner's day were considered to be the source of such mythical creatures.

Because some clouds on the horizon to the right of the sun are shaped to look like the heads of horses, the orb doubles as the sun-god Apollo being pulled aloft in his chariot. Turner probably borrowed the notion of these clouds/Apollonian horses's heads from Poussin's painting *Cephalus and Aurora* (National Gallery, London), in which they similarly appear. In shape the heads themselves clearly derive from an equine head that once adorned the east pediment of the Parthenon, which Turner knew from the Elgin marbles. At the prow of Ulysses's vessel phosphorescent nereids hold aloft stars, Phosphorus being the son of Aurora (who symbolizes Dawn), and thus the personification of the morning star. The luminescence indicates Turner's continuing interest in all types of visual phenomena. His enduring love of reflected light may be seen in the gorgeous colours arrayed across the shadowed side of Ulysses's ship.

It is commonly assumed that Turner represented the actual escape of Ulysses here, but that is incorrect. When Ulysses escapes, the Cyclops hurls huge boulders after him into the sea but such rocks are not visible, although the great rock-arches in the distance might allude to them. Instead, the Greek hero is now following his fleet, as we can see from the ships on the right and their wakes running across the bottom of the image. The timing is therefore dawn on the day after the escape of Ulysses, which is the precise time given by Homer for the hero's departure from the land of the Cyclops.

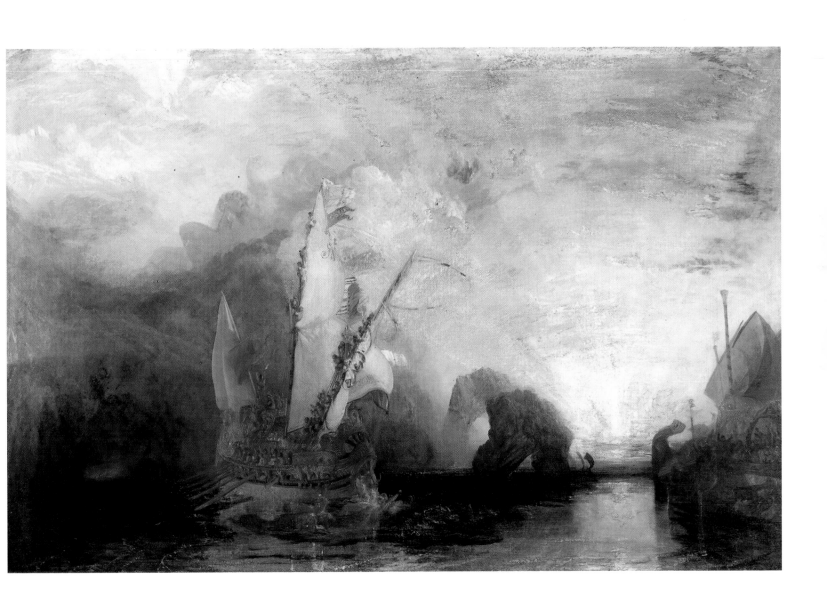

Northampton, Northamptonshire

Winter 1830-31
Watercolour on white paper, 29.5 x 43.9 cm
Private Collection.

Although this watercolour was made for the 'England and Wales' series, it was never engraved, probably because the publisher of the prints felt that politically the image would cause offence to the many admirers of the artist who held Tory views, and thus opinions that would not be at all congruent with the politics of the scene represented. The event depicted is the county election on 6 December 1830 of Lord Althorp, the Chancellor of the Exchequer in the Whig administration of Earl Grey. This government was pledged to reform the highly unrepresentative parliament of the day, and after many vicissitudes it did so by enacting the most momentous piece of British legislation of Turner's entire lifetime, the great Reform Bill of 1832.

In the distance, amid bleak winter light, Lord Althorp is being chaired through the streets in triumph. Banners and flags sport slogans similar to those reported in press accounts of the unopposed election. Thus 'NO BRIBERY' obviously alludes to the corruption of the parliamentary process that had led to the demands for Reform; the old country-dance title 'Speed the Plough' clearly refers to the agricultural interests present at this country town and county town election; 'The Purity of Elections is the Triumph of Law' bears a marked similarity to the title of a well-known Radical political meeting held in 1829; and everywhere on display are banners for 'Reform' and 'Independence'. At the top-left Turner created one of his subtlest and wittier jokes, for obviously he knew that the name 'Althorp' is traditionally pronounced 'Altrop' – that is, with its 'o' and its 'r' transposed; accordingly, he transposed the letters 'A' and 'M' in 'Northampton', to give us 'NORTHMAPTON INDEPENDENCE FOR EVER'.

Lord Althorp's right arm is outstretched, and it therefore points indirectly towards the person sitting at the lower-left. This man's white hair, old-fashioned tricorne hat and gouty foot resting on a pouffe surely identify him as a member of the old order that resists the reform of parliament. Such a supposition is supported by the young woman who stands to the left of him. She is not dressed in Northamptonshire costume at all; instead, she is attired as a 'Marianne' or French post-revolutionary archetype, the gallic equivalent of 'Brittania'. Earlier in 1830 there had been a populist revolution in France, as Turner was well aware, and by placing the hand of the Marianne on the gouty old Englishman's shoulder, the artist both reminds us of the recent uprising in France and subtly predicts what might happen in Britain should political reform not come about by peaceful means. The fact that Turner has invented the balcony on which these figures are located supports this interpretation, for no such structure is known to have stood at the locale depicted.

Turner had visited Northampton in the summer of 1830 when he had drawn the facade of All Saints Church across folios 17v and 18 of the *Birmingham and Coventry* sketchbook (TB CCXL). Here, however, he has rotated the church through 90 degrees, moved its cupola into view from its true position behind the tower, and filled in its portico. The dynamism of the vista is enhanced by the shapes of all the flags and banners blowing in the wind, while the season of the day is projected by the cold, sharp blue of the sky and by the fairly subdued colours distributed elsewhere, as in the muted hues of the Union flag on the right. A stagecoach being pulled slowly through the crowd with passengers craning their necks to witness the passing events adds to the immediacy of the scene.

An election portrayal forming part of Hogarth's 'Industry and Idleness' series, namely *The Industrious 'Prentice Lord-Mayor of London*, may well have influenced the creation of this image, for it also includes a balcony crowded with onlookers, a coach moving through a large throng of people, and many flags and banners. But even if that similarity is merely coincidental, here Turner certainly augmented the tradition of British political comment epitomised by his great predecessor. He also subtly avowed his own understandable identification with the forces demanding progressive political change in Britain.

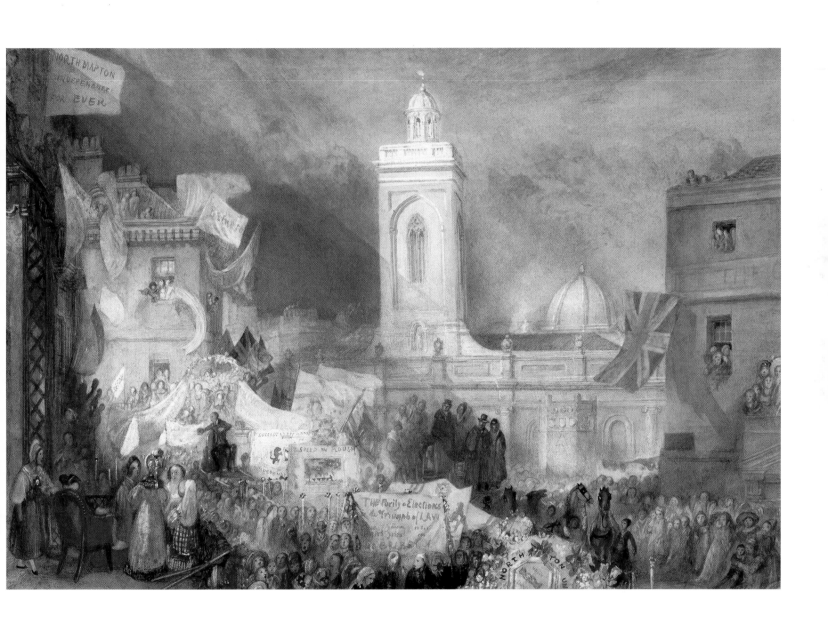

Scio (Fontana de Melek, Mehmet Pasha)

c.1832
Vignette watercolour on white card, 26 x 24 cm overall
Private Collection.

This drawing is one of nineteen designs that were made for engraved reproduction in an edition of the complete works of Lord Byron published between 1832 and 1834. Turner never visited Greece but developed the image from a sketch by William Page (1794-1872), a minor professional topographer. The vignette was used to illustrate the volume containing Cantos 1-3 of *Don Juan*, although the poem only briefly alludes to Chios under its archaic name 'Scio' (hence the title of the work). By the early 1980s the watercolour had become completely forgotten, for instead of being identified as a Turner when it was offered at auction, it was thought to be a design 'in the style of David Roberts'. Accordingly, an astute London dealer was able to obtain it for a mere £65.

The drinking fountain represented still stands in Plateia Vounaki, the main square of the town of Chios on the Greek island of that name. It was built in 1768 by Pasha Mehmet Melek, a Vizier or governor of the island, and later a high-ranking minister in the Turkish Imperial Curia. In the distance on the right stands the Greek Orthodox Church and Monastery of the Predicator, with a mosque beyond.

The watercolour vividly demonstrates how Turner could invest even the most seemingly inconsequential of works with complex meanings. In 1822, after a small insurrection on Chios during the Greek War of Liberation, the Turks controlling the island had shocked Europe by massacring some 25,000 of its inhabitants (an atrocity perhaps best remembered today by a famous painting by Delacroix). After the killings had ended, the Turks sold 47,000 of the remaining Chiots into slavery, leaving only about 1000 of them on the island and severely depressing the market price of slaves in the process.

By 1832, around which date Turner made this watercolour, Greece had been an independent state for some two years, and therefore he made the scene a harmonious one. On the right a Turk and a Greek converse peaceably together, while in the centre-foreground lies a discarded yoke, an obvious allusion to the fact that by now the yoke of Turkish rule had been thrown off. On the left a seated woman with her head in her hand strikes a traditional pose for the denotion of grief, an attitude often used by Turner. Obviously and most appropriately she alludes to the recent tragic history of Chios, particularly as she is placed to the left of another yoked figure who passes out of sight behind two women chatting contentedly.

Turner was wholly aware of Byron's political idealism, and he had openly identified with the cause of Greek independence long before it was finally attained. This outwardly unpromising subject must therefore have afforded him a welcome opportunity to comment upon the final achievement of Greek freedom and peace.

Edward Finden after J.M.W. Turner,
Scio (Fontana de Melek, Mehmet Pasha), 1833
Engraving, British Museum, London.

Loch Coriskin

c.1832

Watercolour on white paper, 8.9 x 14.3 cm

National Gallery of Scotland, Edinburgh.

Turner was at his busiest producing watercolours for engraving during the 1830s. This tiny drawing was created to adorn an edition of the complete *Poetical Works* of Sir Walter Scott, which was published in twelve volumes in 1834. For each volume Turner produced a rectangular design for the frontispiece, and a vignette for the title page opposite. The present drawing was reproduced as the frontispiece to Volume X, which contains 'The Lord of the Isles'. In order to obtain fresh material for the Scott illustrations, Turner visited Scotland in 1831. He stayed for a time with the ailing author and poet before exploring the Highlands and the western isles.

In 'The Lord of the Isles' Scott described Loch Coruisk or 'Coriskin' as a forbidding sight:

> *...rarely human eye has known*
> *A scene so stern as that dread lake,*
> *With its dark ledge of barren stone.*
> *Seems that primeval earthquake's sway*
> *Hath rent a strange and shatter'd way*
> *Through the rude bosom of the hill.*
> *And that each naked precipice,*
> *Sable ravine, and dark abyss,*
> *Tells of the outrage still.*

Turner was not someone to ignore a place like that. Accordingly, on his 1831 tour he made for Oban, from whence he caught a steamer to Elgol on the Isle of Skye, and then took a boat across to the mouth of Loch Coruisk.

The artist greatly compressed actuality here, so that on the right we look up Loch Coruisk towards Sgurr Thuilm (2884 ft/879 m), and on the left up the adjacent coastline and valley towards Sgurr Alasdair (3309 ft/1008 m), with Sgurr na Banachdich (3167 ft/965 m) in the centre. Throughout all these huge rock formations Turner has made apparent the geological idealities of form, those vast stratifications and fissurings that tell of 'the outrage still'.

In the foreground two tiny figures set off the immensity of the landscape by contrast. One of them is clearly Turner himself, sketching the view, while the other must be the boatman who had rowed him across Loch Scavaig from Elgol. Turner later told the publisher of Scott's *Poetical Works*, Robert Cadell, that he had almost been seriously injured (or worse) at Loch Coruisk, for he missed his footing while negotiating its slopes and, 'but for one or two tufts of grass', would have 'broken his neck'. Had he done so we would have been deprived of *The Fighting Temeraire* and a host of other masterpieces.

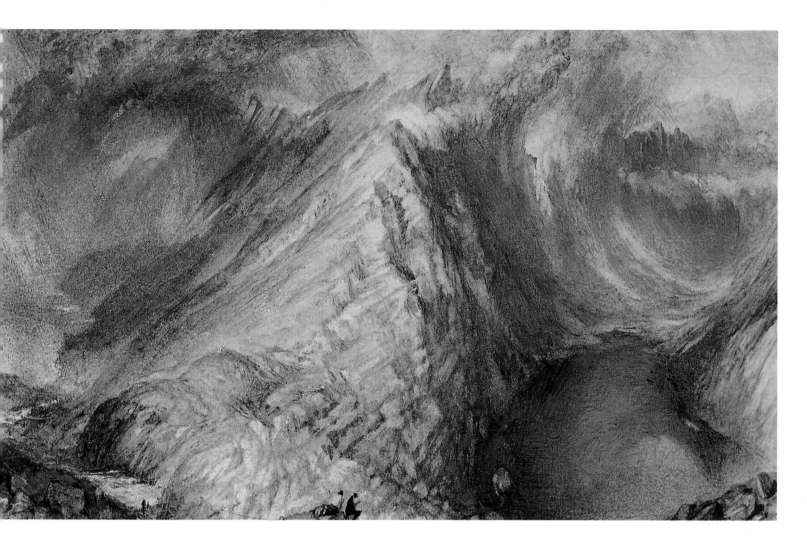

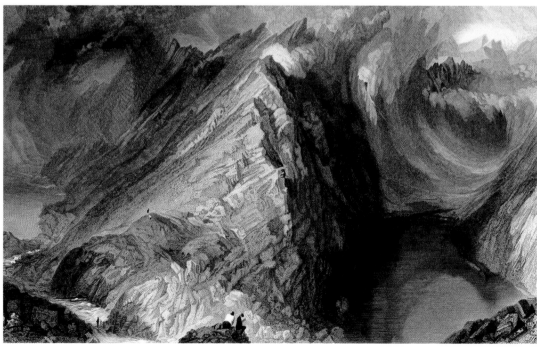

Henry le Keux after J.M.W. Turner, *Loch Coriskin*, 1834
Engraving, British Museum, London.

Mouth of the Seine, Quille-Boeuf

1833
Oil on canvas, 91.5 x 123.2 cm
Fundaçao Calouste Gulbenkian, Lisbon.

In the distance are the lighthouse and church at Quillebeuf that were located at the mouth of the river Seine in Turner's day (now they are stranded inland, for the estuary has moved several kilometres westwards because of silting and land reclamation). Turner was very attracted to this spot, for he visited it on four separate tours of France. He made two colour studies of the place in watercolour, and also worked up a finished watercolour of Quillebeuf on blue paper for engraving in a part-work published in 1834, *Turner's Annual Tour – The Seine*.

When this painting was exhibited at the Royal Academy in 1833 the following note was appended to its title in the catalogue:

This estuary is so dangerous from its quicksands, that any vessel taking the ground is liable to be stranded and overwhelmed by the rising tide, which rushes in one wave. This wave is known locally as the 'Mascaret' *or* 'Barre'.

The 'Mascaret' was a vast tidal surge moving up the river Seine; the 'Barre' was its leading, destructive edge. Until 1963, when the dredging of the Seine estuary and the creation of a new canal at Tancarville dissipated its flow, this tidal bore – which could top 24 feet (7.3 metres) in height – regularly wrought havoc up the Seine as far as Rouen, some 50 miles (80 kilometres) inland from the sea. Between 1789 and 1829, for instance, no less than 112 ships were lost to the bore. In Turner's painting we see the Mascaret moving upriver in the centre, immediately to the right of the church. In the distance on the left, moored boats rock on the river flowing into the sea. Turner often used lighthouses to symbolise the defeat of human hopes, for nearly all his lighthouses have failed in their purpose, being surrounded by wreckage and/or drowning figures. Sadly that is the case here, for a vessel is foundering on the extreme right. Presumably it had run aground on the quicksands mentioned by Turner, and then been smashed to pieces by the Mascaret, which has left extremely choppy waters in its wake.

The composition is unified by a serpentine line that descends down the flock of gulls on the left, curves around to the rising tidal bore in the centre, and moves up the edges of the clouds above. This line neatly frames the lighthouse and church. The people in the churchyard, as well as the lighthouse, adjacent boats and distant north shore of the Seine, glisten in the moist evening sunlight, and there is an enormous sense of dampness in the air. When this work was displayed in 1833 the critic of the *Morning Chronicle* wrote that it made you 'long for a parasol, and put you in fear of the yellow fever, and into a suspicion of the jaundice', although the warm colours do accurately convey the hues given off by a setting sun.

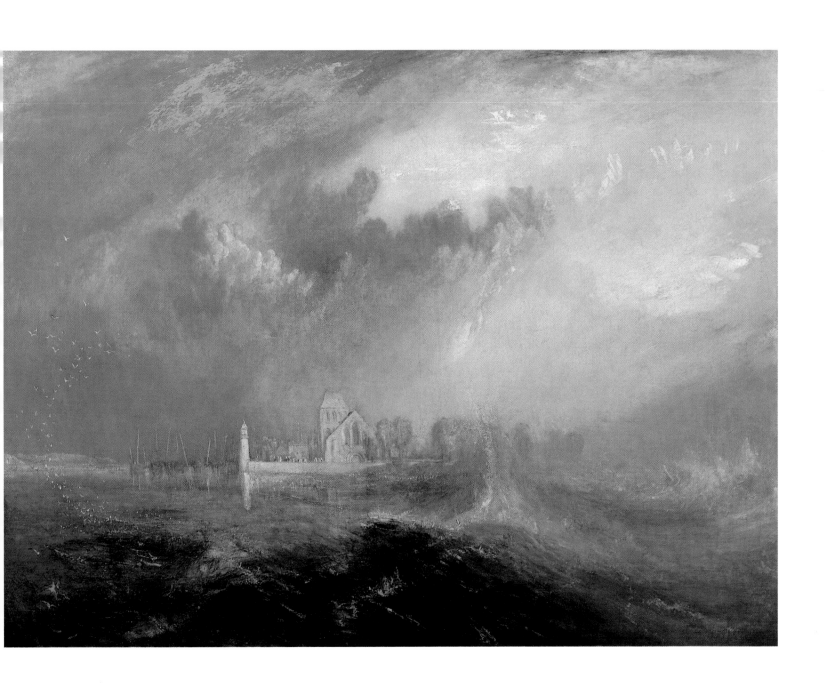

The Golden Bough

1834
Oil on canvas, 104 x 163.5 cm
Turner Bequest, Tate Britain, London.

This view of Lake Avernus in Italy was exhibited at the Royal Academy in 1834. Its title was to have been accompanied in the Exhibition catalogue by verses from 'Fallacies of Hope' but these were suppressed by the Council of the Royal Academy. Turner had already represented the same vista twice: around 1798, when he worked up a painting of the scene from sketches made on the spot by Sir Richard Colt Hoare (who had commissioned the watercolours of Salisbury discussed above); and again around 1815.

In both of the earlier works Turner had complemented the landscape with figures taken from Virgil's *Aeneid*, namely Aeneas and Deiphobe, the Cumaean Sibyl. In each of those images the Sibyl presents Aeneas with the golden bough he needs in order to return from visiting his deceased father in the Underworld, the land of the dead. However, in the present picture Aeneas is nowhere to be seen; instead, the Cumaean Sibyl appears alone on the left. She proffers the golden bough to some dancers and nudes who are surrounded by luxury goods. Clearly, the indifference of these people to the branches that would allow them to escape death typifies a wider human indifference to mortality, while their attraction to hedonism and materialism suggests the reason for their lack of concern. And this is not the only possible meaning residing in the work. Turner might well have wanted to create a parallel between the golden bough represented and his *Golden Bough* painting, for naturally he believed that a work of art confers immortality, just as the magic branches being lifted up by the Cumaean Sibyl were believed to have done so in classical times. In *The Golden Bough* Turner may therefore have been reminding humanity of its mortality and equally celebrating the power of art to triumph over death.

On the extreme left a small statue of the Virgin Mary placed in a blue aureole niche obviously refers to the early Christian belief that the Cumaean Sibyl had prophesied the coming of Christ. The two nudes painted on the right probably replaced three similar figures that Turner had originally painted on paper and stuck onto the canvas but which peeled off about three years after the completion of the picture.

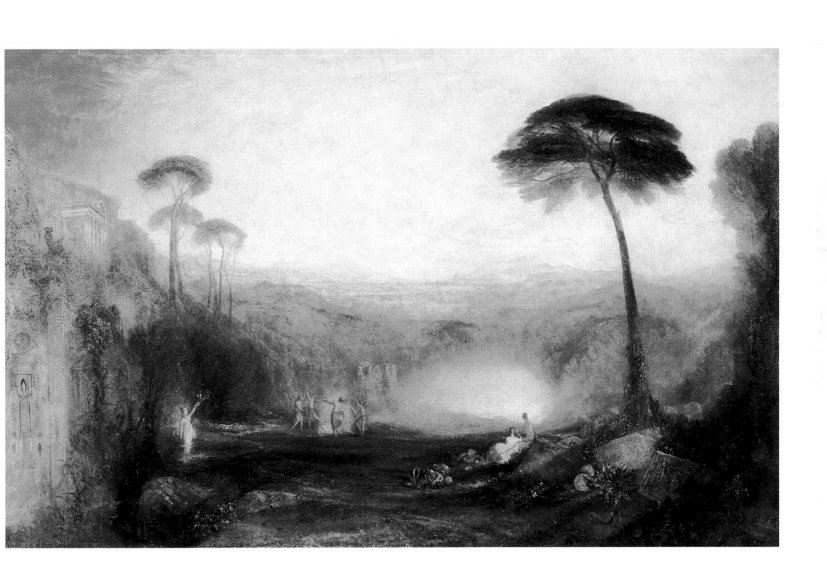

Venice, from the Porch of Madonna della Salute

1835
Oil on canvas, 91.4 x 122 cm
Metropolitan Museum of Art, New York.

In this painting, which was exhibited at the Royal Academy in 1835, we look eastwards in late-afternoon light along the Grand Canal. We are therefore not seeing the vista from the portico of the Church of Santa Maria della Salute as Turner's title claims, but looking past that viewpoint, for it appears on the extreme right.

The artist had first visited Venice in 1819, and made a number of fine views of the city in watercolour both then and in the following years. He had also planned to paint a large canvas of the Grand Canal from the Rialto, but merely roughed it out before abandoning it. However, in the 1833 Royal Academy exhibition he displayed a painting of Venice developed from sketches made in 1819, and the creation of that work spurred him to revisit the city later that year. Thereafter the majority of his Italian views are of Venice. In most of them he blocked in the buildings with areas of colour, and then detailed the architecture by means of line (as here). This separation of elements permitted him to project both the bright optical dazzle or softer vaporous masses of Venetian architecture very easily.

In the distance the campanile of St Mark's Cathedral has been rotated through 45 degrees, so that we see it end-on, rather than across two of its sides. Typically Turner has doubled the Grand Canal in width, an enhancement that invests it with more than twice the grandeur. The reflections off the buildings lining the thoroughfare are much longer than they would have been in reality. Clearly this elongation both heightens the poetic sense that Venetian buildings seem to float on water and reminds us that mainly we experience Venice by floating through it. In the latter respect the painter was once again communicating a profound truth of place.

Yet these are not the only liberties that Turner took with literal reality in this painting. When he visited Venice both in 1819 and 1833 it was particularly impoverished, for it had not yet recovered from the French invasion of 1797. That occupation put an end to Venice as an independent republic. It also seriously damaged its finances, for it ended the long annual Carnival period which had attracted sexually-promiscuous tourists to the city for centuries and become its major economic prop. Even by the 1840s, writers on Venice were still commenting on its 'ghostly and funeral silence'. Yet that dead city is not the place Turner celebrated so gloriously in his later works. Instead, he made Venice a magical place by loading its boats to the gunwales with luxury goods such as gems spilling from jewel-boxes and piles of expensive-looking fabrics, just as we see here. He did so not because he can ever have witnessed such sights in Venice but because they introduce ineluctable associations of the wealth that had originally made the city powerful during the Renaissance period. Moreover, such luxury goods also remind us of the cause of Venetian decline, for the concentration upon private pleasure rather than public good had eventually led to political and military collapse. In this painting and his many other late Venetian scenes containing vessels that overflow opulently, Turner was therefore again making fall-of-empire moral statements.

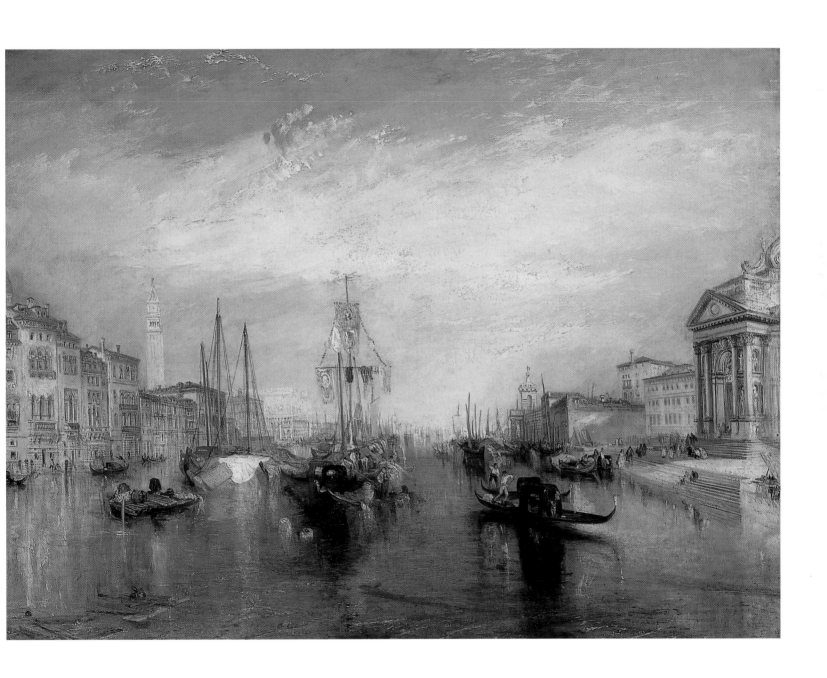

The Burning of the House of Lords and Commons, 16th October 1834

1835
Oil on canvas, 92 x 123 cm
Philadelphia Museum of Art.

We know from the diary of an art student that Turner watched the burning of the Houses of Parliament from a boat on the River Thames on the night of 16 October 1834. He made two depictions of the fire in oils. The present painting was exhibited at the British Institution in 1835, while the other canvas (now in the Cleveland Museum of Art) was shown at the Royal Academy the same year. Both works depict the fire from the south bank of the river, although the Cleveland picture represents the scene from Waterloo rather than Westminster Bridge, and therefore more distantly. Turner also made a tiny vignette watercolour showing the fire from underneath Westminster Bridge (Private Collection); that drawing was created for engraved reproduction in an annual book, 'The Keepsake'. Finally a larger watercolour (Tate Britain) portrays the fire in close-up from across New Palace Yard. It was probably made for the 'England and Wales' series but never engraved.

As related in the introductory essay, the present work was largely painted on the walls of the British Institution, a feat highly admired by those fortunate enough to witness it. In the distance the fire flares up brilliantly, showering sparks across a starry sky. Turner took his usual liberties with actuality by making Westminster Bridge about a mile (1.6 km) in length. He also deformed it into a hump-backed bridge in the process. Swarming across the bridge and both banks of the river are the vast crowds that actually witnessed the blaze in 1834. Not all of them would have been dismayed by the disaster, however, for in the autumn of 1834 Parliament was discussing the Poor Law Bill which would bring into being the workhouse system. Many in Britain thought that the fire was a divine comment upon such punitive legislation. Perhaps that popular opposition explains why the word 'NO' is clearly visible on a placard in the centre-foreground.

At the lower-left several people kneel in supplication before a figure wearing medieval religious garb. He may possibly allude to clerics such as John Wyclif and Sir Thomas More who had once struggled to extend British liberties and were thus relevant to parliamentary history. (Turner had earlier hinted at Wyclif and depicted More in separate works.) Perhaps the supplicants are expressing their hope that the spirit of British liberty will not be lost by the destruction of the palace housing the legislature.

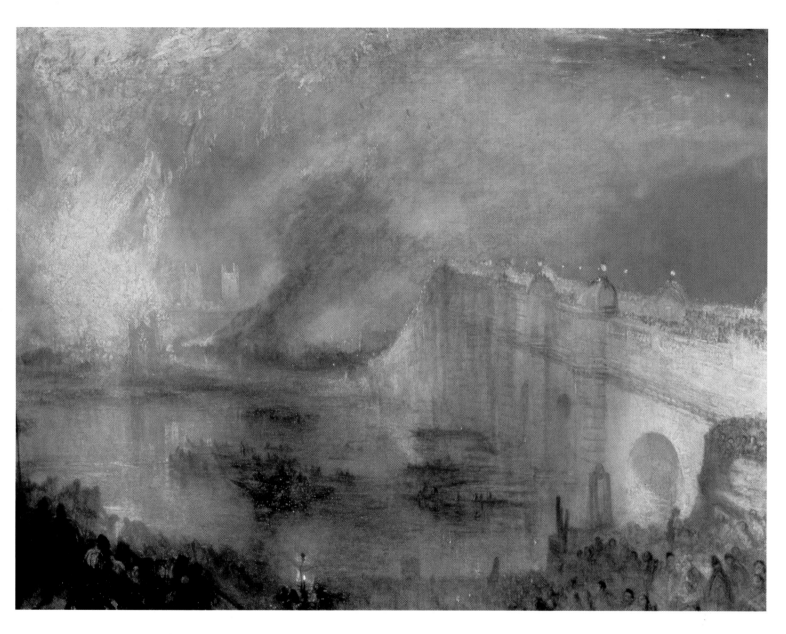

Flint Castle, North Wales

1835
Watercolour on white paper, 26.5 x 39.1 cm
National Museum of Wales, Cardiff.

This is one of the last drawings Turner made for the 'England and Wales' series, and it is also one of the finest watercolours he ever created. He had first visited Flint Castle in 1794, on his second tour of Wales. In 1795 and 1797 two of his watercolour views of it were reproduced as line engravings (one of the drawings is now in a private collection, the other is lost). In 1807 a portrayal of the castle with vessels unloading in the foreground was published in the first part of the *Liber Studiorum*, while in the 1820s a lovely depiction of the castle in watercolour was created as a wedding present for a friend (Private Collection, Japan).

Here Turner brought all of his earlier responses to the castle and its surroundings to a triumphant conclusion. As dawn mists rise from the beach at low tide and the sky fills with endless colours, a shrimper makes his way into the Dee estuary with his creel raised in front of him. To the right another shrimper offers a shrimp to a child, possibly to pictorialise a Turnerian visual pun (the word 'shrimp' has long been used to denote a small child; we could therefore be seeing a shrimper offer a shrimp to a shrimp). On the right another shrimp also reaches out for something tasty to eat.

The strong shocks of vermilion and emerald green in the foreground greatly boost the colouristic brilliance of the work, while throwing the subtle colouring of the distance into relief. Similarly, the dark tones of the nearby shrimper's clothing, and of the anchor and broken basket beyond him, also augment the tonal delicacy of the distance, and thus our sense of spatial immensity. Just to remind us that Flint Castle is a ruin, Turner has placed the timbers of a wrecked boat immediately in front of it.

The artist's technical confidence can be seen at full stretch here. Probably by means of a damp sponge, he simply wiped out the sun and its reflection from an initial basic colour wash of light orange. This was one of several bands of undercolour, the others being washes of soft yellow, blue and green. The details were added later when all of these washes had dried, and the highlights were scratched out from the surface of the immensely strong rag-made paper. Turner made a watercolour study for this work (TB CCCLXV b 28). It only includes the beached boats in the centre distance, the adjacent horses and carts (but facing in the opposite direction), a rather stormy sky and the castle represented in misty, light silhouette.

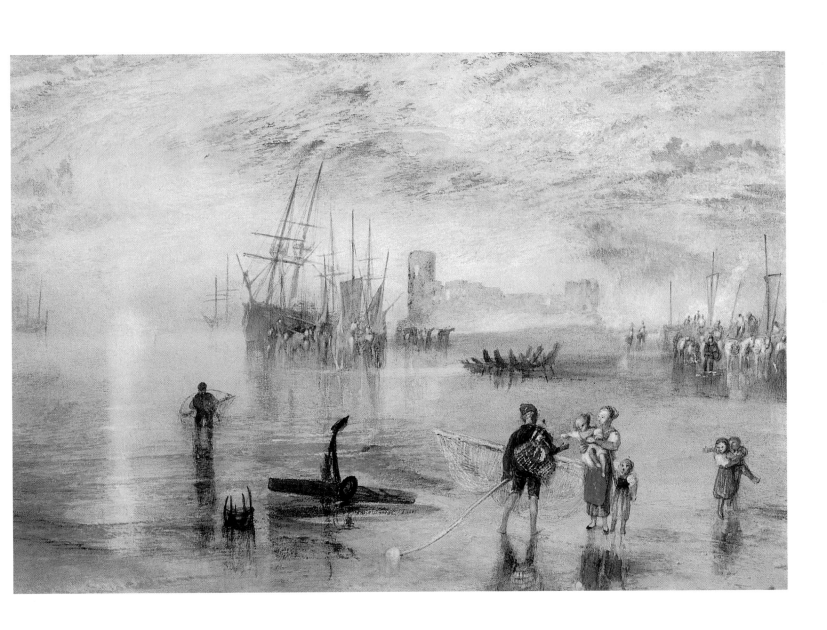

Snow storm, Avalanche and Inundation
– a Scene in the Upper Part of Val d'Aouste, Piedmont

1837
Oil on canvas, 91.5 x 122.5 cm
Art Institute of Chicago.

In the summer of 1836 Turner toured the Val d'Aosta in northern Italy with his friend and patron, H.A.J. Munro of Novar, who later owned this painting. The work was exhibited at the Royal Academy in 1837. Although Turner clearly suffered from poor weather on the 1836 trip (judging by the images he made on the tour), it must somehow be doubted that he witnessed a snowstorm or avalanche that summer, let alone anything as cataclysmic as this.

The landscape represented is probably not a particular scene but a generalized vista drawing upon overall impressions of the upper Val d'Aosta looking northwards towards the Mont Blanc massif. The Theory of Poetic Painting to which Turner subscribed certainly permitted artists to generalize from actualities, and of course he had often done so in the past. As was customary by now, he invested the image with profound insights into the inherent 'qualities and causes' of natural forces.

The summit of a mountain in the Mont Blanc massif just peeks above the distant snowstorm; in front of it a vast avalanche spills down to the valley floor. And whirling around to frame everything in its vortical sweep is the raincloud responsible for the inundation. The river surges wildly towards the bottom-left where an unfortunate individual drowns in its waters. Another victim of drowning is lifted onto the river-bank towards the bottom right. All the survivors of the storm seem especially doll-like, and again they point up Turner's lifelong and wholly conscious desire to make members of our species look especially vulnerable and pathetic when confronted by the immensity and terrifying violence of external nature.

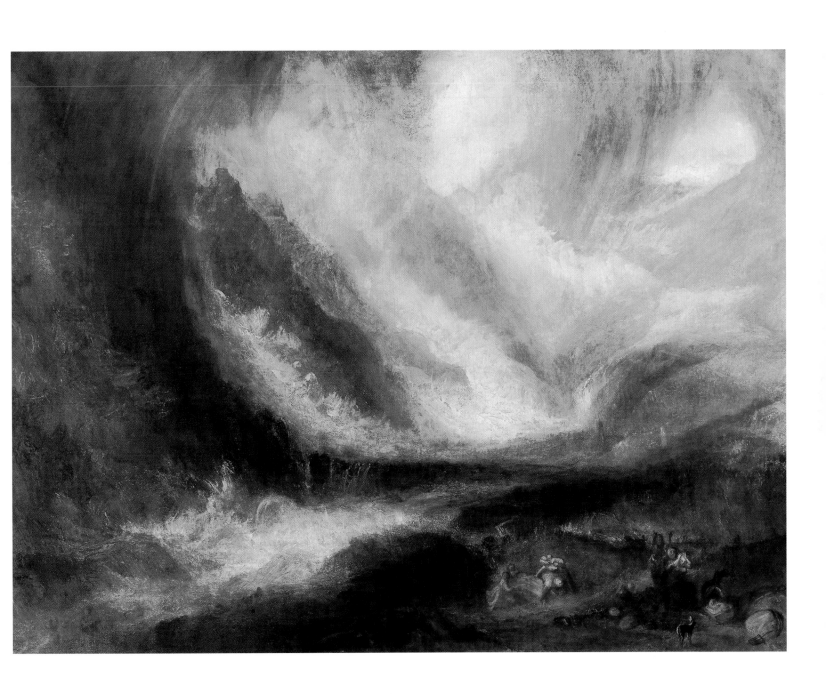

Modern Italy – The Pifferari

1838
Oil on canvas, 92.5 x 123 cm
Glasgow Art Gallery and Museums.

This is one of a pair of paintings exhibited at the Royal Academy in 1838; the pendant is entitled Ancient Italy – Ovid banished from Rome (Private Collection USA).

The pifferari are musicians from the Abruzzi, a mountainous region south of Rome. In order to ease the imagined labour pains of the Virgin before Christmas, they wander down to Rome and other central Italian cities to play their shawms or double-reeded woodwind instruments known as pifferi. One of the pifferari is visible near the bottom-left immediately beyond the woman kneeling in prayer. The juxtaposition of the pifferari and the religious woman makes it clear that Turner knew of the devotional purpose of such pipers. By linking the pifferari to contemporary prayer Turner was probably also addressing the survival of pagan practices into modern times.

In *Ancient Italy – Ovid banished from Rome*, Turner set the banishment of the great poet amid vast buildings and the glaring light of sunset. Clearly that timing complements the decline of Rome itself. It also makes it likely that we are looking at an opposed, morning scene here. Turner evidently synthesized the landscape 'from the various draughts which he had made from various scenes and prospects', as recommended by Reynolds (from whom this quotation is taken). Thus it is possible to recognise Palestrina, south of Rome, on the left; the medieval castle of Poppi in dark silhouette in the centre, with the hills of the Casentino ranged beyond it; and the Temple of Vesta at Tivoli slightly right of centre.

With its mountains, procession of monks on the right and pifferari, this picture has much in common with the *Harold in Italy* symphony of Turner's contemporary, Hector Berlioz. The composer drew his overall title from Byron's *Childe Harold's Pilgrimage* but he based his work – with its evocations of mountains in the first movement, its religious procession in the second and its pifferari in the third – upon his experiences of the landscapes and peoples around Rome, just as Turner did here. It seems unlikely that Turner ever heard the Berlioz symphony (which was written in 1834 and premiered that same year in Paris), but obviously the parallel experiences of the two artists and shared love of Byron shaped their similar imagery.

When this painting was subsequently being copied by an engraver, Turner requested that a child in swaddling clothes and a bird's nest with eggs should be added to the image in order to 'increase the sentiment of the whole'. He probably wanted the baby to allude to the Christ-child, and the eggs to remind us of the generation of life, a hint that seems most relevant not only to Christmas but equally to the generative power of the lovely landscape.

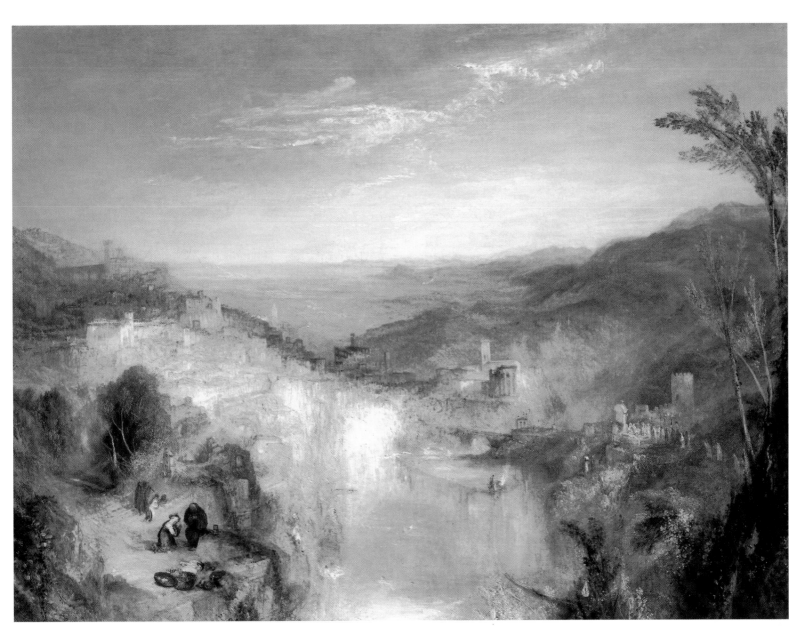

The Fighting 'Temeraire', tugged to her Last Berth to be broken up, 1838

1839

Oil on canvas, 91 x 122 cm

Turner Bequest, National Gallery, London.

When this painting was exhibited at the Royal Academy in 1839 its title was accompanied in the catalogue by these lines from Thomas Campbell's 'Ye Mariners of England':

The flag which braved the battle and the breeze,
No longer owns her.

Clearly, Turner felt that cash was beginning to take precedence over national pride, for although the *Temeraire* had fought nobly at the Battle of Trafalgar in 1805, such merit had done nothing to prevent her destruction.

It has long been thought that Turner actually witnessed the towing of the *Temeraire* upriver from her normal anchorage at Sheerness to Beatson's shipbreaking yard at Rotherhithe on 5 and 6 September 1838. However, it now seems more likely he simply read about the towing in the newspapers. But what he read about and what he painted are very different matters.

For a start, there are the changes he made to the *Temeraire*. It was a standing order of the Royal Navy that everything salvable and reusable from a ship should be taken off her before she was moved from her customary anchorage for destruction. As a result, when the *Temeraire* was towed upriver in 1838, all her masts had already been removed; had Turner been able to see the man-of-war under tow, he would only have witnessed the hull being transported. By replacing all her masts and sails, the painter was therefore restoring the ship to her original glory, as she had appeared in her heyday some thirty years earlier. And by representing her in such comparatively light tones, he made her look unearthly, like a ghost ship. Naturally that ethereal delicacy is greatly intensified by the contrasting dark tones of the tug. Moreover, to make the *Temeraire* look as majestic as possible – as though she has now risen above the earthly fray – Turner also raised her very high in the water. Consequently, she appears to glide above the Thames, rather than in it, a lofty sight indeed. Clearly this effect derived from originally painting the *Victory* riding too high in the water in *The Battle of Trafalgar* in 1822-4, as discussed above.

We know from the 1838 newspaper accounts that the *Temeraire* was towed upriver by two tugs. By merely providing one of them the artist both simplified his composition and made us even more aware of the physical strength of steam power. And then there are the alterations he made to the tug itself.

When this painting was displayed at the Royal Academy in 1839 Turner was criticized for transposing the foremast and funnel of the tug: instead of locating the stack midway between the paddles and thus immediately above the engine, he positioned it at the very prow of the vessel, with the foremast taking its place above the engine. (That Turner certainly did know the correct order of mast and funnel on a steamer can be seen from the *Dover Castle* of 1822 discussed above.) Yet it is easy to see why he effected this transposition: by situating the funnel at the very prow of the tug, he stood it in the vanguard of all the wind-powered shipping in the picture. Clearly he did so in order to symbolize the 'prophetic idea of smoke, soot, iron and steam, coming to the fore in all naval matters', as one of his more astute contemporaries commented.

The panorama is greatly compressed, so that we look eastwards towards the Thames estuary on the left, and westwards towards London on the right (the painter frequently used such compression in his topographical scenes). Because of the view looking eastwards it has often been suggested that we are seeing a sunrise here. However, Turner himself provided the evidence that this is a sunset, for the moon is located to the left of the sun and is lit down its right-hand edge, a location and lighting only visible around sunset (if this was a dawn scene, the orb would appear to the right of the sun and be lit down its left-hand edge). Obviously the glorious sunset is a metaphor, for once again Turner has most appropriately matched his time of day to dramatic meaning: just as the *Temeraire* approaches its end, so the day nears its end, with a moonrise reminding us of the proximity of night. In the case of the doomed vessel, that night will be an extremely long one indeed.

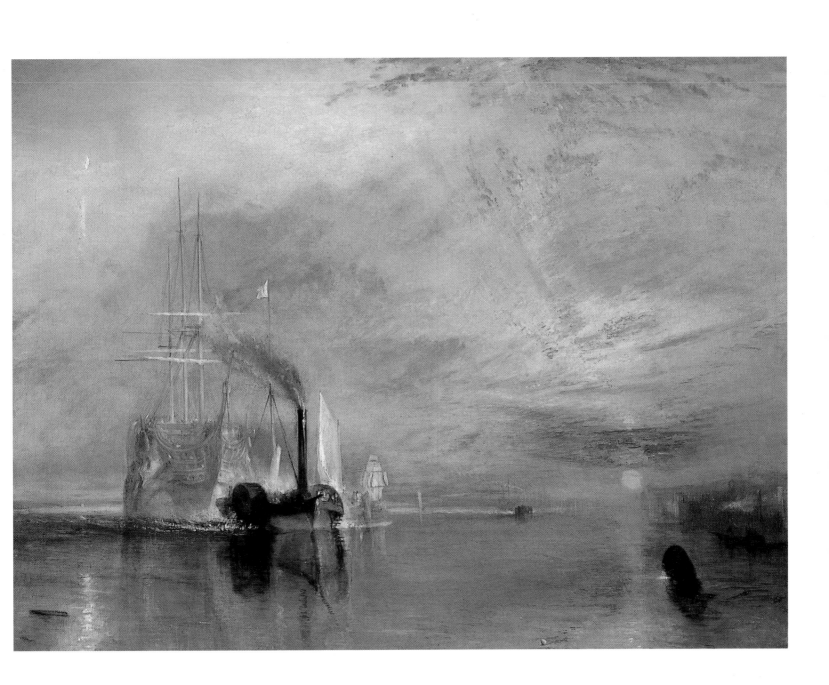

Ancient Rome: Agrippina landing with the Ashes of Germanicus.
The Triumphal Bridge and Palace of the Caesars restored

1839
Oil on canvas, 91.5 x 122 cm
Turner Bequest, Tate Britain, London.

This painting was exhibited at the Royal Academy in 1839, along with a pendant entitled *Modern Rome – Campo Vaccino* (National Gallery of Scotland, Edinburgh). Its title was accompanied by the following lines in the catalogue:

> *– The clear stream,*
> *Aye, – the yellow Tiber glimmers to her beam,*
> *Even while the sun is setting.*

Clearly the last golden blaze of daylight and approach of night link associatively to the subject.

Germanicus Julius Caesar was the adopted son and heir of the Emperor Tiberius. Turner obtained the account of his death in AD 19 from *The Roman History* by Oliver Goldsmith, which was in his library. Goldsmith points out that at the beginning of the reign of Tiberius 'nothing appeared but prudence, generosity and clemency' in the Emperor. However, in time he became madly jealous of Germanicus, the successes of whom 'first brought his natural dispositions to light, and discovered the malignity of his mind without disguise'. Eventually Tiberius had Germanicus poisoned, with disastrous effects on the Emperor himself; as Goldsmith comments:

> *Hitherto Tiberius had kept within bounds....But now, from the ninth year of his reign, it is that historians begin to trace the bloody effects of his suspicious temper....Having now no object of jealousy to keep him in awe, he began to pull off the mask, and appeared more in his natural character than before.*

Clearly for Turner, as for Goldsmith, the death of Germanicus therefore marked a significant historical turning-point, for not only would it mentally unbalance Tiberius but ultimately it would lead to that monarch being succeeded by three further 'mad' Caesars, namely Caligula, Claudius and Nero. In such a context the last golden blaze of day and coming of night can only prefigure the death of Rome, just as in the companion painting a similar timing and comparable light effects comment upon the continuing sad decay of the city in the nineteenth-century.

A scythe placed at the bottom-right introduces relevant associations of death. In reality the remains of Germanicus (who had died in Antioch, Syria) were landed at Brindisi, not Rome; however, Turner followed Goldsmith in this error. A notable passage of painting in this image is the distant sculpted column rising above the bridge to the left of centre. In order to capture the encrusted surface of such a column, Turner built up his paint surface with minute encrustations of pigment, thus creating a physical parallel to the original object. Visually the painting is a magnificent exercise in historical reconstruction, for which the artist drew upon both Piranesi's similar reconstructions of classical Rome, and those of his contemporaries C.R. Cockerall and J.M. Gandy. And it is also a magically coloured picture, being one of those late Turners whose hues still enjoy an undimmed richness, subtlety and beauty.

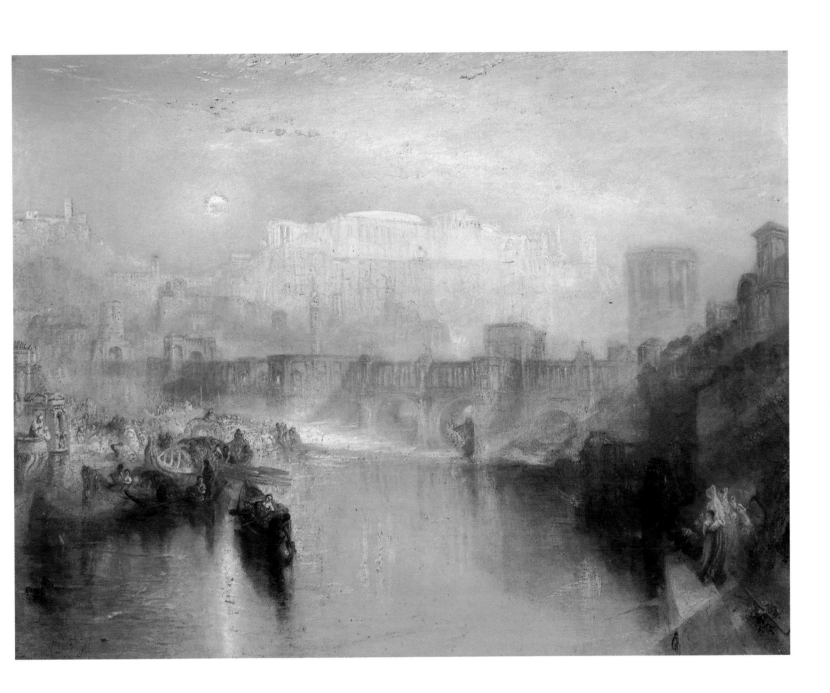

Venice: A Storm in the Piazzetta

c.1840
Watercolour on white paper, 21.9 x 32.1 cm
National Gallery of Scotland, Edinburgh.

Turner revisited Venice in 1840 and made this drawing either then or soon afterwards. As has recently been demonstrated (Warrell, 2003), originally it formed a sheet in one of the two soft-covered sketchbooks the painter took to Venice, the so-called *Storm* sketchbook whose contents comprised a number of highly finished or detailed watercolours that are now dispersed around the world. It is not known whether Turner detached the drawing from the book, or whether his agent did so at a later date. But in common with all of the artist's other late Venetian watercolours, the work was never exhibited during his lifetime.

The entire image is charged with energy. Turner's observational acuity can be witnessed along the top edge of the Doge's Palace, where the electricity makes it shimmer. On the Piazzetta the blurring and repetition of forms imparts a sense of danger and speed, as people wield umbrellas and scurry to escape the lightning.

Turner was at his most technically confident here, for many of the brilliantly lit architectural details of the Doge's Palace, and the whole of the visible part of St Mark's Cathedral (seen in the distance beyond the nearby column of St Theodore) were simply scratched out from the surface of the enormously strong rag-made paper, thereby revealing its white substrata beneath. On the left Turner the master of architectural perspectives (and the ex-Professor of Perspective at the Royal Academy), has swung the arcade below the Sansovino Library around by an appreciable degree in order both to create a view down its entire length and to fan open the Piazzetta before it. This expansion is widened even further by the diagonal lines of shadow cutting across the forefront of the image, and by the bright light streaming across the Piazzetta on the right.

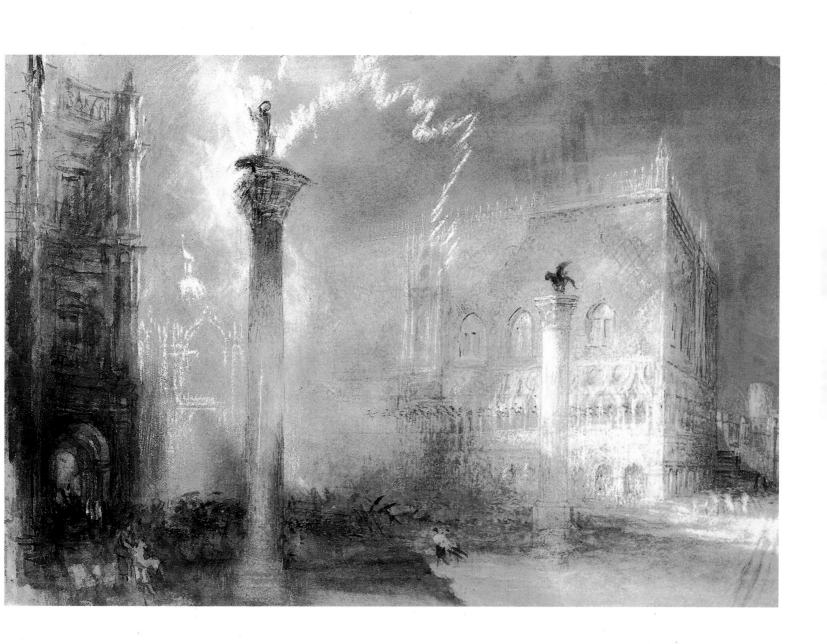

Venice: the Grand Canal looking towards the Dogana

c.1840
Watercolour on white paper, 22.1 x 32 cm
British Museum, London.

This work also originally formed a sheet in the *Storm* sketchbook taken to Venice in 1840. The approach it demonstrates, whereby line and colour are almost completely severed from one another, is visible in many other Venetian watercolours dating from around 1840 and takes even further the same separation witnessed in earlier oils of the city (for example, *Venice, from the Porch of Madonna della Salute* of 1835 discussed above). The delicacy liberated by this method permitted Turner to make Venice seem utterly weightless, and thereby to communicate a sense of floating, which is only appropriate to such a place.

Technically, the artist was at his most formidably economical here. First he laid down a wash of very delicate ochre for the sunlit areas. When this had dried he used another brush to lay in a similarly gentle ultramarine blue, to which he added a few brushings of warmer cobalt blue at the lower-left and right. Using a finer brush, he next drew details of a number of buildings with the ultramarine, after which he slightly darkened that blue to add further particulars. Returning to his first brush, he then mixed and applied a slightly darker-toned ochre, to be seen in the depiction of boats at the lower-left, the space in front of the Salute Church towards the right and the shadowed side of the buildings on the extreme right. At some point delicate pinks were used to cross-hatch the façade of the Doge's Palace and to depict the Campanile of St Mark's Cathedral. As in the 1835 oil, the latter structure has been turned through 45 degrees to face us side-on (just as the Grand Canal has again been doubled in width).

The next, darker ochre down the tonal scale was then employed to delineate the buildings on the far side of the Grand Canal. A few touches of the ochre mixed with some even darker burnt umber were all that finally proved necessary to anchor those buildings spatially, as well as to denote gondolas, barges, moorings, roof tiles and people at the lower-right. Some mid-toned black was subsequently employed to denote the gondolas in mid-canal and the globe on top of the Dogana or Customs House. A few broader brushings of deeper cobalt blue provided reflections on the water immediately in front of our viewpoint. One or two touches of unadulterated umber gave us the hulls of two gondolas at the lower-right, plus some adjacent shadows. Lastly, an intense black was used for the final touches on the foreground gondolas. In all, then, Turner made this image by using twelve tones of various colours, and he must have created the drawing in about four work sessions, possibly in under an hour. He may have used no more than three or four brushes, one of which would necessarily have been a long-haired and extremely fine sable, with which to provide the sharpest lines. Although it has been suggested that this drawing was made on the spot, that notion seems extremely unlikely because Turner's habitual need to labour on sequences of watercolours while washes were drying would necessarily have required the use of a studio or other workspace.

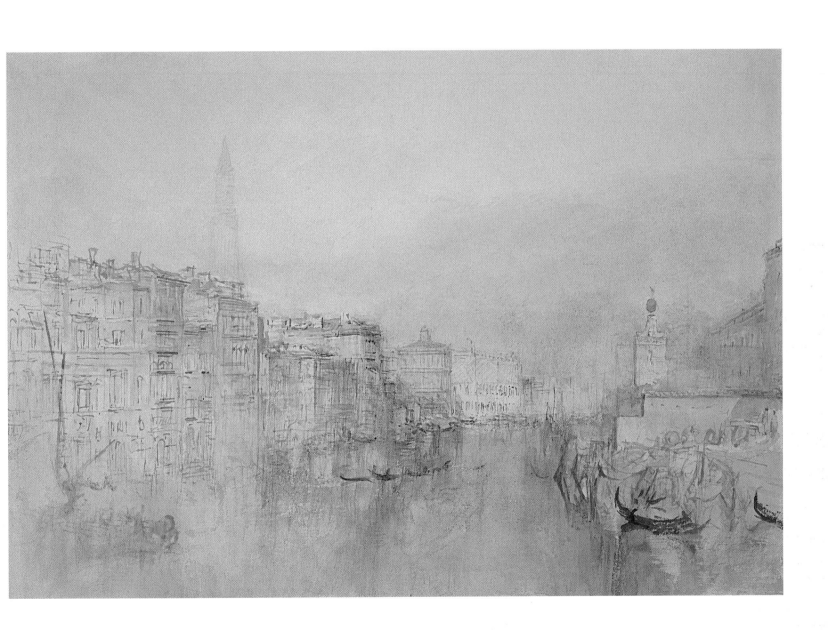

Slavers throwing overboard the Dead and Dying – Typhon coming on

1840

Oil on canvas, 91 x 138 cm

Museum of Fine Arts, Boston, Mass.

When this painting was first exhibited at the Royal Academy in 1840, its title was accompanied in the Exhibition catalogue by the following lines from 'Fallacies of Hope':

> *Aloft all hands, strike the top-masts and belay;*
> *Yon angry setting sun and fierce-edged clouds*
> *Declare the Typhon's coming.*
> *Before it sweeps your decks, throw overboard*
> *The dead and dying – ne'er heed their chains*
> *Hope, Hope, fallacious Hope!*
> *Where is thy market now?*

Because the word 'Hope' here signifies merely the hope of profit, the painting must therefore constitute a comment upon the inhumanity of man induced by the cash-nexus.

Turner may have been stimulated to create this picture by a passage in one of his favourite poems, 'Summer', from James Thomson's *The Seasons*. For many years it has alternatively been thought that the painting was inspired by an incident related in a history of the slave trade by Thomas Clarkson, republished in 1839. Turner possessed a copy of this book. It furnishes an account of a 1783 court case mounted against London insurers by the owners of a slave ship, the *Zong*, who were entitled to claim for loss of slaves by drowning but not through their deaths by illness on board ship. The captain of the *Zong* claimed that he had thrown diseased slaves overboard in three batches because of a lack of water. However, it was demonstrated that a 'shower of rain' lasting three days had followed the murder of the second batch of slaves, thus rendering any further deaths unnecessary. Given the verses it does seem possible that Turner remembered this incident when painting *The Slave Ship*, although he altered the 'shower of rain' into a 'Typhon'.

More recently it has been argued (McCoubrey 1998) that the story of the *Zong* did not provide Turner with the subject pictured here. Instead, it is suggested that the painter took his cue from the fact that, although slavery had been abolished throughout the British empire in 1838, ships from other countries – and especially Spanish and Portuguese vessels – were still very active in the slave trade between Africa and South America. Because Britain did not want the economy of the West Indies to be damaged by the use of slaves in Spanish-controlled Cuba and other parts of Central and South America, the Royal Navy was very vigorous in chasing slave ships to liberate their cargoes. To increase their chances of escape when chased, the slave traders would lighten their loads by simply throwing their human cargo overboard. That may have been the case here, for although no pursuing naval ship is visible, its presence might nonetheless be implied by the many drowning slave traders who are still chained: evidently they have been tossed overboard in a hurry, for if the slave traders had been less pressed for time they would surely have removed the comparatively expensive manacles for later re-use.

Certainly Turner provided references to Spain that support this reading. Thus the banner floating on the sea in front of the slaver has been identified as the ensign of a ship from Buenos Aires, possibly used as a flag of convenience for a Spanish or Portuguese slaver. Then there is the ship itself, with its clipper bow and low, sleek lines designed to maximize speed, as well as its polacca arrangement of masts. Ships bearing such a rig were commonly called *barques espagnoles* in the Mediterranean. And then there are the three dark-toned spaniel dogs inexplicably paddling across the bottom-right of the image; here Turner was surely giving us 'spaniel dogs' to pun upon 'Spanish Dogs', a derogatory term much employed historically in Britain.

So there may have been up to three sources for this picture. But whatever its derivation, in the distance the slave ship has furled all her sails because of the approaching 'typhon', while weird and exotic fish dine on the flesh of its tragically abandoned merchandise. Stylistically the fish owe much to Bruegel the Elder, whose prints Turner could have seen in the British Museum Print Room. And above everything flares a blood-red sunset, the only appropriate colour and timing for such a scene of brutal carnage and death.

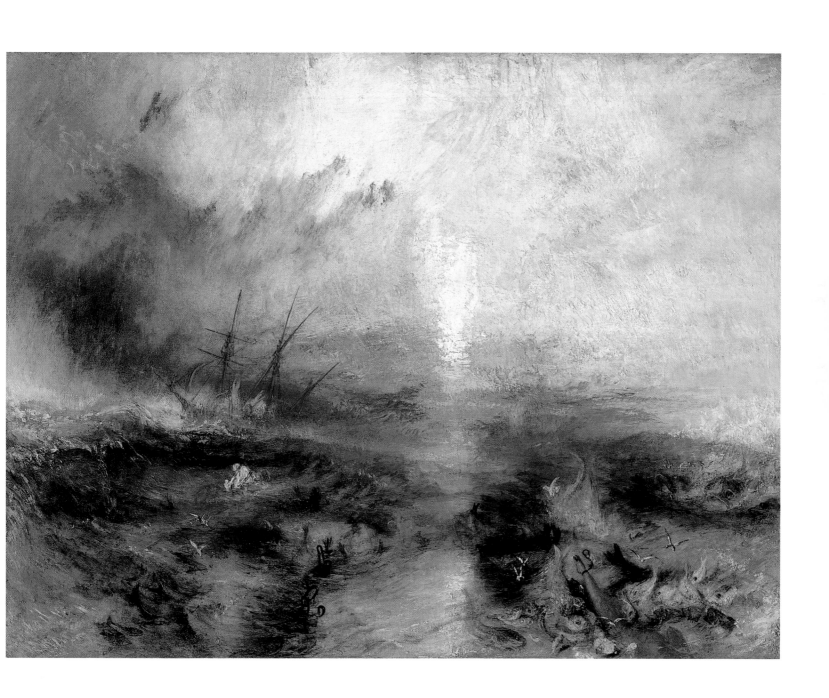

The Lake of Geneva with the Dent d'Oche: tending the vines

1841
Watercolour on white paper, 22.8 x 29.1 cm
Turner Bequest, Tate Britain, London.

In the early 1840s Switzerland took on a new appeal for Turner who visited the country each summer between 1841 and 1844. On those tours he often used sketchbooks with limp covers that could be rolled up, and were therefore extremely portable.

During the first of the annual trips Turner made four depictions of the view looking across Lake Geneva towards the Dent d'Oche massif on the southern side of the lake. He did so in two different roll sketchbooks, the *Lausanne* sketchbook (TB CCCXXXIV) and the *Fribourg, Lausanne and Geneva* sketchbook (TB CCCXXXII), from which the present work was later detached. All four watercolours were evidently created from memory and imagination, for although the relative position of the lake and distant mountains remains fairly constant in each work, the foregrounds alter from drawing to drawing. Thus in one watercolour Lausanne is spread before us. In a second we see a cemetary, as we do in a third, with a funeral cortege making its way towards it. Possibly Turner included these cemeteries in homage to the British historian Edward Gibbon, the author of *The Decline and Fall of the Roman Empire*, who was buried in just such a cemetary near Lausanne. And in a fourth drawing, reproduced here, Turner gave us grapepickers labouring well into the evening in the vineyards near Lutry to the east of Lausanne.

Turner had washed his paint onto wet paper and allowed it to diffuse before adding the foreground details after the paper had dried. However, when he came to elaborate the forms of the huge group of mountains rising above the lake, clearly he found the massif expressive enough as it was, and so left it. That decision seems very understandable, given its lovely colouring.

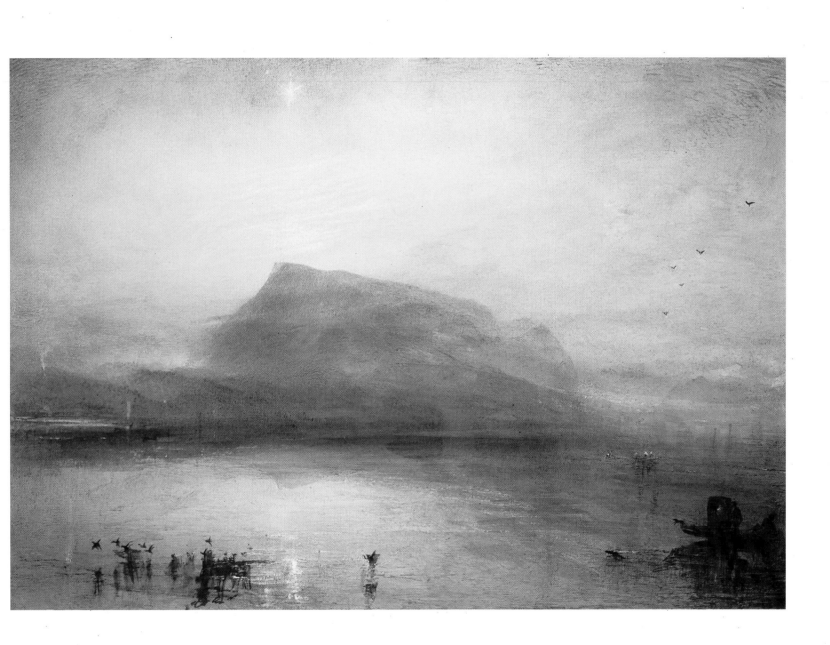

Lake Lucerne: the Bay of Uri from above Brunnen

1842
Watercolour on white paper, 29.8 x 45.7 cm
Private Collection.

Turner loved Lake Lucerne, and especially its lower reaches known as the Urnersee, or Bay of Uri, which we view here from above the small town of Brunnen. In addition to a good number of sketchy portrayals of the area, between 1841 and 1845 the painter also made three highly detailed watercolours of the present prospect, while a fourth drawing represents the view looking off to the right in a westerly direction along the main body of the lake. The present work may have been based on a 'sample-study', TB CCCLXIV-354.

The sense of atmospheric moisture, subtlety of colouring and tonal delicacy in this early-morning view are outstanding, even for Turner. In the distance on the left and jutting out into the lake is the Tellsplatte promontory, at the base of which stands William Tell's chapel; opposite, on the right, is the immense Uri-Rotstock mountain (9606 ft/2927 m). Before it are the lower peaks of the Oberbauenstock which glint in gold above the enormous mass of the Seelisberg promontory and the Rütli meadow, a hallowed spot in Swiss history. However, historical associations do not seem to have interested Turner here, for faced with scenery like this, the ancient affairs of men were no longer of much consequence. Only the present, humble doings of humanity stimulated him in these settings, and then usually just to establish the scale of such vast surroundings.

The composition is unified by the great sweep upwards into the rainclouds above the Tellsplatte promontory, and by the circular line of shadow passing across the Oberbauenstock on the opposite side of the lake. This expansive framing device sets off the ethereality of the more distant mountains by contrast. Both on the nearer hills and summits, and on the lake itself, we can witness Turner's widespread use of stippling. Equally it denotes the multitude of trees and their reflections, and adds a sense of vibrancy to the scene, almost making it shimmer. And Turner's interlinked powers as a colourist and tonalist can be witnessed to the full here, for although the colours of the Uri-Rotstock and the more distant mountains are beautifully soft and pearly in the dawn haze, the tangibility of those mountains is never in doubt, being effected by incredibly delicate modulations of tone.

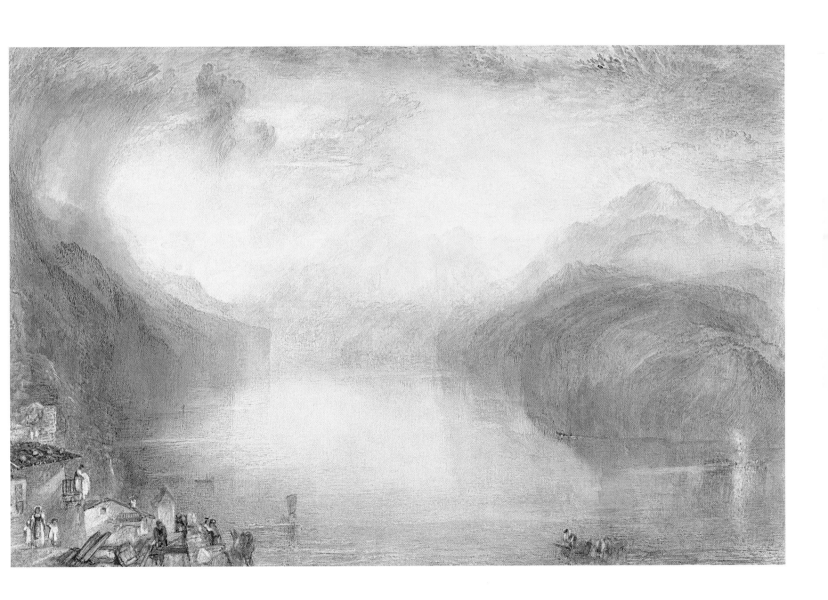

Snow Storm – Steam-Boat off a Harbour's Mouth making Signals in Shallow Water, and going by the Lead. The Author was in this Storm on the Night the Ariel left Harwich

1842
Oil on canvas, 91.5 x 122 cm
Turner Bequest, Tate Britain, London.

Arguably this is Turner's finest seascape, and possibly the greatest depiction of a storm in all art. It was exhibited at the Royal Academy in 1842.

Turner once claimed that in order to paint this scene he 'got the sailors to lash me to the mast to observe it; I was lashed for four hours, and I did not expect to escape, but I felt bound to record it if I did'. However, he may have fabricated this story, for it is suspiciously similar to one told of the marine painter Joseph Vernet. Moreover, no steamer named the *Ariel* is known to have sailed from Harwich in the years leading up to 1842; perhaps the title of the vessel was intended to allude to Shakespeare's *The Tempest*. The title of the painting does not fully accord with what we actually see, either, for a ship 'going by the lead' denotes that a weighted line is being periodically dropped from her bow to gauge the shallowness of the waters, so as to avoid running aground. Such a prudent, measured precaution seems to be fully at odds with the predicament of a boat caught up in a maelstrom, although it is easy to appreciate why her crew should be firing signal rockets to denote her position offshore. Yet even if some or all of Turner's factual claims are false, and there seems to be some disparity between the nautical behaviour indicated in the title and what appears to be happening to the ship, the veracity of his communication of what it is like to be at the heart of a cataclysmic storm is beyond question. The entire visible universe wheels in a massive vortex, both pulling us into the scene and radiating infinite energy outwards.

On the steamer the foremast and funnel are located in their correct positions, which again indicates that Turner had purposefully taken liberties with literal reality in *The Fighting 'Temeraire'* of three years earlier. The artist was very annoyed to read a criticism of this work stating that it represents a mass of 'soapsuds and whitewash'. He was overheard to say 'soapsuds and whitewash! What would they have? I wonder what they think the sea's like? I wish they'd been in it.' Naturally, today it is much easier to appreciate how his freedom of handling imparts the raw energy of a storm far more authentically than if he had depicted every snowflake, drop of rain and wave with mundane verisimilitude.

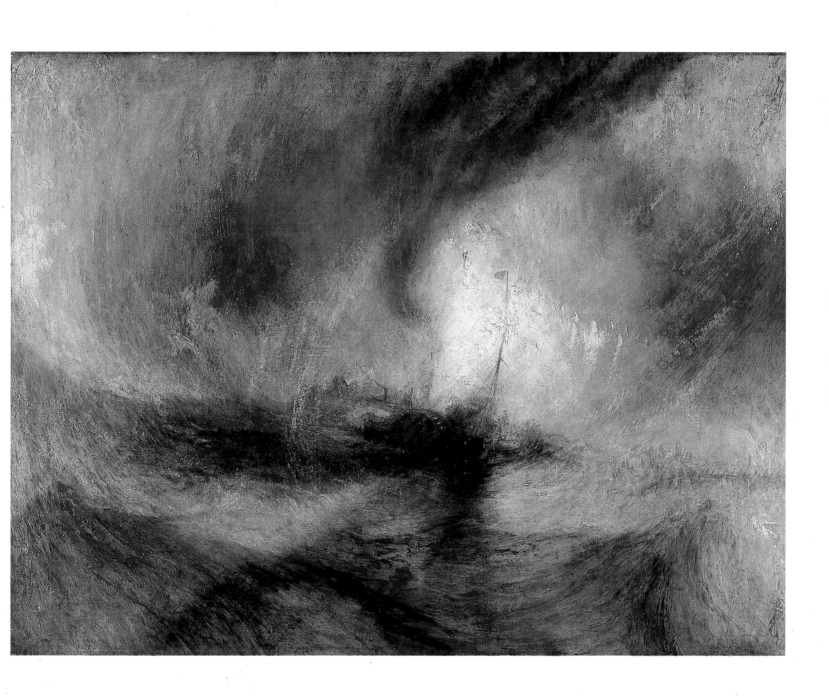

The Pass of Faido

1843
Watercolour on white paper, 30.5 x 47 cm
Pierpont Morgan Library, New York.

This drawing was made for John Ruskin, who commissioned it after seeing Turner's 'sample-study' for the design, which has remained in the Turner Bequest (TB CCCLXIV-209). Ruskin called the watercolour 'the greatest work [Turner] produced in the last period of his art'.

The river rushing through the landscape is the Ticino, which forms part of the lower St Gotthard Pass, one of the major routes through the Swiss alps into Italy. When Ruskin visited the spot in 1845 he marvelled at the liberties Turner had taken with actuality, declaring 'The Stones, road, and bridge are all true, but the mountains, compared with Turner's colossal conception, look pigmy & poor'.

As in many of the other late Swiss watercolours, there is an enormous sense of movement running through the vast, inert masses of rock, so that the entire visible realm seems filled with energy. Yet because we know from Turner's writings that he apprehended a metaphysical reality underlying everything, and also believed that 'The Sun is God', he surely did not intend this power to denote merely a physical force. The constantly varied modulations of tone in the work do articulate emotional responses to the scene, as well as capture the 'truths' of geological form, communicate the primal energies that brought those rocks into being and express the natural energies swirling around the alps, but equally they convey Turner's apprehension of some divine continuum pulsing through everything.

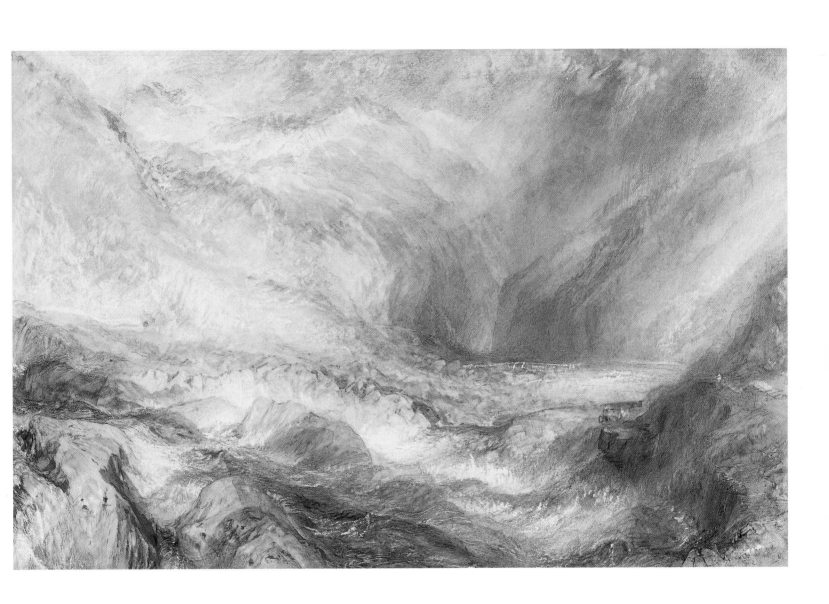

Rain, Steam, and Speed – the Great Western Railway

1844

Oil on canvas, 91 x 122 cm

Turner Bequest, National Gallery, London.

Turner here celebrated both the coming of steam locomotion on land, and British technological triumph over water.

The railway bridge depicted crosses the River Thames at Maidenhead. It was a very new structure in 1844, having only been completed in 1839. Designed by Isambard Kingdom Brunel, it was an engineering triumph, for because of the need to keep the waterway clear for river traffic, it could only comprise two spans. As a consequence, it was the widest-arched and flattest-spanned bridge ever to have been built in brick. In 1839 that unprecedented shape had led to fears that the structure would collapse, especially when subjected to inclement weather. However, it is still in use today. On the left is the bridge carrying the Great West Road over the Thames at Maidenhead.

When this painting was first exhibited at the Royal Academy in 1844 the anonymous critic of *Fraser's Magazine* warned its readers to hasten to see the work lest the locomotive 'should dash out of the picture, and be away up Charing Cross through the wall opposite'. The warning seems prudent, given the suggested velocity of the engine. Today that implied movement derives only from the pronounced perspective of the train, railway line and bridge emerging from a distant haze of rain. However, when the paint was still fresh, the sense of speed was augmented by three puffs of steam emanating from the locomotive, whiffs that had already been 'left behind by the engine'. Sadly, time has rendered them far less visible.

Turner joked about speed here, for in front of the train is a hare which has been startled by the approaching machine and is possibly outpacing it. Because of the pictorial proximity of the animal to a ploughman at work in a field beyond the bridge, it seems certain that the artist intended the conjunction of fast hare and slow plough to remind his audience of a popular song 'Speed the plough', with which he was familiar (as we have seen when discussing the Northampton election drawing discussed above).

In addition to the 'Speed' of the title and the 'Rain' falling across the entire picture, we can also perceive the 'Steam', for Turner has removed the front of the locomotive in order to reveal the inner workings of its boiler. Nothing else would explain the brilliant fiery mass at the front of the engine, for it is too formless to be an outside light. Turner may well have derived this image from explanatory cut-away diagrams, of the type that were frequently to be seen in the Victorian popular press. By means of it we are witnessing yet another realization of his desire to make visible the underlying 'causes' of things.

Turner himself owned shares in the Great Western Railway Company, and may therefore have had a hidden agenda for puffing the power of Steam here. But in any event he had already celebrated the advent of Steam long before, as we have already noted in the *Dover Castle* of 1822. And if, in *The Fighting 'Temeraire'* of 1839, he had made clear the price of technological advance, he also celebrated the physical power of Steam there, as we have discovered.

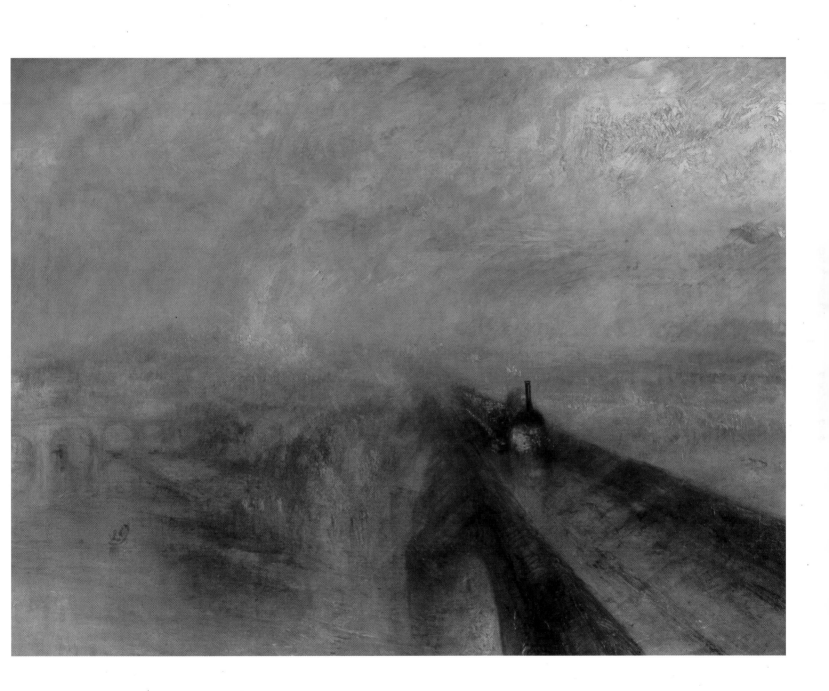

Whalers

1845
Oil on canvas, 91.7 x 122.5 cm
The Metropolitan Museum, New York.

In 1845, and again in 1846, Turner exhibited pairs of oil paintings depicting whales and whaling. The titles of the two 1845 oils were identical – which is why the present painting is also known usefully as 'The Whale Ship' – and those titles were accompanied in the Royal Academy catalogue by specific page references to Thomas Beale's book, *The Natural History of the Sperm Whale*, which had been reissued in 1839. In the case of the painting under discussion, the passage cited tells of how a Sperm Whale was both harpooned and wounded with lances off Japan. It then dived but re-emerged to overturn one of the boats whose crews had been tormenting it. Finally, after being lanced again, it died and sank into the deep before its body could be recovered. Turner probably thought of this disappearance as yet another example of the fatuity of human endeavours.

On the left we see the re-emergence of the whale, with blood and water spouting from its blow-hole. On the right an overpainted semicircular band suggests the path through the air previously taken by the whale, although the absence of a large splash where this shape enters the sea make it clear that Turner was not being directly illustrative here but more allusive. Such a contention is supported by the fact that a number of tail-fins are visible beyond the whaleboats being tossed about by the whale, as well as in front of the whale ship itself. Clearly they do not belong to more whales. Instead, Turner appears to have condensed moments in time, to give us several simultaneous junctures in the progress of the whale under attack. As we have seen above with *The Battle of Trafalgar*, he occasionally played with chronology in this way.

Turner painted this picture for the Sperm Whale fisheries magnate and collector of his works, Elhanan Bicknell. Unfortunately Bicknell took exception to the fact that some touches had been added to the canvas in watercolour. He rubbed these out with his 'Handky' and then asked the artist to repaint the affected areas in oils, which Turner did begrudgingly. But even then Bicknell refused to take the picture, due to another disagreement with the painter. Fortunately Turner soon found another buyer for the work.

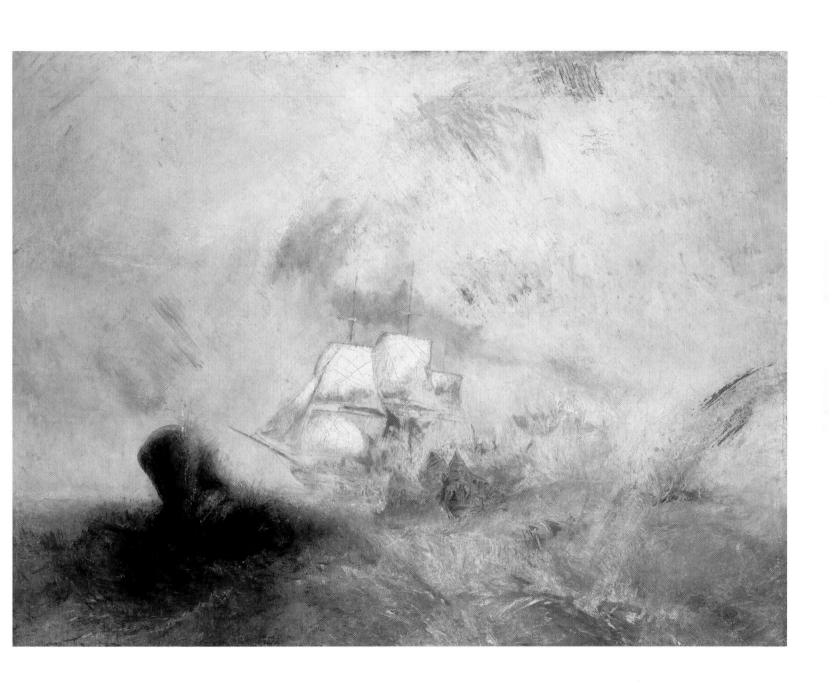

The Clyde

c.1845
Oil on canvas, 89 x 119.5 cm
Lady Lever Art Gallery, Port Sunlight.

This is one of a magnificent group of around ten late paintings based upon images used previously in the *Liber Studiorum*, the set of mezzotint prints created between 1806 and 1819. The present work derived from Plate 18 of the *Liber*, published in 1809; that design itself grew out of a sepia watercolour made a year or so earlier. Turner kept all the *Liber Studiorum* printing plates, and in 1845 had the entire set of prints run off again, even though the plates were very worn. That reprinting surely acted as the stimulus for the late set of paintings.

The Cora Linn waterfall is one of three waterfalls on the river Clyde south of Glasgow. Turner had first depicted the cascade in a watercolour exhibited at the Royal Academy in 1802 (the sepia watercolour made for the *Liber Studiorum* design was developed from that earlier image). The title of the 1802 watercolour in the Royal Academy catalogue referred the viewer to Mark Akenside's poem 'Hymn to the Naiads'. It did so to make evident Turner's identification with Akenside's notion that Naiads or river-nymphs personified underlying natural powers. Even by 1802 Turner was attempting to pictorialise the universals behind appearances. But by the mid-1840s the artist no longer needed the symbolic personifications of natural drives. That is surely why the women/deities are no longer so evident here, for the primal energies they once embodied now fill the entire landscape.

This is one of Turner's very greatest masterworks in terms of its colour, being equally a study of the way that strong light breaks down prismatically as it passes through the fine spray of moisture given off by a waterfall. The two rainbows on the right are enormously subtle, as are all the phenomenally minute differentiations of tone used to define the trees spread across both banks of the river. Here Turner brought together all his lifelong concerns, with form, meaning, colour, tone and optics, in a great paean to the forces of nature and art.

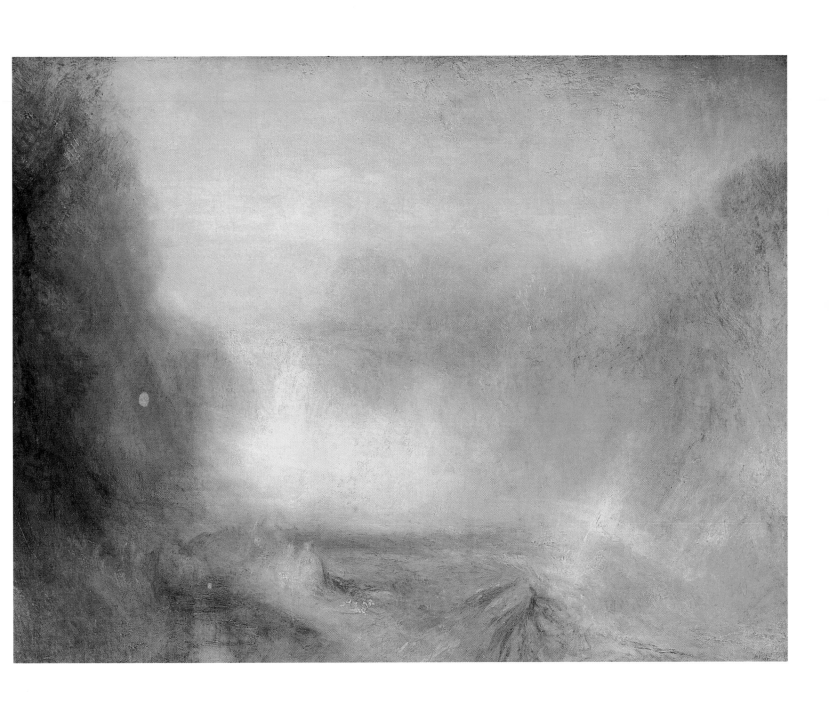

The Lauerzersee, with the Mythens

c.1848
Watercolour on white paper, 33.7 x 54.5 cm
Victoria and Albert Museum, London.

For many years this work was known as 'Lake of Brienz'. However, research by the present writer established the true identity of the lake depicted. The drawing was made for the fourth and final set of Swiss watercolours.

The Lauerzersee is a small lake situated not far from Lake Lucerne at Brunnen; the town of Schwyz is located on its south-easternmost shore, which we see in the distance. Although Turner included Schwyz in the 'sample-study' he made for this work (Private Collection, USA), here he has excluded the town altogether by closing up the space between the Schwanau island on the left, and the Urmiberg mountain on the right. He also took topographical liberties with the two distant peaks known as the Mythens. Whereas in the 'sample-study' they are depicted in their full serrated majesty, here they are less pointed and have been lowered in relation to their surroundings, with the Greater Mythen being reduced almost to the level of the smaller one.

The colouring of this drawing seems unearthly in its beauty. The image is unified by constant modulations of colour and tone that are not limited by the hard and sharp confines of inert masses of mountains and rocks; instead, those ceaseless shimmerings of colour again convey a sense of some universal energy passing imperceptibly through everything.

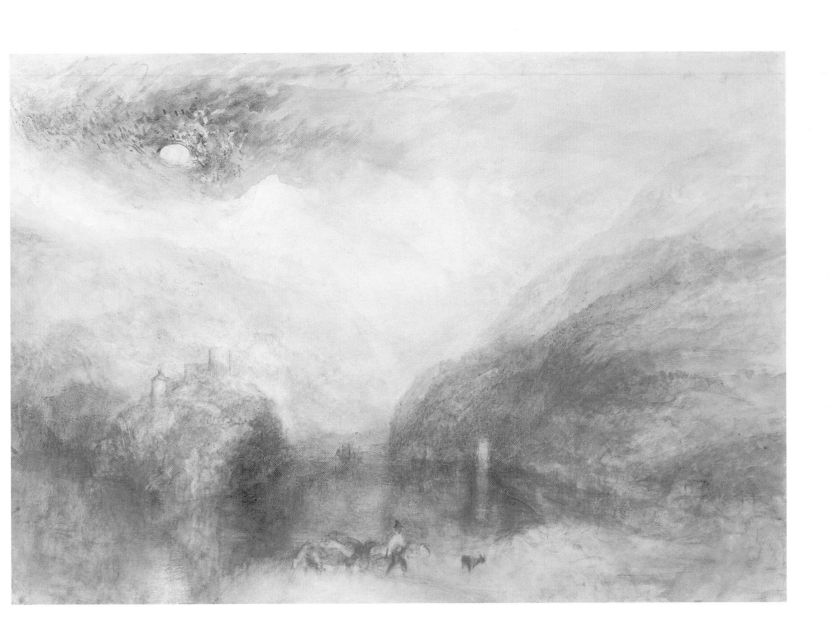

Yacht approaching the Coast

c.1850
Oil on canvas, 102 x 142 cm
Turner Bequest, Tate Britain, London.

The title of this canvas did not derive from Turner, for he never exhibited it. Its date is equally uncertain. The way the paint is worked suggests that the picture could have been made as late as 1850, for the area of thick scumbled pigment around the sun and the drawing of the yacht are respectively very similar to the handling and draughtsmanship encountered in the three surviving pictures of the group of four related paintings exhibited at the Royal Academy in 1850. A further link between that final batch of exhibited works and the present work is the centrality of the sun in the image.

Clearly this is not primarily a picture of a yacht approaching a coast. Nor is it only a picture of one vessel, despite the title, for three or four boats are discernible. Instead, Turner surely intended it to act as a great hymn to the sun, which the artist latterly identified as God. The painter's lifelong love of poetry that linked the power of light to the Divinity, his open identification with the Platonic metaphysics of Sir Joshua Reynolds and Mark Akenside, his constant concern with essentials – of natural process, human behaviour and the mechanics of light and form – all support the view that for Turner the sun was not merely a physical object. And naturally his paintings best make that belief clear. In works such as this the sun burns its way into the heavens, both as the ultimate source of life on earth and as the key to all those other essentials Turner had spent a lifetime exploring and celebrating.

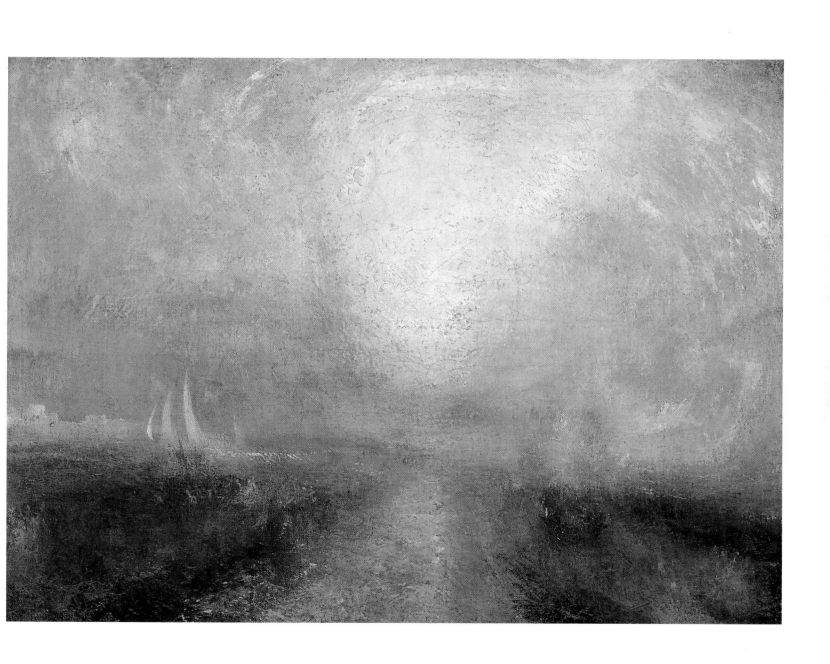

TURNER AND HIS CRITICS

[Turner] seems to view nature and her operations with a peculiar vision, and that singularity of perception is so adroit that it enables him to give a transparency and undulation to the sea more perfect than is usually seen on canvas. He has a grace and boldness in the disposition of his tints and handling which sweetly deceive the sense; and we are inclined to approve him the more as all our painters have too servilely followed the steps of each other and given us pictures more like japanned tea boards, with ships and boats on a smooth glassy surface, than adequate representations of that inconstant and ever-changing element.

ANTHONY PASQUIN, 1797

Turner's pictures were spoken of. Hoppner reprobated the presumptive manner in which He paints, and his carelessness. – He said that so much was left to be imagined that it was like looking into a Coal fire, or upon an Old wall, where from many varying undefined forms the fancy was to be employed in conceiving things. But his manners, so presumptive & arrogant, were spoken of with great disgust.

JOSEPH FARINGTON, 1803

Humphry remarked on the arrogant manners of a new member of Council & of the Academy T[urner]. more like those of a groom than anything else: no respect to persons or circumstances.

JOSEPH FARINGTON, 1803

[Turner] must be loved for his works; for his person is not striking, nor his conversation brilliant.

EDWARD DAYES, 1805

To exalt Mr Turner, it is not at all to depreciate others; such an idea must ever be remote from impartial reviewers of art; and Turner is a diamond that needs no foil. Yet the good and evil of fine art, are comparative terms, and we need not fear nor forbear to remark, how much less Mr Turner appears to depend than most exhibitors, on those dazzling and intrinsic qualities which address themselves to the external sense, and how much more on the manifestation of mind. He seems to feel with Akenside, that –

– Mind! – mind alone!
The living fountain in itself contains
Of beauteous and sublime: –

and from this source the science which regulates his various art, appears to flow with spontaneous freedom and in an ample stream.

JOHN LANDSEER, 1808

I dined with the Royal Academy last Monday in the Council Room – it was entirely a meeting of artists (none but the members and exhibitors could be admitted) and the day passed off very well. I sat next to Turner, and opposite Mr West and Lawrence – I was a good deal entertained with Turner. I always expected to find him what I did – he is uncouth but has a wonderful range of mind.

JOHN CONSTABLE, 1813

We here allude particularly to Turner, the ablest landscape painter now living, whose pictures are however too much abstractions of aerial perspective, and representations not properly of the objects of nature, as of the medium through which they were seen....They are pictures of the elements of air, earth, and water. The artist delights to go back to the first chaos of the world....All is without form and void. Some one said of his landscapes that they were pictures of nothing, and very like.

WILLIAM HAZLITT, 1816

Turner has some golden visions, glorious and beautiful; they are only visions, but still they are art, and one could live and die with such pictures....

JOHN CONSTABLE, 1828

J.M.W. Turner is the only man who has ever given an entire transcript of the whole system of nature, and is, in this point of view, the only perfect landscape painter whom the world has ever seen....We have had, living with us, and painting for us, the greatest painter of all time; a man with whose supremacy of power no intellect of past ages can be put in comparison for a moment.

JOHN RUSKIN, 1843

[Turner] is the Shelley of English painting – the poet and painter both alike veiling their own creations in the dazzling splendour of the imagery with which they are surrounded, mastering every mode of expression, combining scientific labour with an air of negligent profusion, and producing in the end works in which colour and language are but the vestments of poetry.

ANONYMOUS OBITUARIST, *The Times*, 1851

Of all the light-hearted, merry creatures I ever knew, Turner was the most so; and the laughter and fun that abounded when he was an inmate in our cottage was inconceivable, particularly with the juvenile members of our family....He was a firm, affectionate friend to the end of his life; his feelings were seldom seen on the surface, but they were deep and enduring. No one would have imagined, under that rather rough and cold exterior, how very strong were the affections that lay hidden beneath.

CLARA WELLS WHEELER, 1850s

Near [Sir Joshua Reynolds] lies his successor as president, West, the Quaker painter; courtly Lawrence; Barry, whom Reynolds detested; rough, clever Opie; Dance; and eccentric Fuseli. In this goodly company, also, sleeps a greater than all of these – Joseph Mallord William Turner, the first landscape painter of the world. He had requested, when dying, to be buried as near to his old master, Reynolds, as possible.

WALTER THORNBURY, 1877

And this is the lesson of these admirable drawings – the feeling they impart, that idealism like Turner's has for its main condition of beauty the fact that it rests upon a solidity of execution that almost defies ultimate analysis.

HENRY JAMES, 1878

It has been, perhaps justly, observed, that 'after all allowance and deduction, Turner remains the fullest exponent of nature, the man above all others who was able to reflect the glory and the grandeur, the sunshine and the shade, the gladness and the gloom which in the outward landscape responds to the desires and the wants of the human heart'.

EDWARD WALFORD, 1878

[Edward] Lear told me that he approved of the saying of some one, 'Study the works of the Almighty first, and Turner next'. Once meeting a friend who had stayed in a house where Turner was painting, Mr Lear anxiously asked, 'Cannot you tell me something the great man said?' 'He never said anything' was the reply.

HENRY STRACHEY, 1882

A group of French painters, united by the same aesthetic tendencies, struggling for ten years against convention and routine to bring art back to the scrupulously exact observation of nature, applying themselves with passion to the rendering of the reality of forms in movement, as well as to the fugitive phenomena of light, cannot forget that it has been preceded in this path by a great master of the English School, the illustrious Turner.

Excerpt from a letter signed by
EUGÉNE BOUDIN, EDGAR DEGAS, CLAUDE MONET,
CAMILLE PISSARRO, AUGUSTE RENOIR, ALFRED SISLEY,
MARY CASSAT, BERTHE MORISOT
and other artists in 1882-3

I think that Turner is the greatest landscape painter that has ever lived, far superior to Claude or the Dutch painters....What marvellous pictures the Turners are! I think *Ulysses and Polyphemus* is the most wonderful in the [National Gallery]. Well might Turner despise fame and wealth with such a world in his brain....What a mixture of height and depth!

BEATRIX POTTER, 1884

The 'simply natural' interests me no longer. After looking at the landscape ascribed to Bonington in our drawing room I feel that Nature is played out as a Beauty but not as a Mystery. I no longer want to see the original realities – as optical effects. In Turner's work I find the deeper reality underlying the scenic, the expression of what are sometimes called abstract imaginings....The much-decried, late-Turner rendering is now necessary to create my interest....[Each Turner watercolour] is a landscape plus a man's soul....[Turner] first recognises the impossibility of really reproducing on canvas all that is in a landscape; then gives for that which cannot be reproduced a something else which shall have upon the spectator an approximate effect to that of the real.

THOMAS HARDY, 1887

Who does not know Turner's picture of the Golden Bough? The scene, suffused with the golden glow of imagination in which the divine mind of Turner steeped and transfigured even the fairest natural landscape, is a dream-like vision of the little woodland lake of Nemi – 'Diana's Mirror', as it was called by the ancients.

J.G. FRAZER, 1890

These are no longer pictures, but aggregations of colours, quarries of precious stones, painting in the most beautiful sense of the word.

PAUL SIGNAC, 1898

Turner must be accepted as the greatest of all artists. He spent his days in a more strenuous endeavour to grasp nature, outside man, at once synthetically and analytically, than was ever made before, with the result that his legacy of natural description is without any sort of rival in its wealth of commentary , explanation and illustration of what a man may see between his cradle and his grave.

SIR WALTER ARMSTRONG, 1902

Turner authorises us to create forms that go beyond conventional reality.

ANDRÉ DERAIN, 1906

I am trying to do something 'different' – realities, in a manner of speaking – something the fools call 'Impressionism', a term that is utterly misapplied, especially by critics who don't hesitate to apply it to Turner, the greatest creator of mystery in all art.

CLAUDE DEBUSSY, 1908

Turner lived in a cellar. Once a week he had the shutters suddenly flung open, and then – what incandescence! What dazzlement! What jewels!

HENRI MATISSE, 1908

I have never known anything really about [Turner's] life, but have always felt from his divine pictures that he has a kind of ecstatic soul....

PERCY GRAINGER, 1909

...all we need is to affirm that Turner...was a worshipper, that he bowed down before, and therefore exalted himself in the contemplation of, the invisible within the visible. This is why there is in his work a beauty that nature cannot show; a beauty, one must hasten to say, not surpassing but different from that of nature, no mere imitation of what nature sets before us....Is not every artist, consciously or unconsciously, a Platonist, seeking everywhere the types of which visible things are but the imperfect forms? Could Plato have seen a Turner landscape would he not at once have given to painting a place in his Republic?

J.E. PHYTHIAN,1910

The Turner vortex rushed at Europe with a wave of light.

WYNDHAM LEWIS, 1914

I can't describe it, I don't know what it is, I don't see what it is. It's easier to enter into the most unreal world of the poet than into that of the painter. It is strange that we can move with such ease in the atmosphere of words and with such difficulty among the almost tangible images of painting. I don't want to know what [Turner's] interior at Petworth represents. Why plunder the unreal? Besides, I couldn't enter the interior at Petworth, I wouldn't dare enter; it's enough that the door is wide open for our contemplation. I wouldn't dare go in, I'd be afraid of being burnt up; the air looks so hot, so boiling hot, and the mass of air is so thick, so voluminous! Only the soul of the painter can survive in it; perhaps other great painters as well are in fusion, in preparation there; it's no place for recognizable nature or even for a partially idealized one. In the interior at Petworth moving strains are being brought to birth.

RENÉ GIMPEL, 1922

The great moderns in England and France are Turner and Millet. And we are still, and shall be for some centuries, concerned with Turner and Millet as the supreme standards of modern art....Turner's monumental position is not only due to the wealth of what he had to say. Part of his genius consisted in the infallible instinct comparable to that of a great actor, which dictated to him the proper dose that audiences of different degrees of culture, or of surroundings habitually different, were in a position to assimilate. With the added experience of a century, to which experience his own labours remain the most considerable contribution, Turner, were he to come to life, could make from them today a selection which would prove him still the first of the moderns.

WALTER SICKERT, 1926, 1929

When we look at the larger Turners – canvases yards wide and tall – and observe that they are all done in one piece and represent one single second of time, and that every innumerable detail, however small, however distant, however subordinate, is set forth naturally and in its true proportion and relation, without effort, without failure, we must feel in the presence of an intellectual manifestation

the equal in quality and intensity of the finest achievements of warlike action, of forensic argument, or of scientific or philosophical adjudication.

SIR WINSTON CHURCHILL, 1932

Turner was ready to shake the confines of his theatre, to push aside the porticoes and dissolve the frontiers of the sea.

ANDRÉ MASSON, 1949

This chap Turner, he learnt a lot from me.

MARK ROTHKO, 1966

Turner was great not only as an academician in the Renaissance tradition, but also because he was the first painter in Europe to break with that tradition and initiate the modern revolution of Painting sixty years before Matisse and Picasso.

SIR VICTOR PASMORE, 1984

Abstract Expressionism was alive and well 160 years ago. This kind of vision – predating Impressionism and Abstract Expressionism – I think is extraordinary...[With late Turner] it's not unlike looking into the universe. On the one hand, it seems to diminish one because it seems to dissolve the singularity of self, but it is also overpowering.

JAMES TURRELL, 2000

BIBLIOGRAPHY

BAILEY, Anthony
Standing in the Sun, A Life of J.M.W. Turner (London, 1997).

BUTLIN, Martin and JOLL, Evelyn
The Paintings of J.M.W. Turner, Rev. ed., 2 Vols., New Haven and London, 1984.

BUTLIN, Martin, HERRMANN, Luke and JOLL, Evelyn, eds.
The Oxford Companion to J.M.W. Turner, Oxford, 2001.

FINBERG, A.J.
The Life of J.M.W. Turner, RA, 2nd Ed., London, 1961.
A Complete Inventory of the Drawings in the Turner Bequest, 2 Vols., London, 1909.

GAGE, John
Colour in Turner: Poetry and Truth, London, 1969
(ed.), *Collected Correspondence of J.M.W. Turner*, Oxford, 1980.
J.M.W. Turner,'A Wonderful Range of Mind', London, 1987.

GOLT, Jean
'Beauty and Meaning on Richmond Hill: New Light on Turner's Masterpiece of 1819', *Turner Studies*, vol. 7, no.2, 1987.

HAMILTON, James
Turner, A Life, London, 1997.

HILL, David
In Turner's Footsteps, London, 1984.
Turner in the Alps, London, 1992
Turner on the Thames, New Haven and London, 1993.
Turner in the North, New Haven and London, 1996.

LINDSAY, Jack
J.M.W. Turner, His Life and Work. A Critical Biography, London, 1966.

McCOUBREY, John
'Turner's Slave Ship: abolition, Ruskin, and reception', *Word and Image*, vol. 14, no.4, October 1998.

POWELL, Cecilia

Turner in the South, London, 1987.

Turner's Rivers of Europe, The Rhine, Meuse and Mosel, exh. cat., Tate Gallery, London, 1991.

Turner in Germany, exh. cat., Tate Gallery, London, 1995.

RAWLINSON, W.G.

The Engraved Work of J.M.W. Turner, 2 Vols., London, 1908, 1913.

Turner's Liber Studiorum, a Description and a Catalogue, London, 1878, 2nd ed., 1906.

RUSKIN, John

Modern Painters, (in *The Complete Works of John Ruskin*, E.T. Cook and Alexander Wedderburn, eds., London, 1904)

SHANES, Eric

Turner's Picturesque Views in England and Wales, London, 1979.

Turner's Rivers, Harbours and Coasts, London, 1981.

Turner's Human Landscape, London, 1990.

Turner's England, London, 1990.

Turner's Watercolour Explorations, exh. cat., Tate Gallery, London, 1997.

Turner: The Great Watercolours, exh. cat., Royal Academy of Arts, London, 2000

'Identifying Turner's Chamonix water-colours', *The Burlington Magazine*, November 2000, pp. 687-694.

TURNER STUDIES

Journal published by the Tate Gallery, London, 22 numbers 1980-91.

THORNBURY, Walter

The Life of J.M.W. Turner, 2 Vols., London, 1862, 2nd ed. 1877.

VENNING, Barry, 'A Macabre Connoisseurship: Turner, Byron and the Apprehension of Shipwreck Subjects in Early Nineteenth-Century England', *Art History*, Vol.8, No.3, September 1985.

Turner, London, 2003.

WARRELL, Ian

Turner on the Loire, exh. cat., Tate Gallery, London, 1997.

Turner on the Seine, exh. cat., Tate Gallery, London, 1999.

Turner et le Lorrain, exh. cat. musée des Beaux-Arts, Nancy, France, 2002

Turner in Venice, exh. cat., Tate Britain, London, 2003.

WILTON, Andrew

The Life and Work of J.M.W. Turner, London, 1979.

Turner in his Time, London, 1987.

CHRONOLOGY

1775 Birth of Joseph Mallord William Turner in London on 23 April (?).

1787 Makes first signed and dated watercolours.

1789 Probably begins studying with Thomas Malton, Jr. and also admitted as student to Royal Academy Schools.

1790 Exhibits first work at the Royal Academy.

1791 Tours the West Country.

1792 Tours south and central Wales.

1793 Awarded the 'Greater Silver Pallet' for landscape drawing by the Royal Society of Arts.

1794 Tours Midlands and north Wales.

1795 Tours southern England and south Wales.

1796 Exhibits first oil painting at the Royal Academy.

1797 Tours north of England and Lake District.

1798 Tours north Wales.

1799 Elected an Associate Royal Academician. Visits West Country, Lancashire and north Wales.

1801 Tours Scotland.

1802 Elected Royal Academician. Tours Switzerland.

1804 Death of mother after a long illness.

1805 Holds first exhibition in own gallery in London.

1807 Elected Royal Academy Professor of Perspective.

1808 Visits Cheshire and Wales. Probably pays first visit to Farnley Hall, home of Walter Fawkes.

1811	Delivers first course of perspective lectures at the Royal Academy. Tours West Country for material for the 'Southern Coast' series.
1812	First quotation from his own poem, 'Fallacies of Hope', in the Royal Academy catalogue.
1813	Completes Sandycombe Lodge in Twickenham. Revisits West Country.
1814	Again tours West Country.
1815	Tours Yorkshire.
1816	Tours Yorkshire to gain material for the 'Richmondshire' series.
1817	Tours Belgium, Germany and Holland.
1818	Visits Edinburgh.
1819	Walter Fawkes exhibits over sixty Turner watercolours in his London residence. Pays first visit to Italy, stays in Venice, Florence, Rome and Naples.
1821	Visits Paris and tours northern France.
1822	Visits Edinburgh for State Visit of King George IV.
1824	Tours south-east England, also the Meuse and Moselle rivers.
1825	Tours Holland, Germany and Belgium. Death of Walter Fawkes.
1826	Tours Germany, Brittany and the Loire.
1827	Stays at East Cowes castle, the home of the architect John Nash. Autumn, starts visiting Petworth regularly.
1828	Delivers last lectures as Royal Academy Professor of Perspective. Visits Italy a second time, stays principally in Rome.
1829	Exhibits seventy-nine 'England and Wales' series watercolours in London. Visits Paris, Normandy and Brittany. Death of father. Draws up first draft of will.

1830 Tours Midlands. Exhibits a watercolour for last time at the Royal Academy.

1831 Tours Scotland. Revises will.

1832 Visits Paris, probably meets Delacroix.

1833 Exhibits 66 'England and Wales' watercolours in London. Visits Vienna and Venice.

1835 Tours Denmark, Prussia, Saxony, Bohemia, the Rhineland and Holland.

1836 Tours France, Switzerland and the Val d'Aosta.

1837 Death of Lord Egremont. Resigns as Royal Academy Professor of Perspective.

1839 Tours the Meuse and Moselle rivers.

1840 Meets John Ruskin for first time. Visits Venice.

1841 Tours Switzerland, and does so again in following three summers.

1845 Acts as temporary President of Royal Academy. Tours northern France in May; in the autumn Dieppe and Picardy, his last tour.

1846 Moves to Chelsea around this time.

1848-49 Growing infirmity. Revises will.

1850 Exhibits for last time at the Royal Academy.

1851 Dies 19 December in Chelsea, London.

LIST OF PLATES